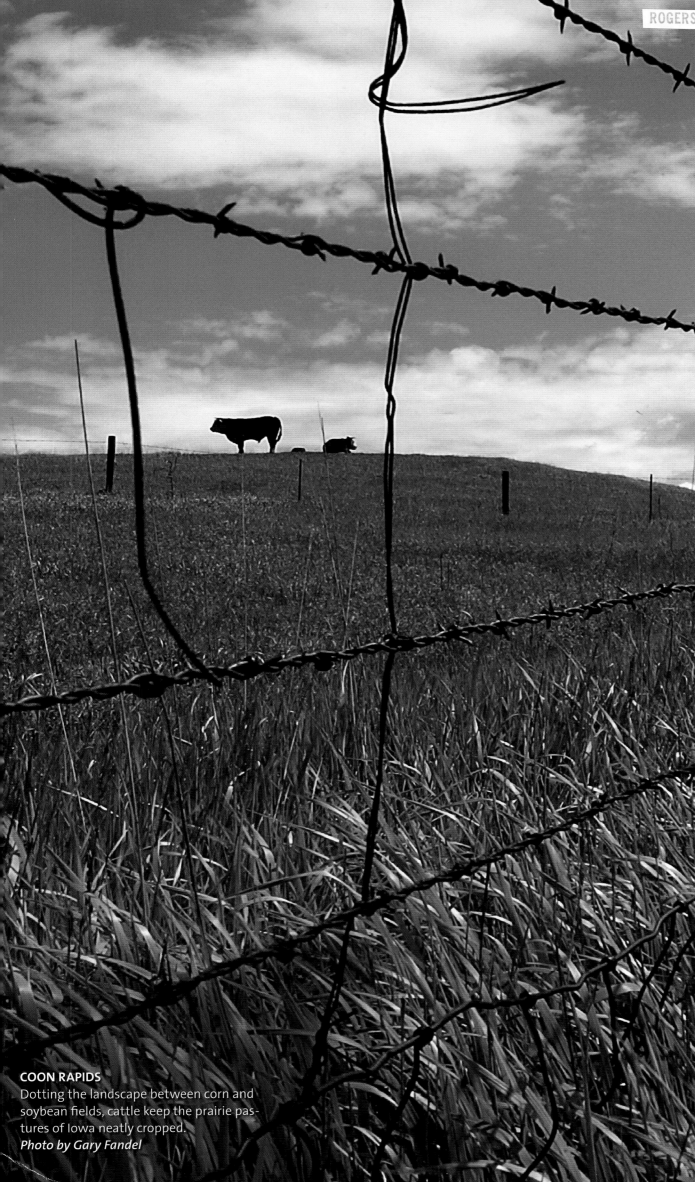

*Iowa 24/7* is the sequel to *The New York Times* bestseller *America 24/7* shot by tens of thousands of digital photographers across America over the course of a single week. We would like to thank the following sponsors, the wonderful people of Iowa, and the talented photojournalists who made this book possible.

WEBWARE™

Google™

DIGITAL POND

**COON RAPIDS**
Dotting the landscape between corn and soybean fields, cattle keep the prairie pastures of Iowa neatly cropped.
*Photo by Gary Fandel*

W9-ANI-297

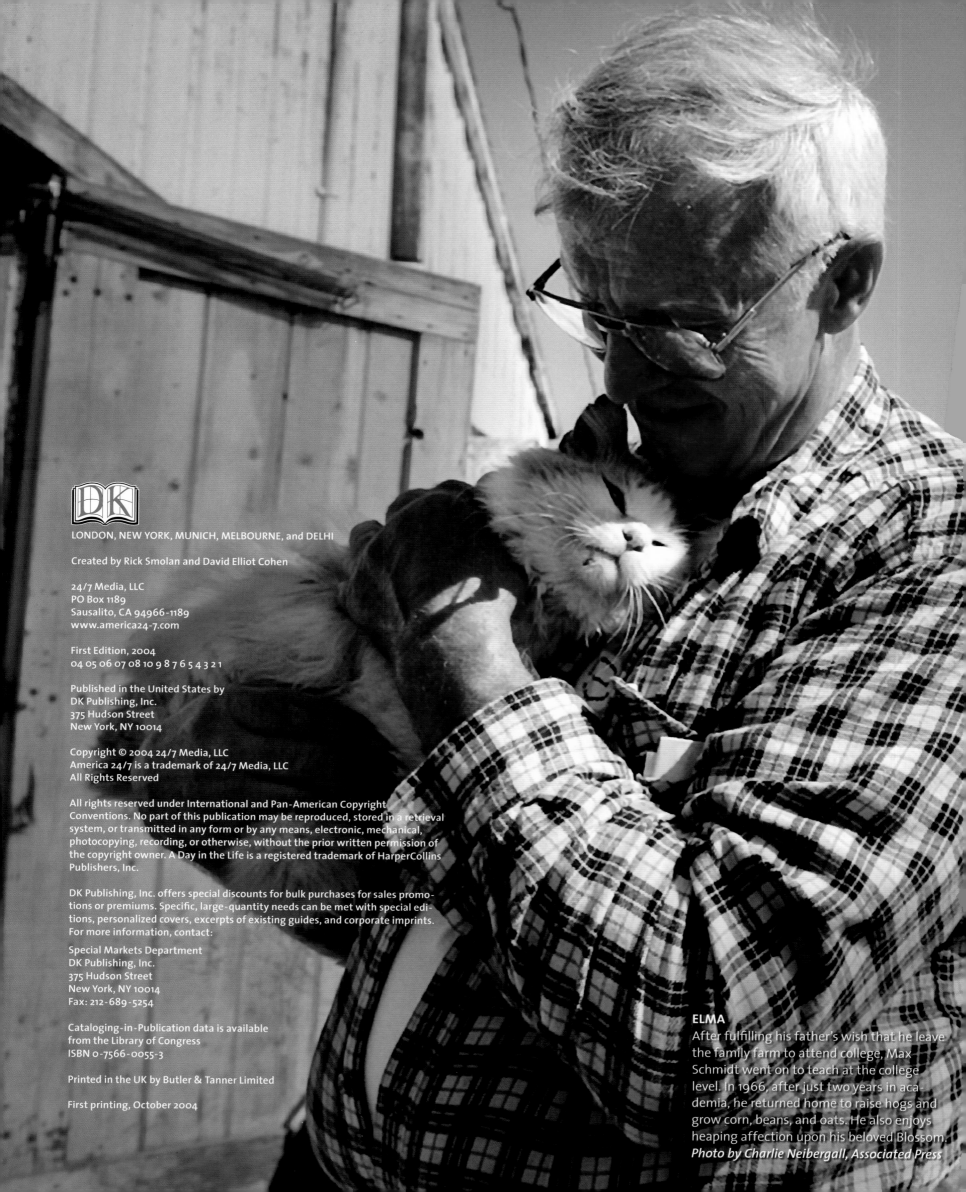

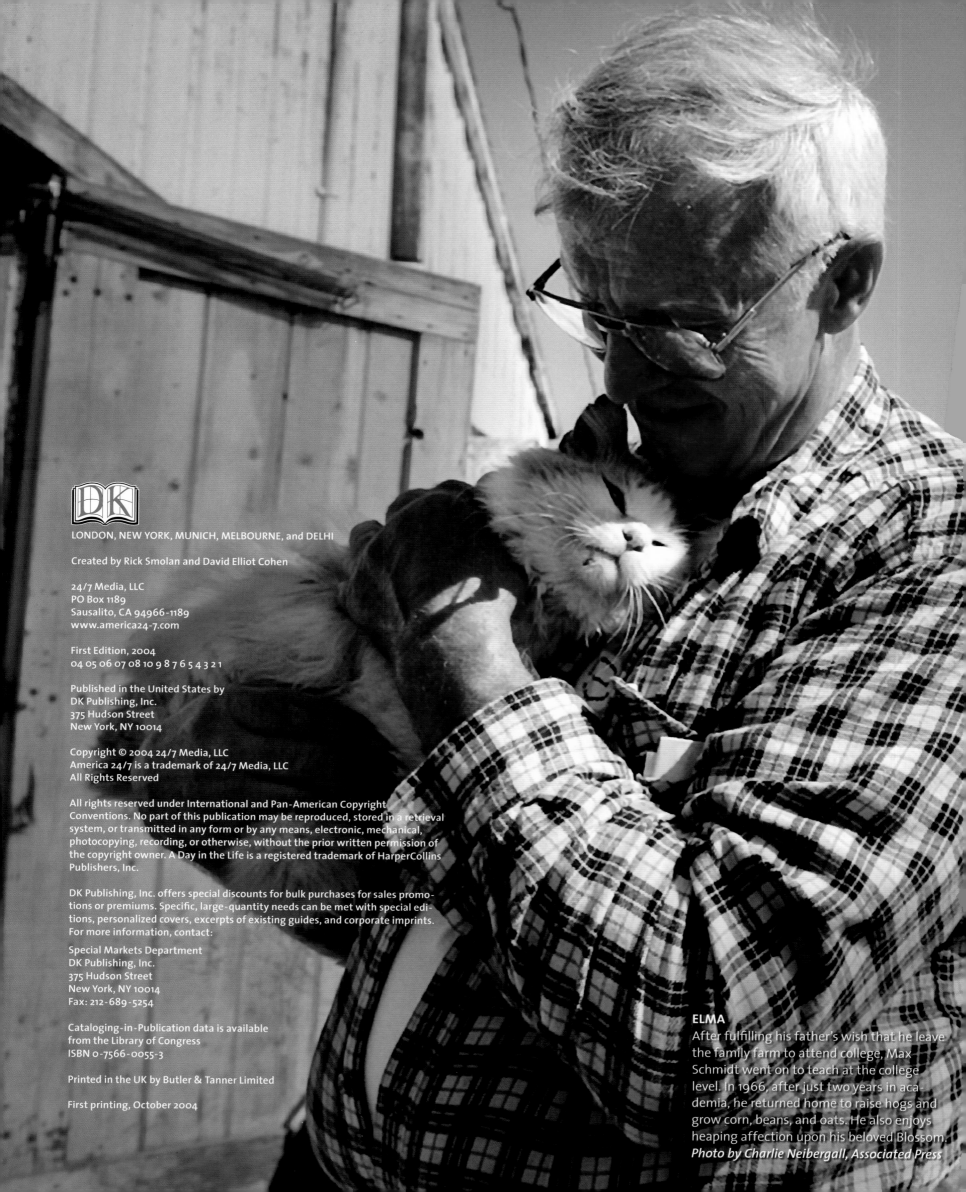

**DK**

LONDON, NEW YORK, MUNICH, MELBOURNE, and DELHI

Created by Rick Smolan and David Elliot Cohen

24/7 Media, LLC
PO Box 1189
Sausalito, CA 94966-1189
www.america24-7.com

First Edition, 2004
04 05 06 07 08 10 9 8 7 6 5 4 3 2 1

Published in the United States by
DK Publishing, Inc.
375 Hudson Street
New York, NY 10014

DK Publishing, Inc. offers special discounts for bulk purchases for sales promo-
tions or premiums. Specific, large-quantity needs can be met with special edi-
tions, personalized covers, excerpts of existing guides, and corporate imprints.
For more information, contact:

Special Markets Department
DK Publishing, Inc.
375 Hudson Street
New York, NY 10014
Fax: 212-689-5254

Cataloging-in-Publication data is available
from the Library of Congress
ISBN 0-7566-0055-3

Printed in the UK by Butler & Tanner Limited

First printing, October 2004

**ELMA**
After fulfilling his father's wish that he leave
the family farm to attend college, Max
Schmidt went on to teach at the college
level. In 1966, after just two years in aca-
demia, he returned home to raise hogs and
grow corn, beans, and oats. He also enjoys
heaping affection upon his beloved Blossom.
*Photo by Charlie Neibergall, Associated Press*

# IOWA 24/7

### 24 Hours. 7 Days.
### Extraordinary Images of
### One Week in Iowa.

Created by Rick Smolan and David Elliot Cohen

DK Publishing

# About the America 24/7 Project

A hundred years hence, historians may pose questions such as: What was America like at the beginning of the third millennium? How did life change after 9/11 and the ensuing war on terrorism? How was America affected by its corporate scandals and the high-tech boom and bust? Could Americans still express themselves freely?

To address these questions, we created *America 24/7,* the largest collaborative photography event in history. We invited Americans to tell their stories with digital pictures. We asked them to shoot a visual memoir of their lives, families, and communities.

During one week in May 2003, more than 25,000 professionals and amateurs shot more than a million pictures. These images, sent to us via the Internet, compose a panoramic yet highly intimate view of Americans in celebration and sadness; in action and contemplation; at work, home, and school. The best of these photographs, more than 6,000, are collected in 51 volumes that make up the *America 24/7* series: the landmark national volume *America 24/7,* published to critical acclaim in 2003, and the 50 state books published in 2004.

Our decision to make *America 24/7* an all-digital project was prompted by the fact that in 2003 digital camera sales overtook film camera sales. This techno-logical evolution allowed us to extend the project to a huge pool of photographers. We were thrilled by the response to our challenge and moved by the insight offered into American life. Sometimes, the amateurs outshot the pros—even the Pulitzer Prize winners.

The exuberant democracy of images visible throughout these books is a revela-tion. The message that emerges is that now, more than ever, America is a supersized idea. A dreamspace, where individuals and families from around the world are free to govern themselves, worship, read, and speak as they wish. Within its wide margins, the polyglot American nation manages to encompass an inexplicably complex yet workable whole. The pictures in this book are dedicated to that idea.

—*Rick Smolan and David Elliot Cohen*

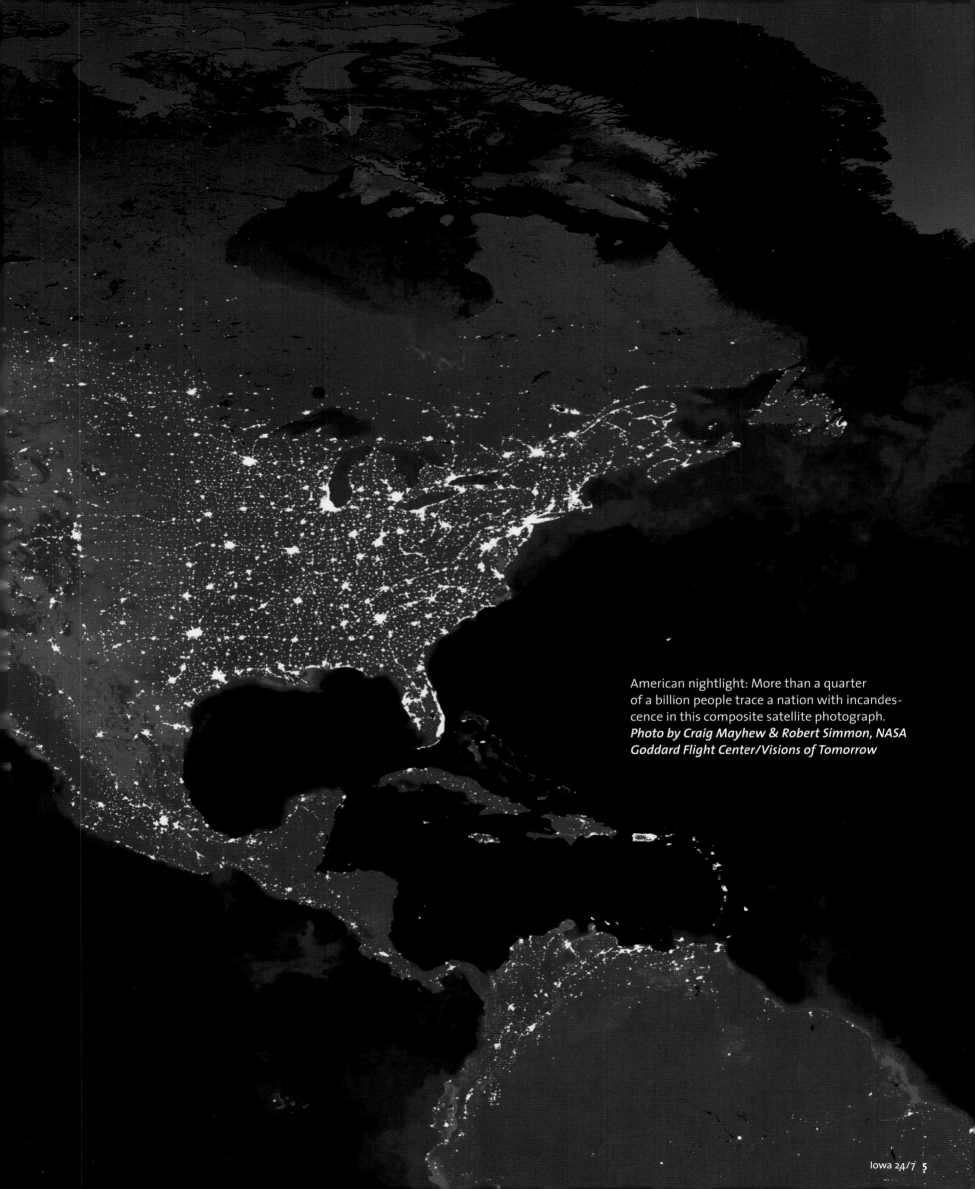

American nightlight: More than a quarter of a billion people trace a nation with incandescence in this composite satellite photograph.
*Photo by Craig Mayhew & Robert Simmon, NASA Goddard Flight Center/Visions of Tomorrow*

# A Simple Rhythm

*by John Gaps III*

I want you to know my Iowa in the spring, in mid-May, when promises made in earlier months become real. The fields are planted, evening clouds begin piling up on the horizon, far off purple lightning threatens rain, and the wind picks up just before dark. Spring comes gradually; winter's snows reappear as recharged ponds and lakes. The withering heat of summer is still three months away—or six feet of cornstalk growth.

In Iowa, nothing, not the land, the weather or season, will be bent to anyone's will. Accommodation will have to do—at best, there is negotiation. Some states boast of wild rivers tamed by steam engines and concrete and of mountains defeated by hard men, but Iowa is practically a parable of simple folk—patient people wait for spring to turn the topsoil and burn the prairie grass, knowing full well that both earth and undergrowth will revert, in the cycle, to their prior toughness.

Likewise, every four years, presidential candidates bring their hopes to Iowa to test their mettle with Iowans who look them in the eye and offer their hand and, eventually, their judgment. Warm autumnal rallies can turn icy cold by caucus time; the seemingly simple people consign most of the presidential hopefuls back to their someplaces, other than Iowa.

Here and there, Iowa reeks of the past. Nostalgia comes in old farmhouses sheltered under big oaks, where supper is still lunch, and dinner is,

well, the last meal of the day; where the reliable farmer still works the fields astride his well-oiled John Deere; where windmills, rusty and tottering, creak in the wind, whirring water out of century-old wells. But the field is planted just a few miles from a university campus and its large research lab. In the lab, scientists busily work on biotechnology to make the rich dark Iowa soils even richer and the corncobs more rot-resistant. The old oily John Deere has been replaced by the behemoth John Deere combine, complete with air conditioning and crop reports beamed onto the on-board television monitor. Business, technology, and agriculture combine through the corn.

Standing atop the dirt-wise past and the chemical present of American food production are the Iowans themselves, with little time for subtexts or irony, much less the brusque pace of Chicago, New York, or Los Angeles. Civility is still the coin of the realm in a place where the people must negotiate with nature in good faith. We take it for granted that a neighbor will throw sand bags during a flood or open up their house in a blizzard. Yeah, Iowans hang onto their civility, their sense of civic engagement; they value the education of their children, a fresh ear of corn, the simple rhythm of life, land, and season—all harmonious in the mild days of May.

---

*Iowa native* JOHN GAPS III *was the Iowa photography coordinator for the America 24-7 project. He is director of community publications for the* Des Moines Register.

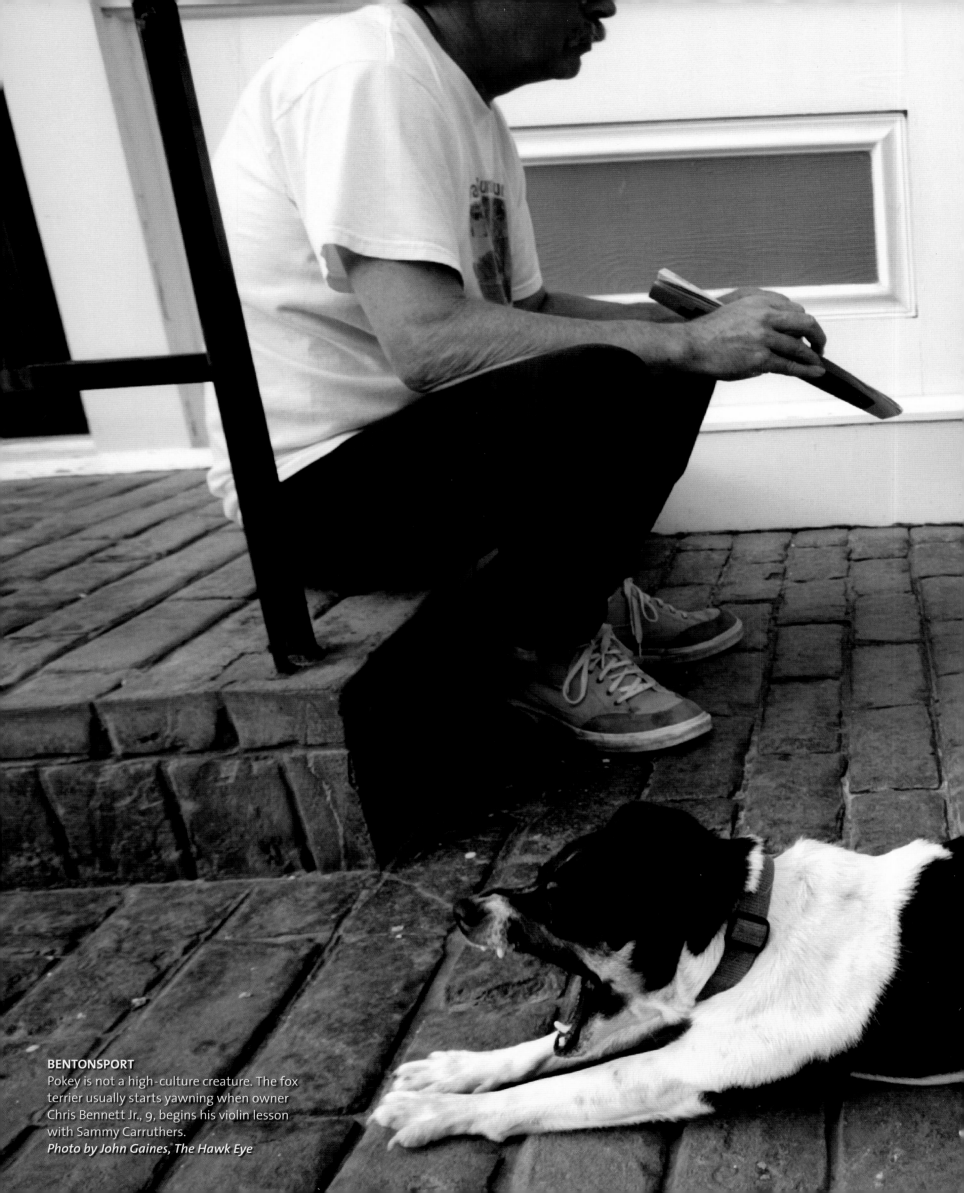

**BENTONSPORT**
Pokey is not a high-culture creature. The fox terrier usually starts yawning when owner Chris Bennett Jr., 9, begins his violin lesson with Sammy Carruthers.
*Photo by John Gaines, The Hawk Eye*

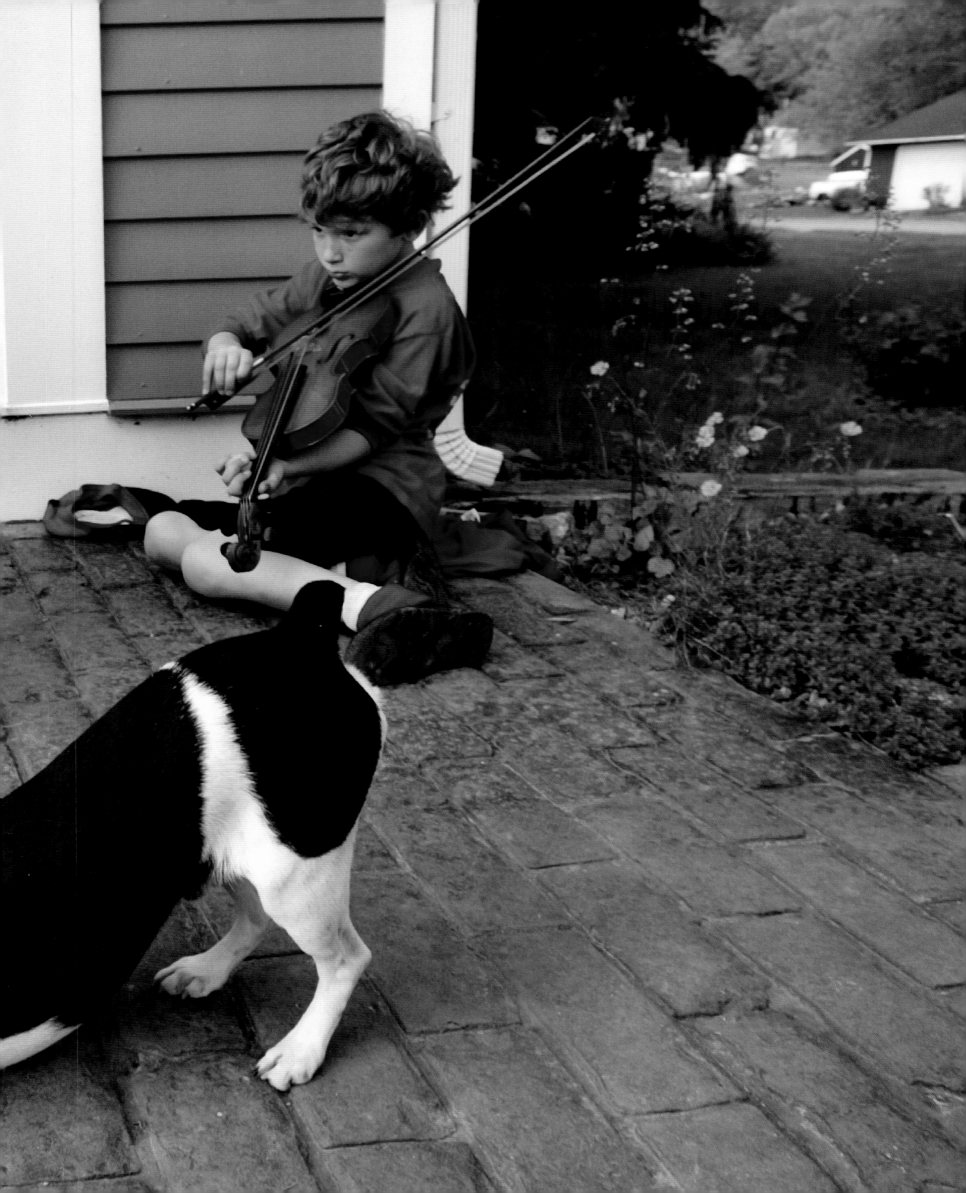

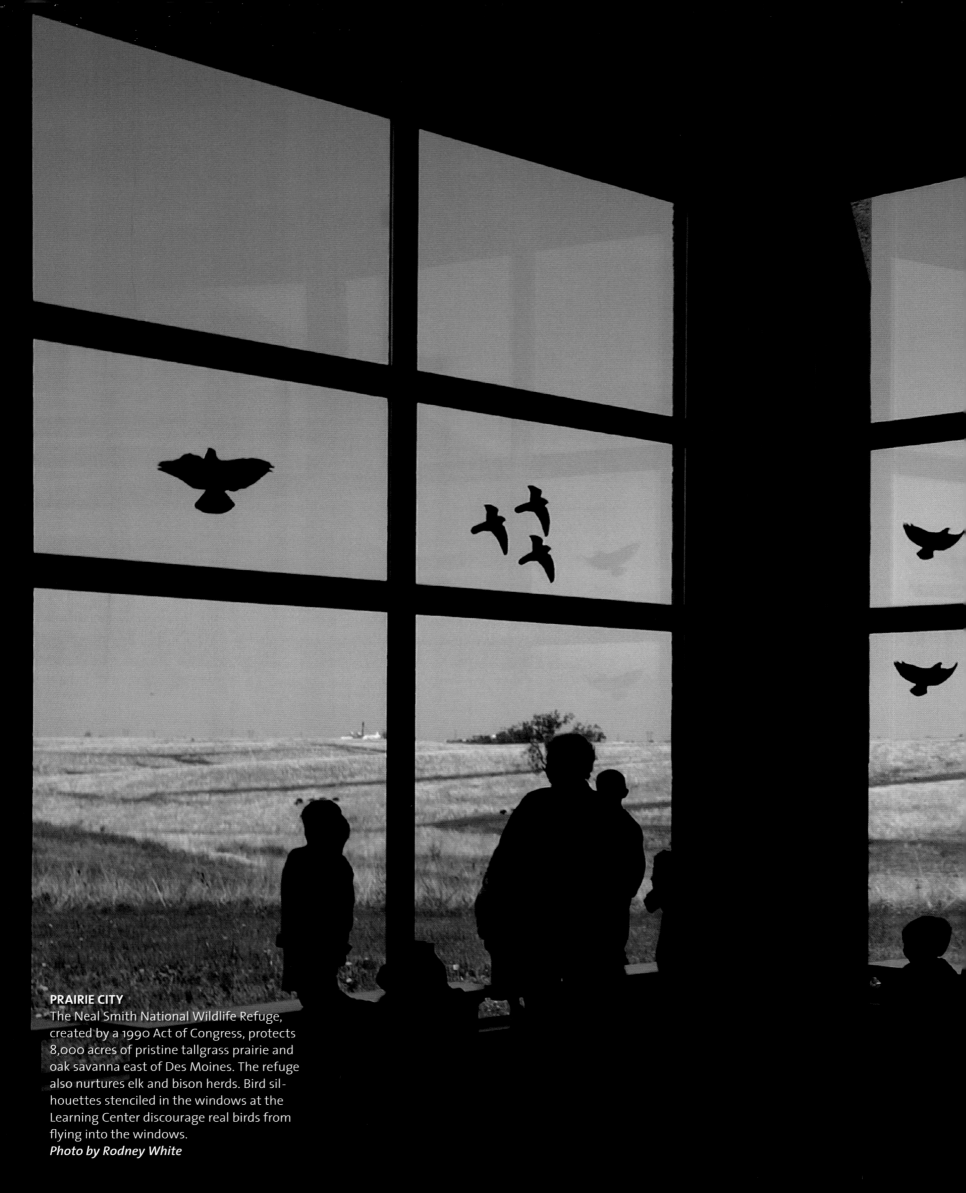

**PRAIRIE CITY**
The Neal Smith National Wildlife Refuge, created by a 1990 Act of Congress, protects 8,000 acres of pristine tallgrass prairie and oak savanna east of Des Moines. The refuge also nurtures elk and bison herds. Bird silhouettes stenciled in the windows at the Learning Center discourage real birds from flying into the windows.
*Photo by Rodney White*

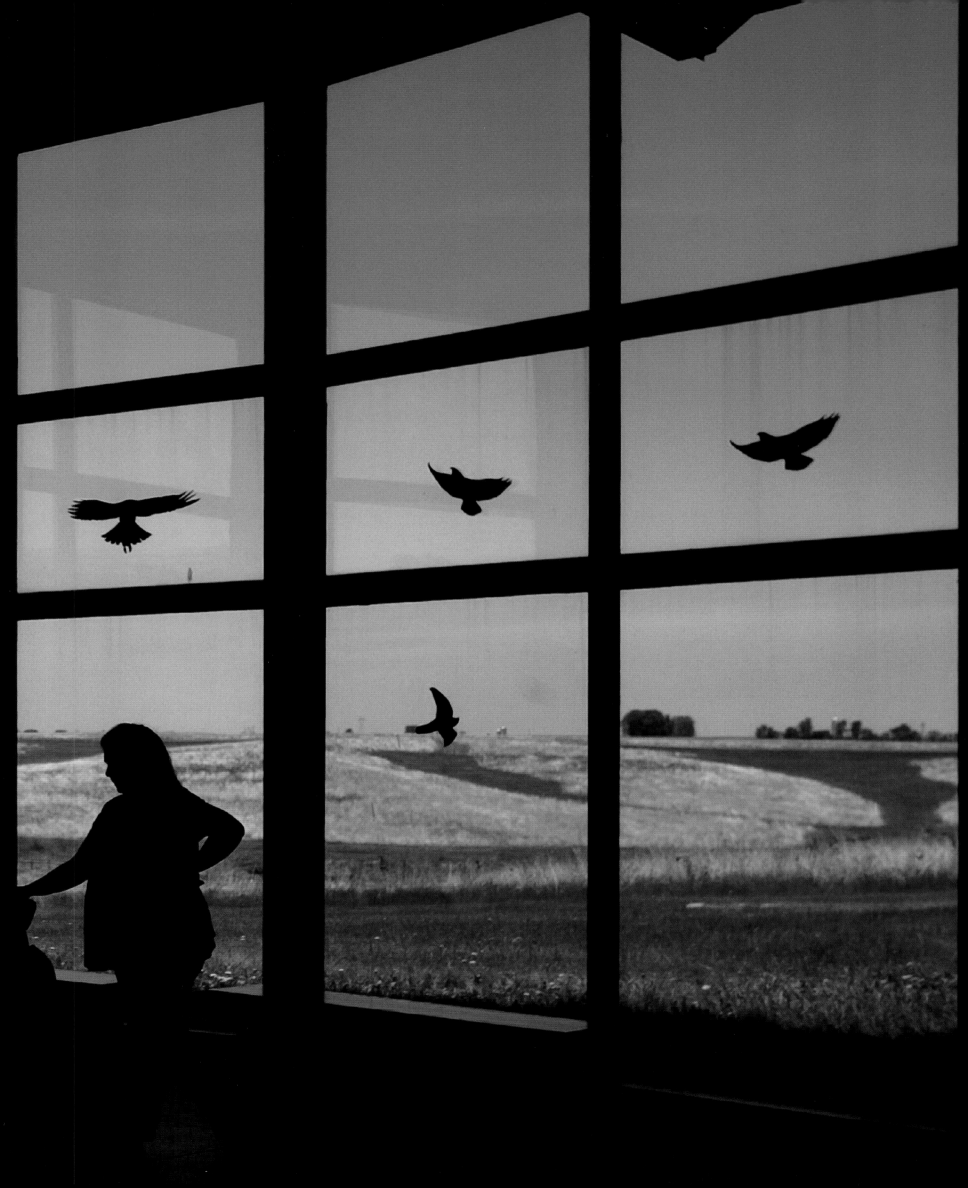

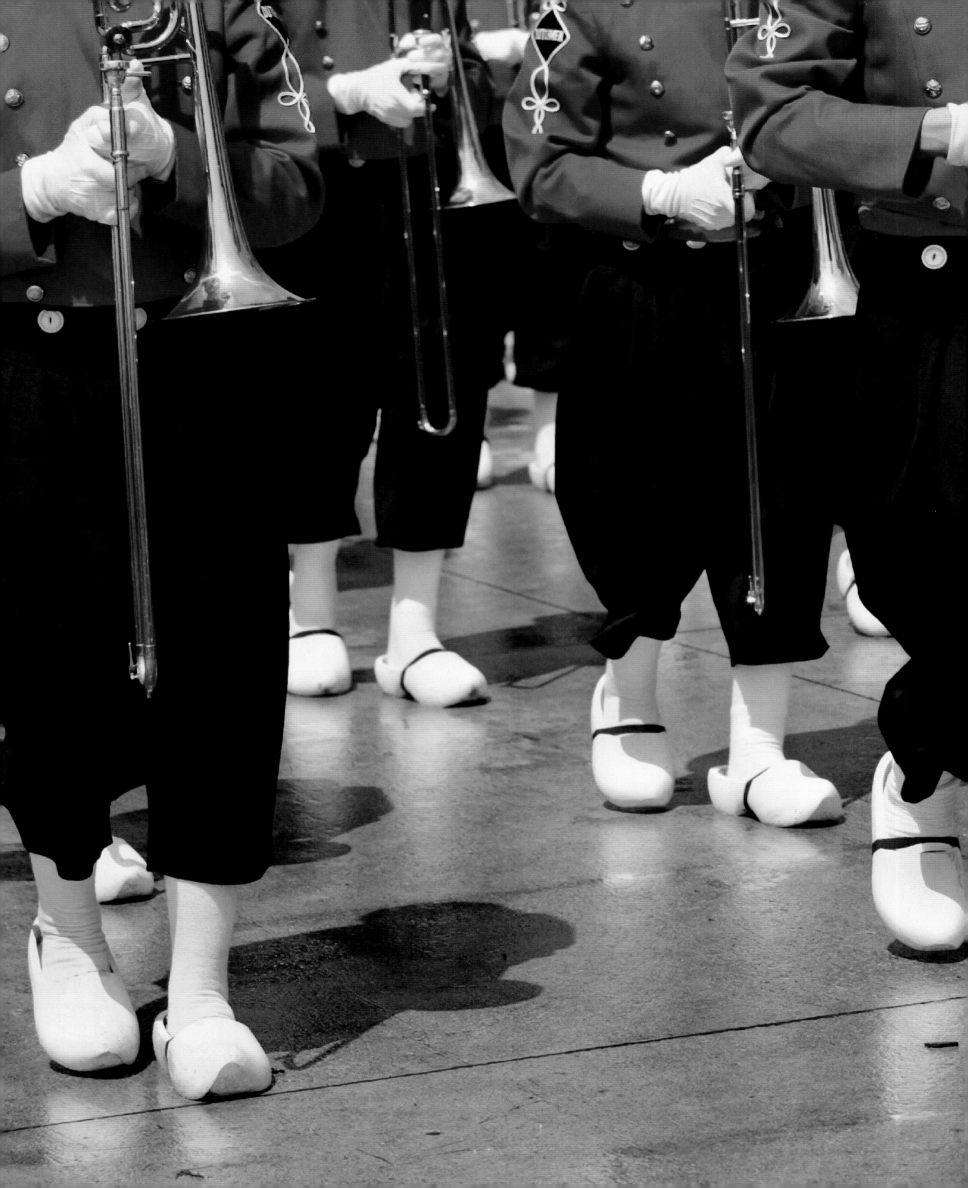

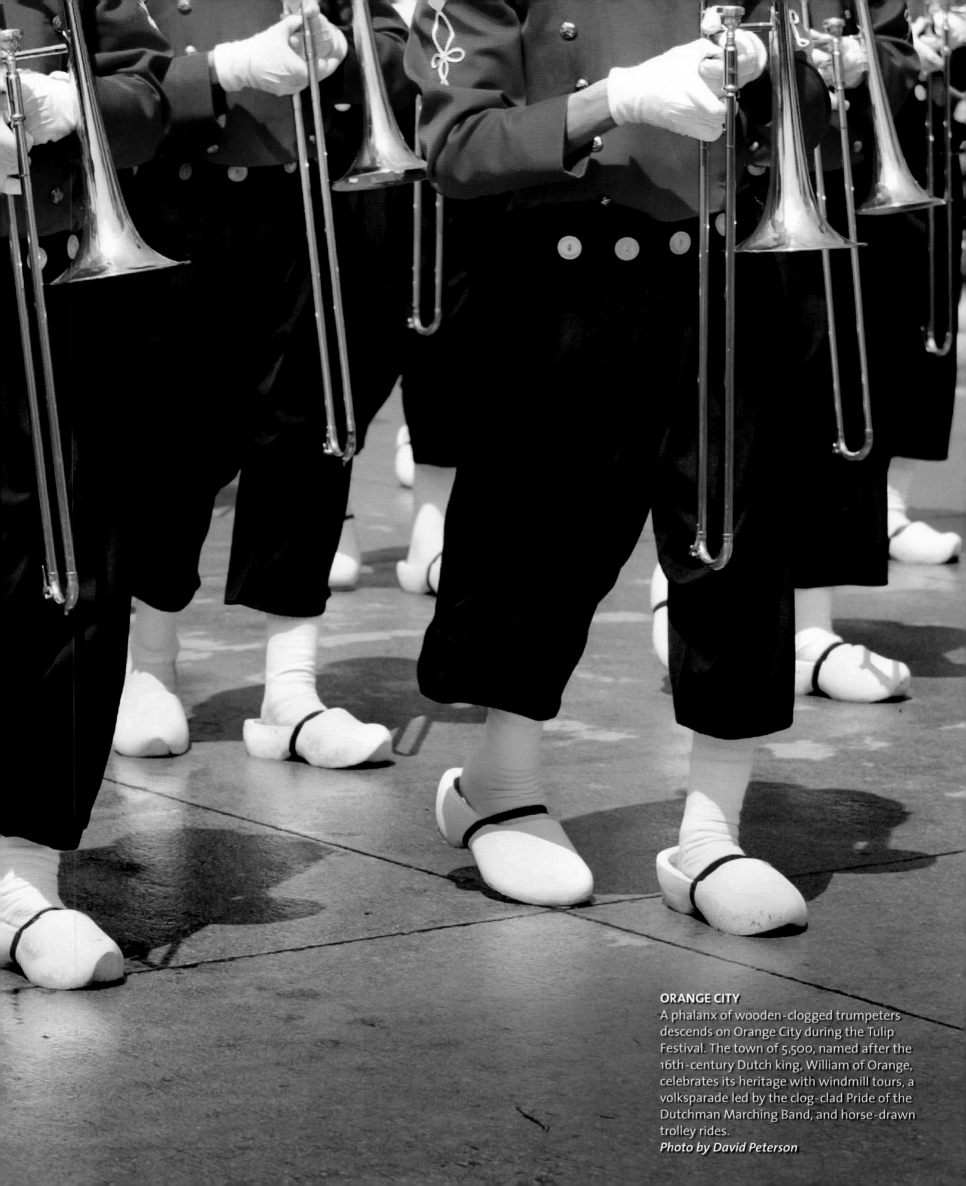

**ORANGE CITY**
A phalanx of wooden-clogged trumpeters descends on Orange City during the Tulip Festival. The town of 5,500, named after the 16th-century Dutch king, William of Orange, celebrates its heritage with windmill tours, a volksparade led by the clog-clad Pride of the Dutchman Marching Band, and horse-drawn trolley rides.
*Photo by David Peterson*

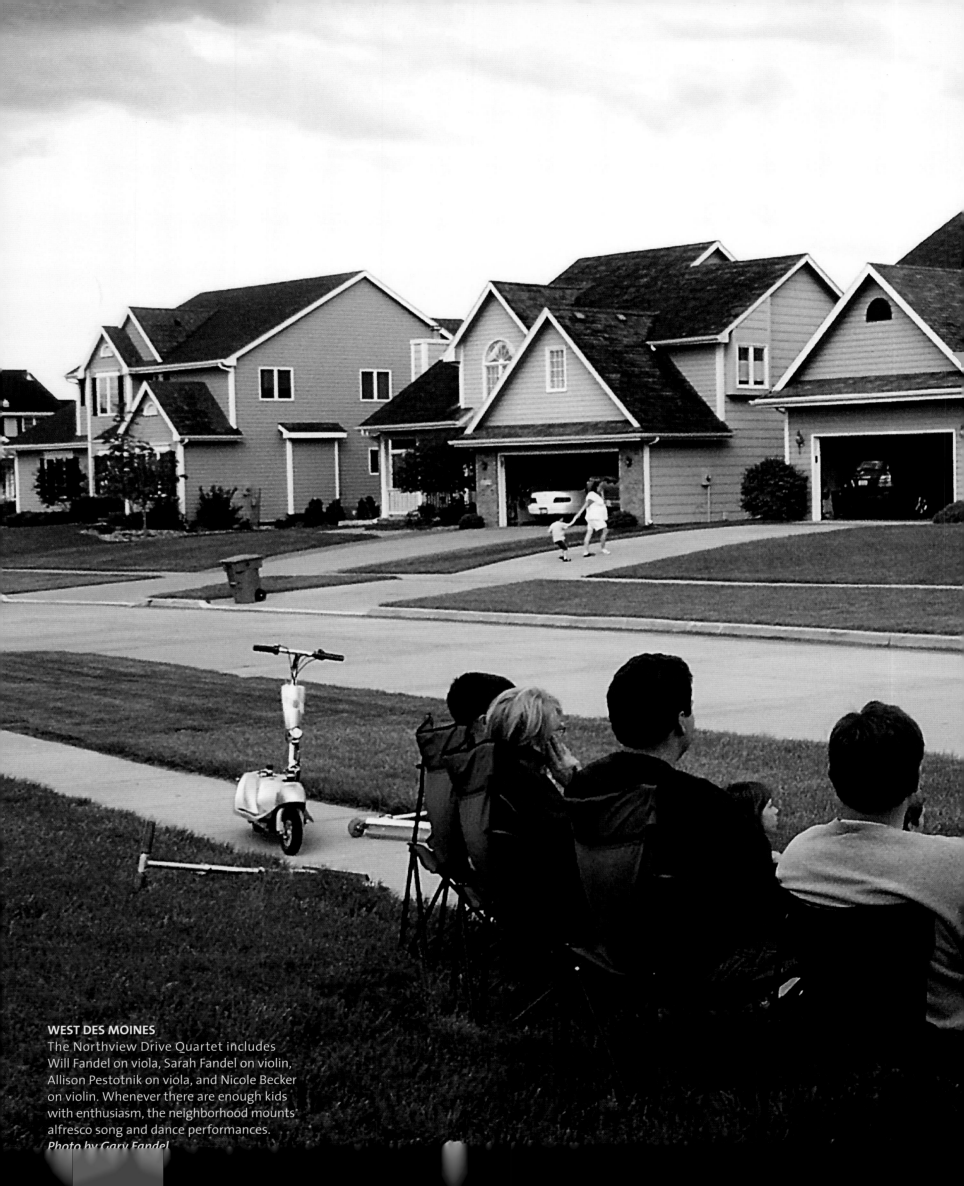

**WEST DES MOINES**
The Northview Drive Quartet includes
Will Fandel on viola, Sarah Fandel on violin,
Allison Pestotnik on viola, and Nicole Becker
on violin. Whenever there are enough kids
with enthusiasm, the neighborhood mounts
alfresco song and dance performances.
*Photo by Gary Fandel*

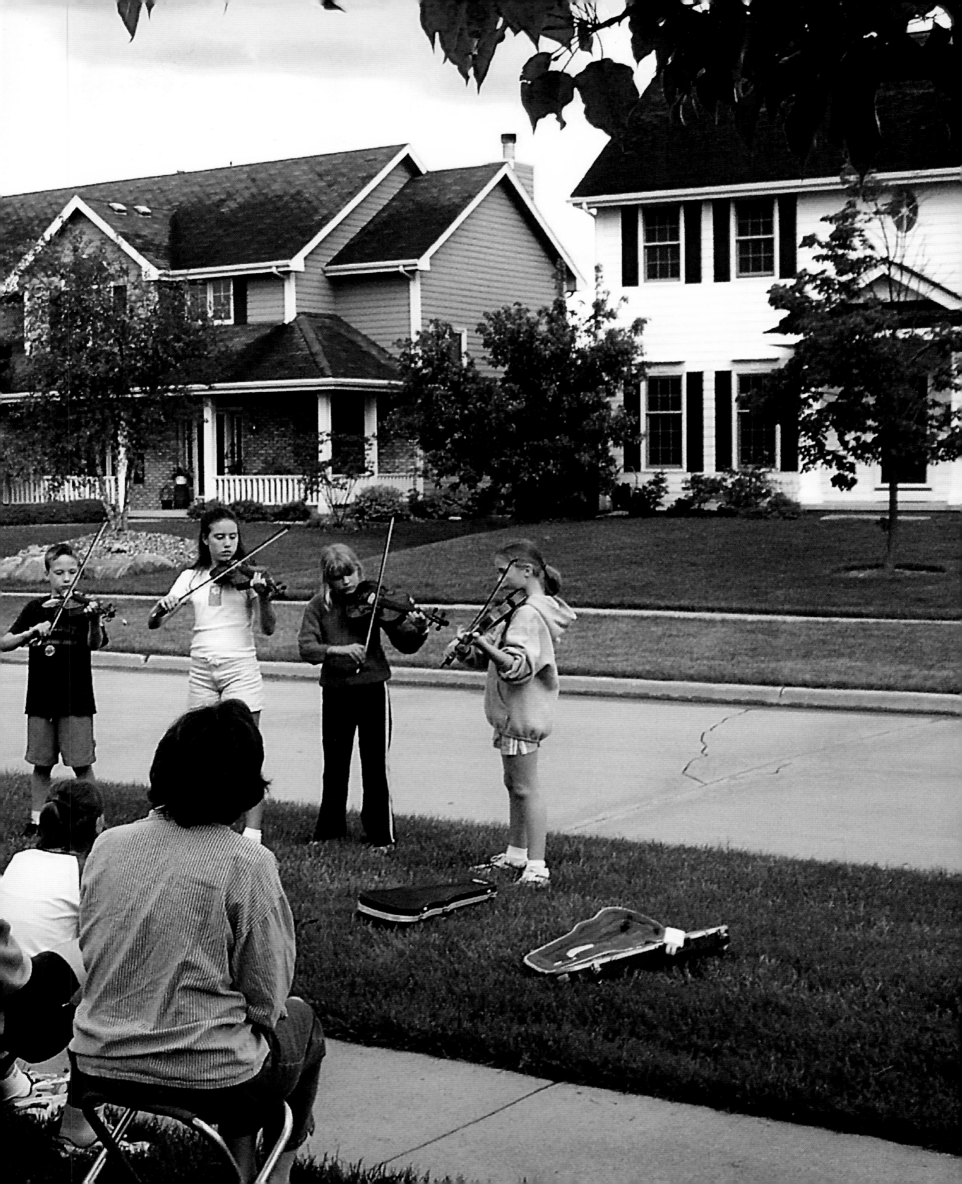

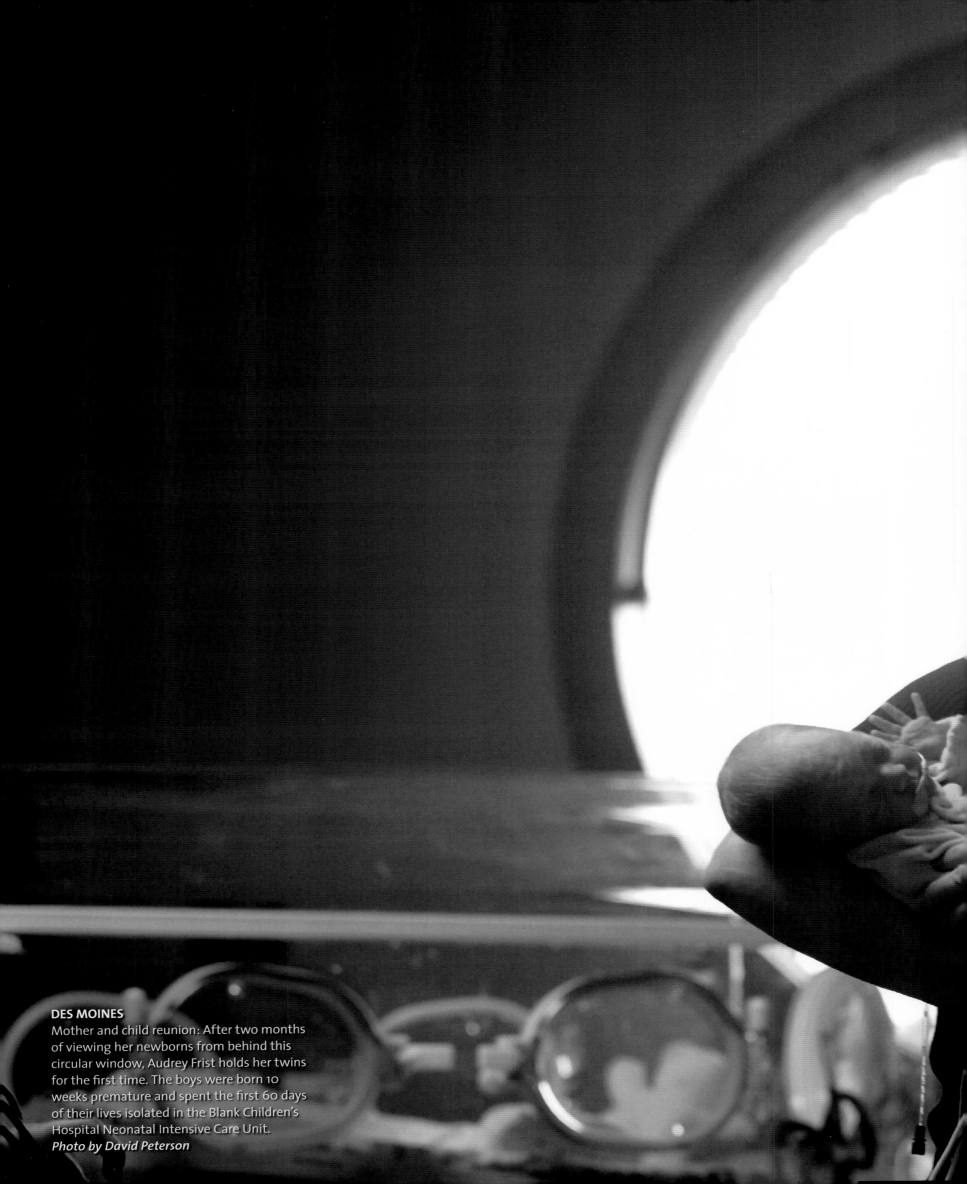

**DES MOINES**
Mother and child reunion: After two months of viewing her newborns from behind this circular window, Audrey Frist holds her twins for the first time. The boys were born 10 weeks premature and spent the first 60 days of their lives isolated in the Blank Children's Hospital Neonatal Intensive Care Unit.
*Photo by David Peterson*

Hearth & Home

**PEOSTA**
Regan, Kristy, Rachel, and Royce, four of the seven Demmer children, take five with rocket popsicles after finishing their barn chores. The Demmers live on a dairy farm that's been in the family since 1957.
*Photo by Mark Hirsch, Telegraph Herald*

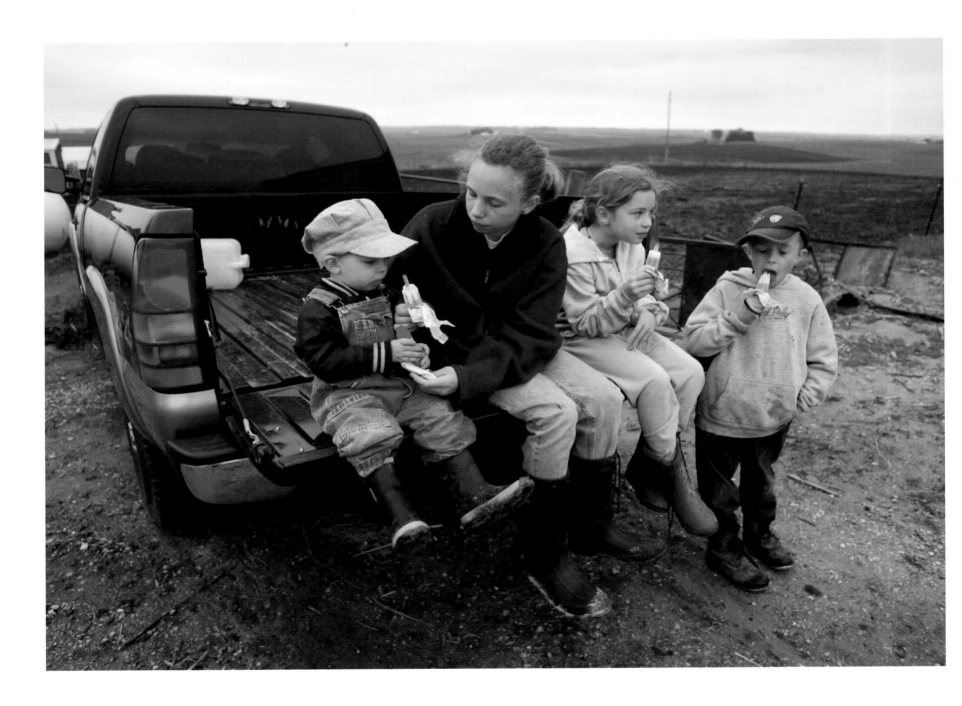

**BERNARD**

Dairy farmer (and occasional waiter) Mike Turnis serves dinner to his family. The clan almost always eats together even though Turnis and his wife Joan have five kids, including two active teenagers. "If we need to, we organize supper around their schedules. It's important to sit down together and find out what's going on," says Joan.

*Photo by Dave Kettering, Telegraph Herald*

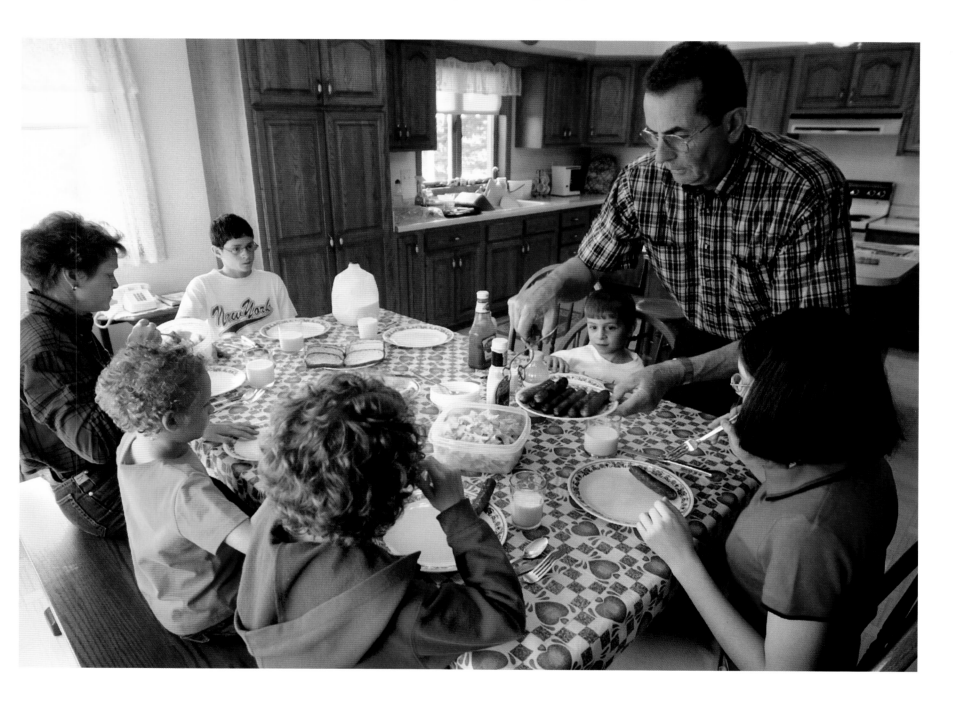

**KALONA**

The soybean and corn seeds have been planted, the hogs and cattle have been fed, and a casserole is in the oven. In the spare moments before dinner, Edith Helmuth steals off to water her backyard garden of radishes, lettuce, strawberries, red beets, and string beans.
*Photo by Buzz Orr*

**EARLY**

Farm life captivates Tiffany and Alyssa Johnson, who live in "downtown" Odebolt (pop. 1,153). During weekend visits to their uncle Dustin's farm in Early, the sisters insist on tagging along for even the most mundane chores, in this case checking soybean and corn seed distribution. "They bug me until I let them come along," says Dustin Carlson affectionately.
*Photo by David Peterson*

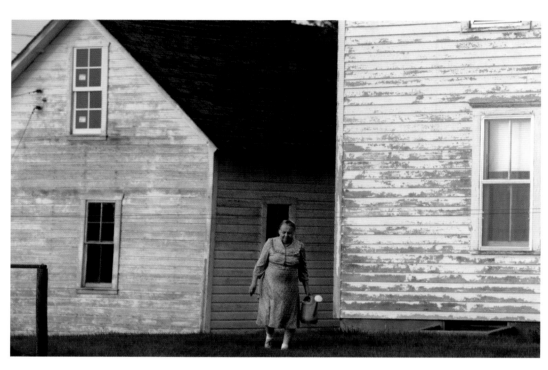

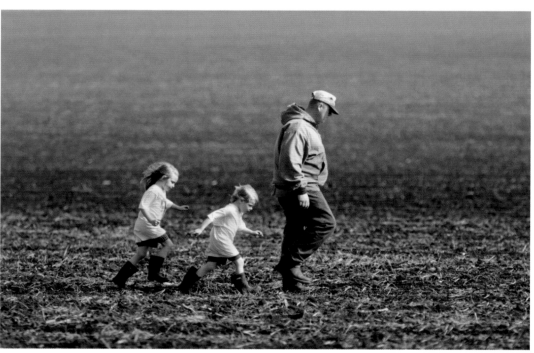

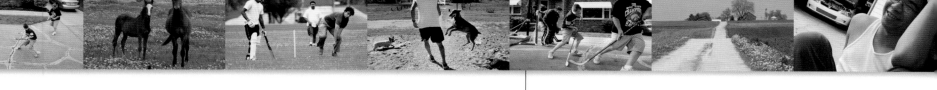

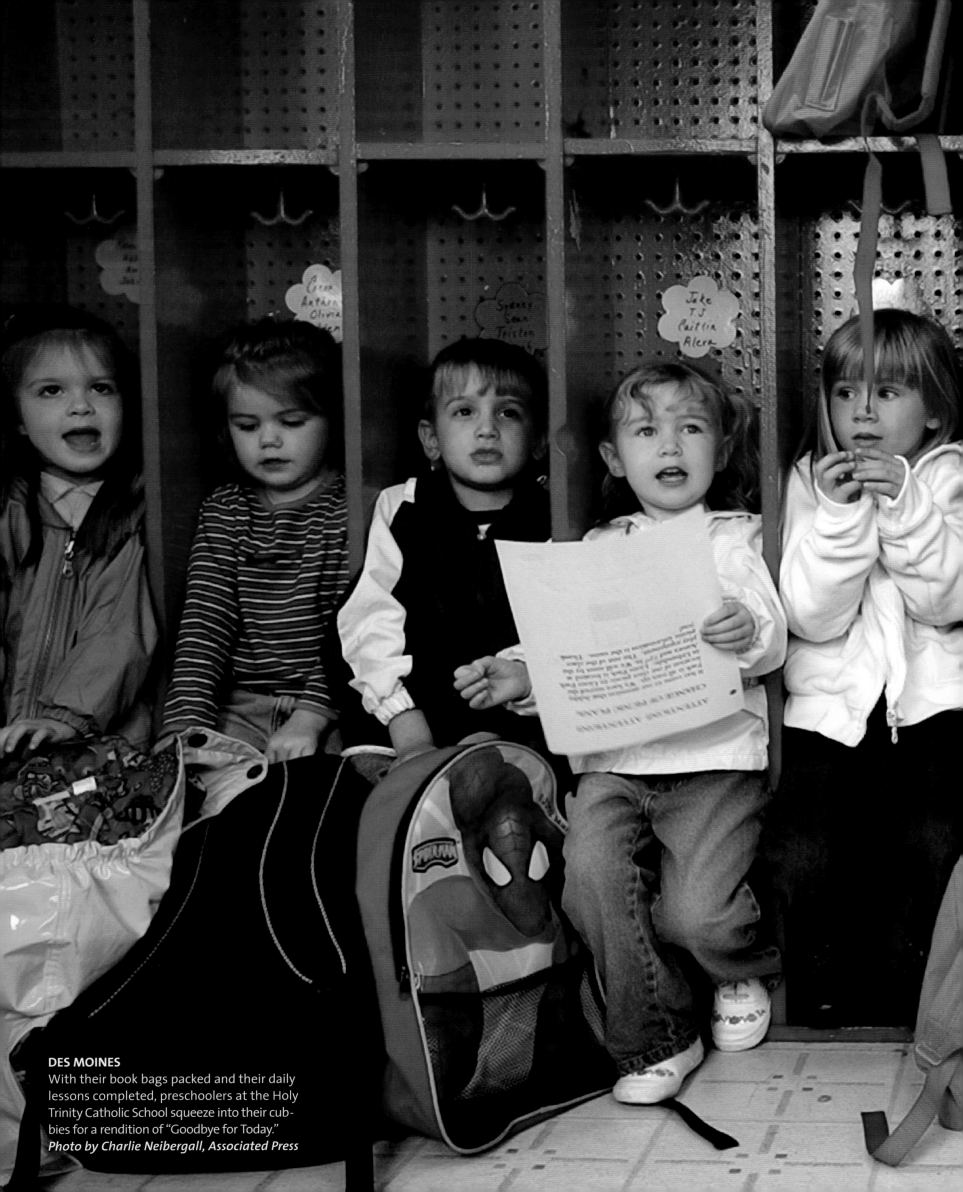

**DES MOINES**
With their book bags packed and their daily
lessons completed, preschoolers at the Holy
Trinity Catholic School squeeze into their cub-
bies for a rendition of "Goodbye for Today."
*Photo by Charlie Neibergall, Associated Press*

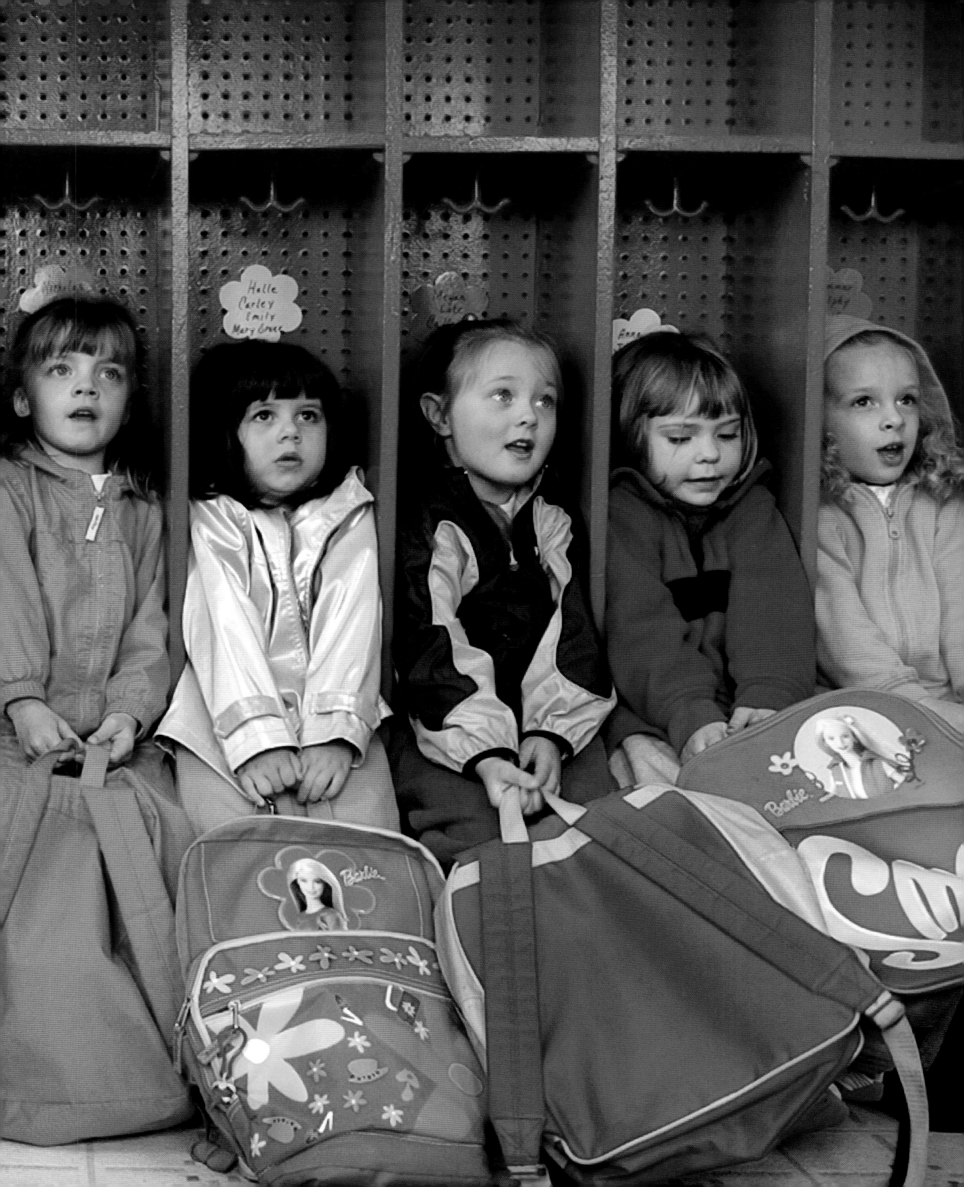

**KALONA**

Members of the liberal Beachy Amish order, Joni Stutzman and his wife Ruby use modern farm equipment to till their fields. On the side, they work as sales representatives for Excel, a Texas-based telecommunications company. Although the Beachy Amish drive cars and have telephones and electricity, they maintain the core Amish principles of pacifism and adult baptism.

*Photo by Danny Wilcox Frazier*

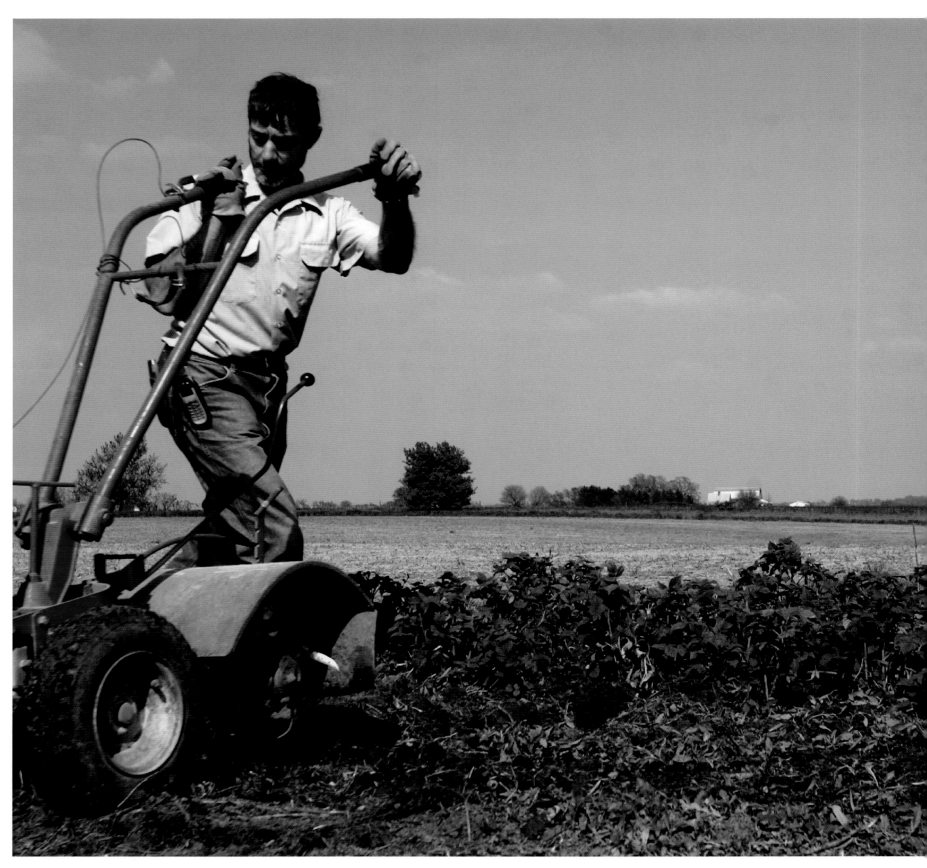

**SALEM**

The Iowa Energy Center recommends that Iowans use a clothesline instead of an electric dryer, because "it makes clothes smell nice, there's no static build-up, and sunlight is free." This household takes advantage of a slightly overcast, 56-degree afternoon.
*Photo by John Gaines, The Hawk Eye*

**BLOOMFIELD**

Dresses dry outside an Amish farmhouse just west of Bloomfield, where a community of 150 families has lived since the 1970s. Despite their agricultural roots, only five of these families run farms. The rest work in sawmills and furniture, textile, and tack shops.
*Photo by Gary Fandel*

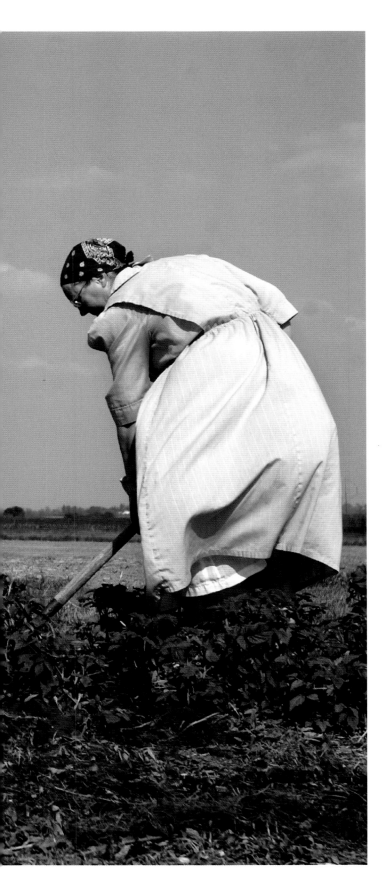

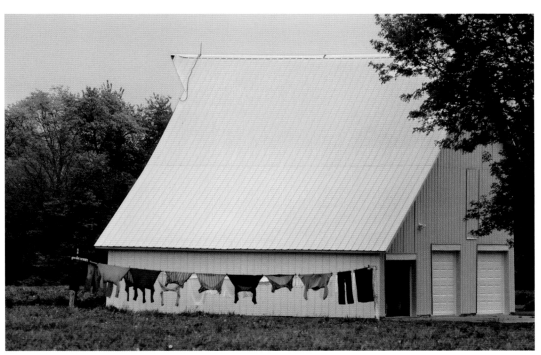

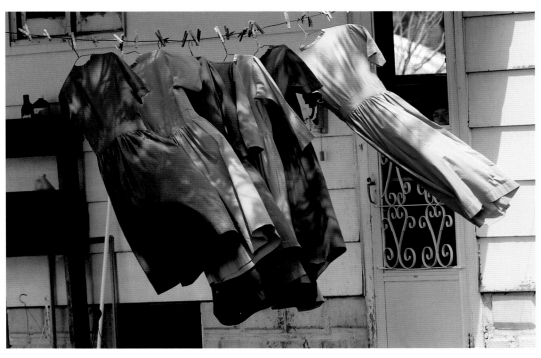

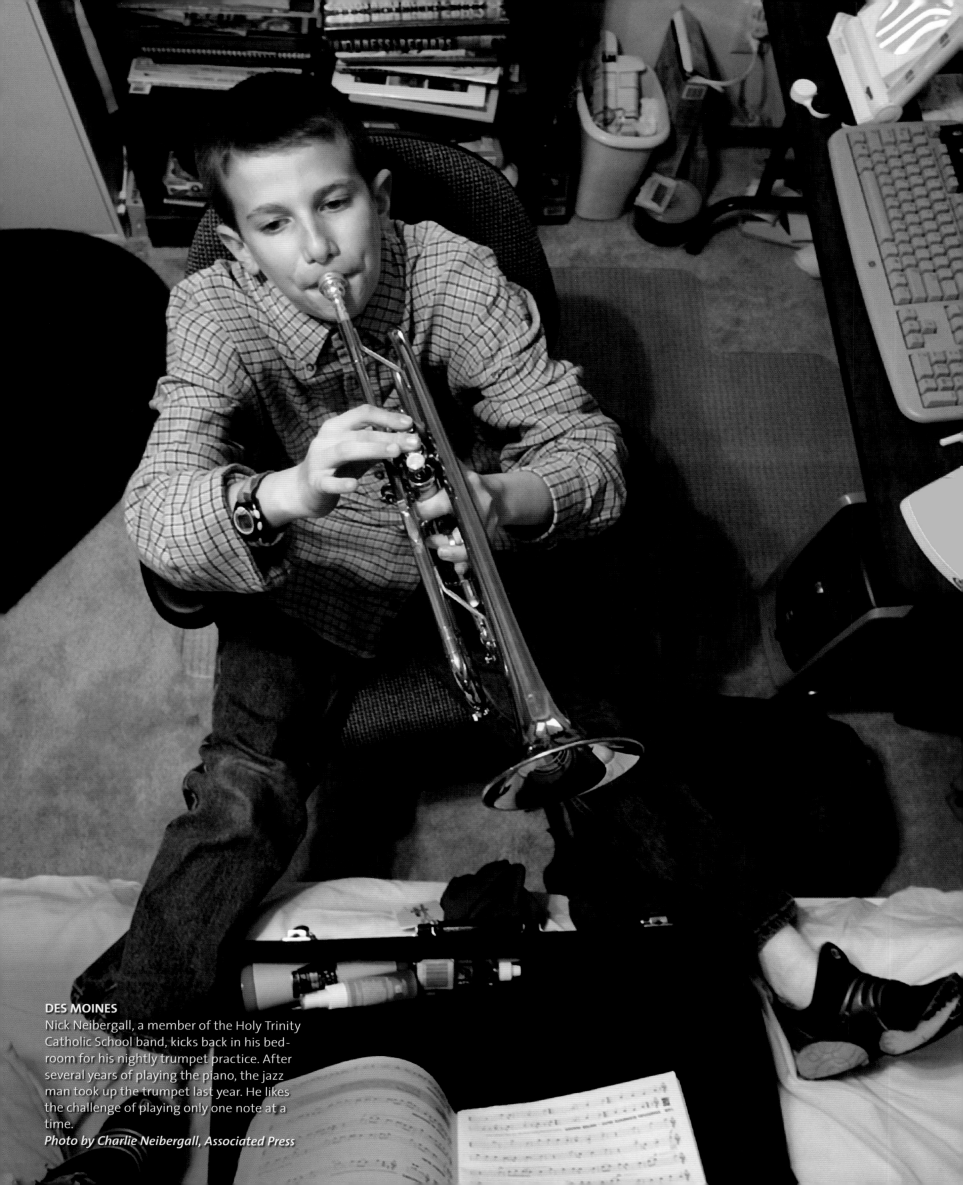

**DES MOINES**
Nick Neibergall, a member of the Holy Trinity Catholic School band, kicks back in his bedroom for his nightly trumpet practice. After several years of playing the piano, the jazz man took up the trumpet last year. He likes the challenge of playing only one note at a time.
*Photo by Charlie Neibergall, Associated Press*

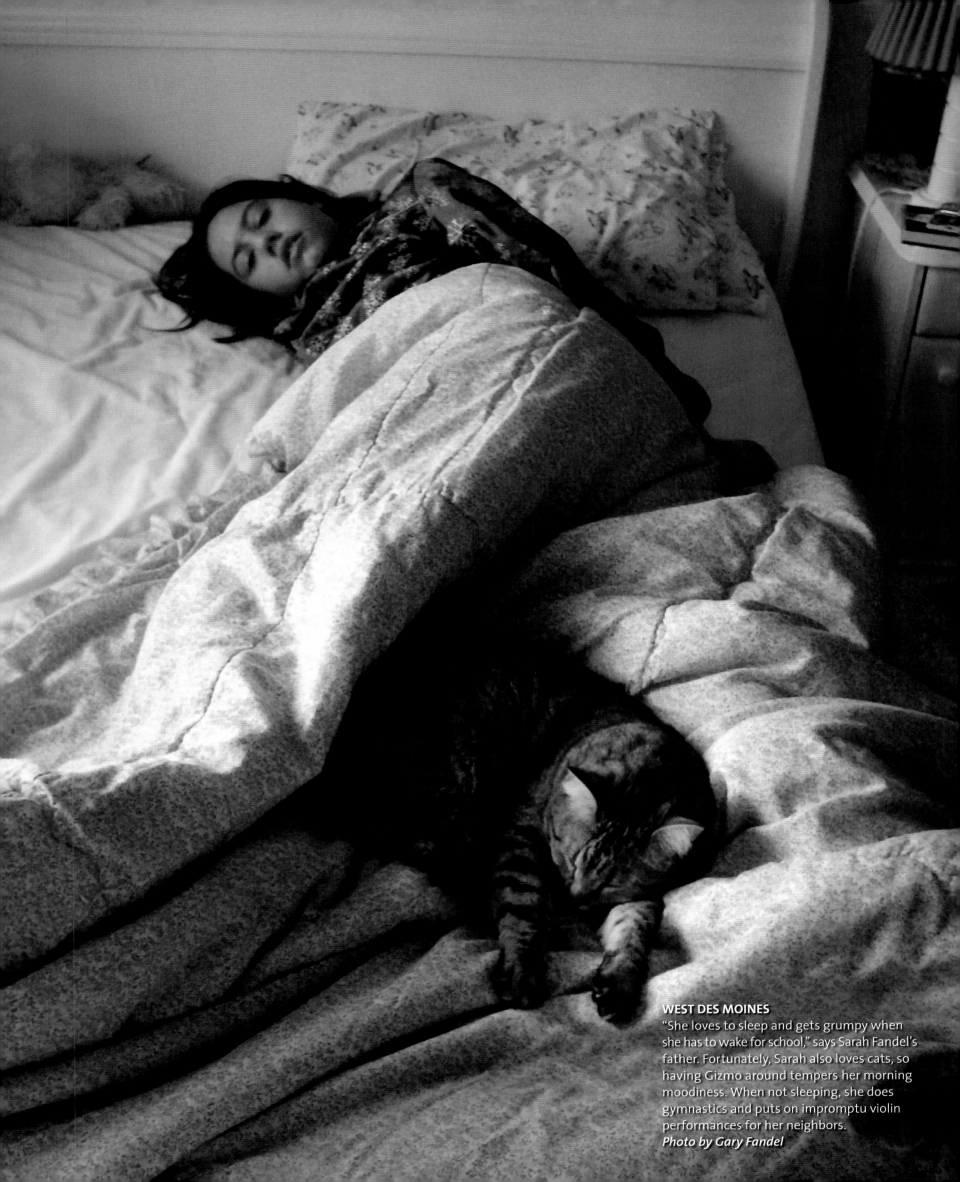

**WEST DES MOINES**

"She loves to sleep and gets grumpy when she has to wake for school," says Sarah Fandel's father. Fortunately, Sarah also loves cats, so having Gizmo around tempers her morning moodiness. When not sleeping, she does gymnastics and puts on impromptu violin performances for her neighbors.
*Photo by Gary Fandel*

Vintrea Davis and her little sister Brianna use the sidewalk outside their home as canvas. Although the black community in Cedar Rapids numbers only 4,000, the city has its own 17,000-square-foot African-American Historical Museum. In the 1850s, Cedar Rapids was one of 60 stations in the Iowa section of the Underground Railroad.
*Photo by Kevin R. Wolf*

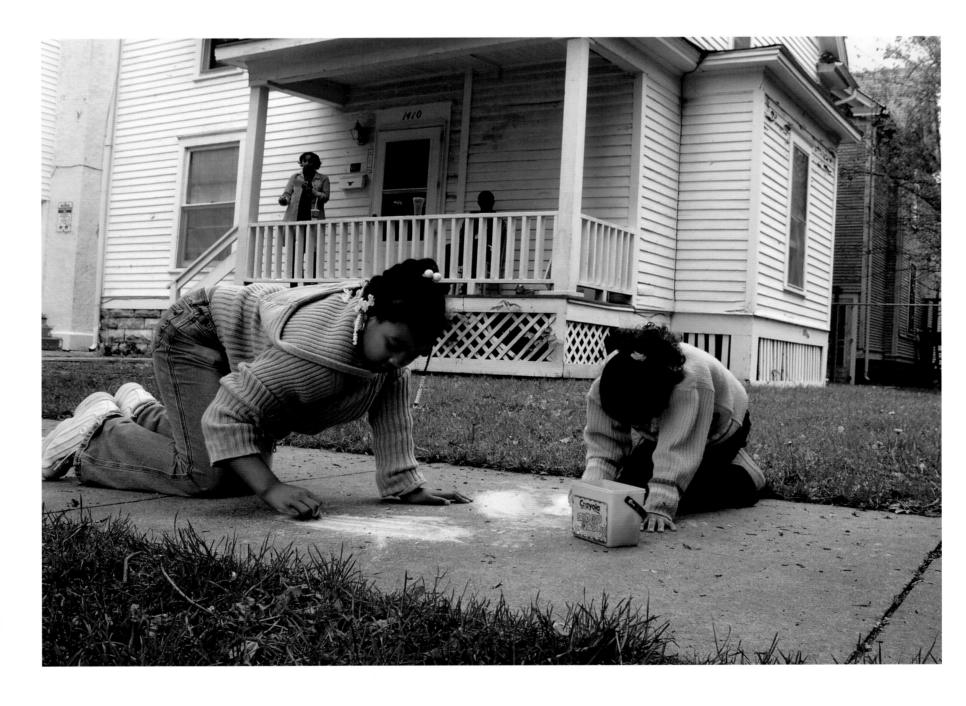

## KEY WEST

"I come from a family of artists," says Laura Buechele. "My mom is a musician and my cousins own a pottery studio." Buechele and her daughter Esther stopped by a friend's farm to show off her latest paintings before heading to Choices Coffee Shop and Book Store in Dubuque, where she sells her acrylic creations.

*Photo by Joey Wallis*

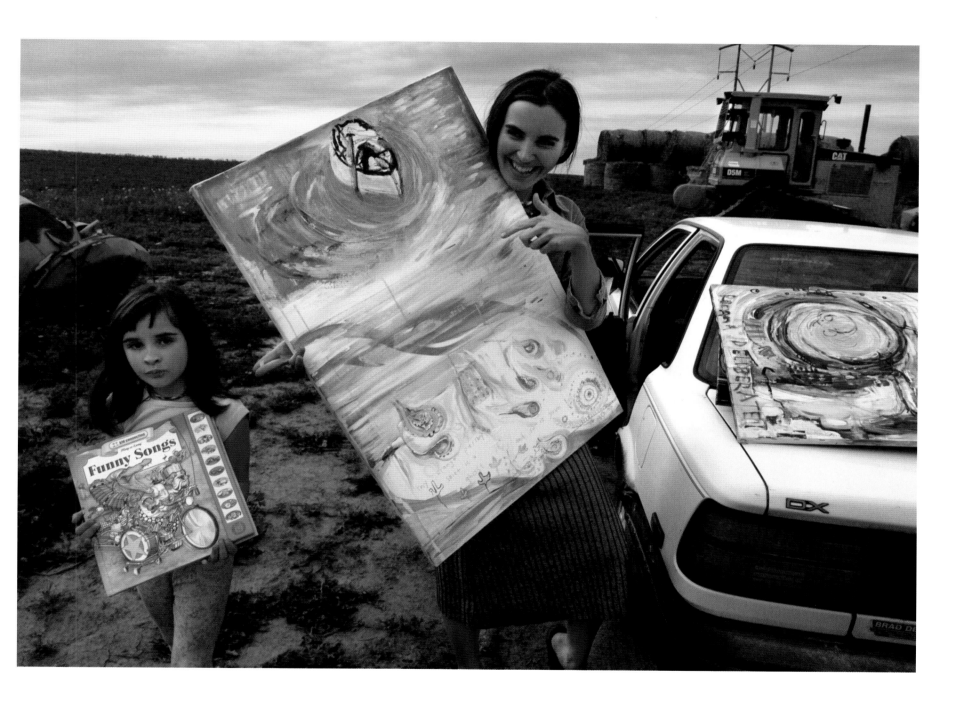

**DES MOINES**

Who is that masked woman? Kim Leang Poam and fiancé Jeff Logan relax on the couch at the end of a long day. Two years ago, Poam, a native of Cambodia, started the Iowa Asian Alliance, the equivalent of an Asian Chamber of Commerce. The organization promotes business and community development for Iowa's Asian-American communities.

*Photo by Kim Seang Poam*

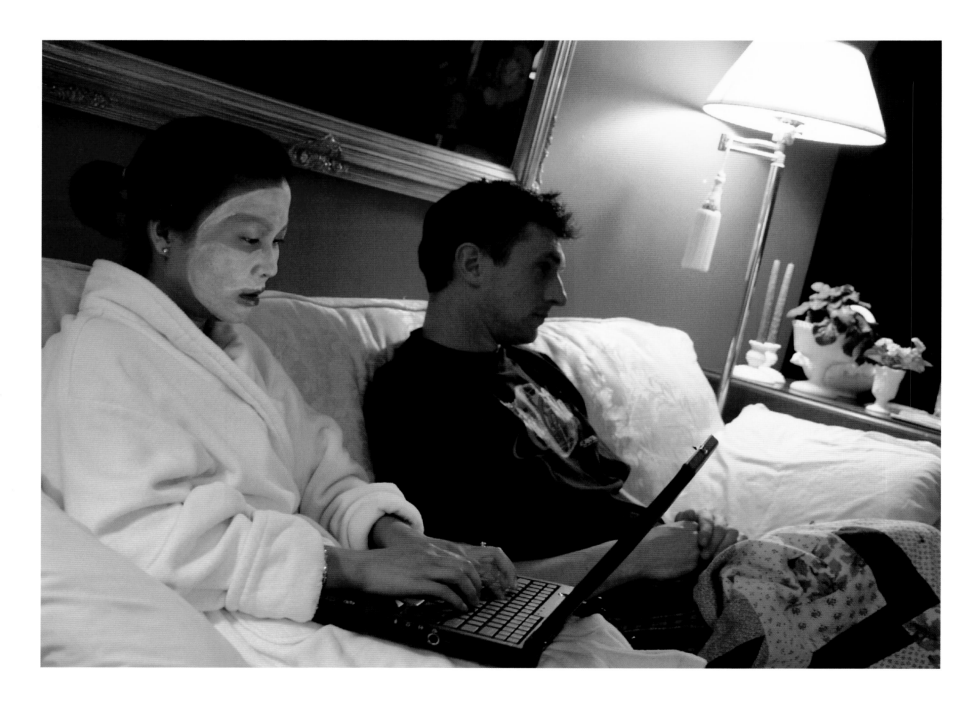

## BURLINGTON

When Jeanne Wilson's health deteriorated, her five daughters stepped up to provide her with around-the-clock care. Maggie Pettit (right) arrives at 5:30 a.m. to pick up a grocery list and read horoscopes. Wilson's second youngest prepares breakfast and lunch and helps with household chores until one of the three other daughters arrives to take the night shift.
*Photo by John Gaines, The Hawk Eye*

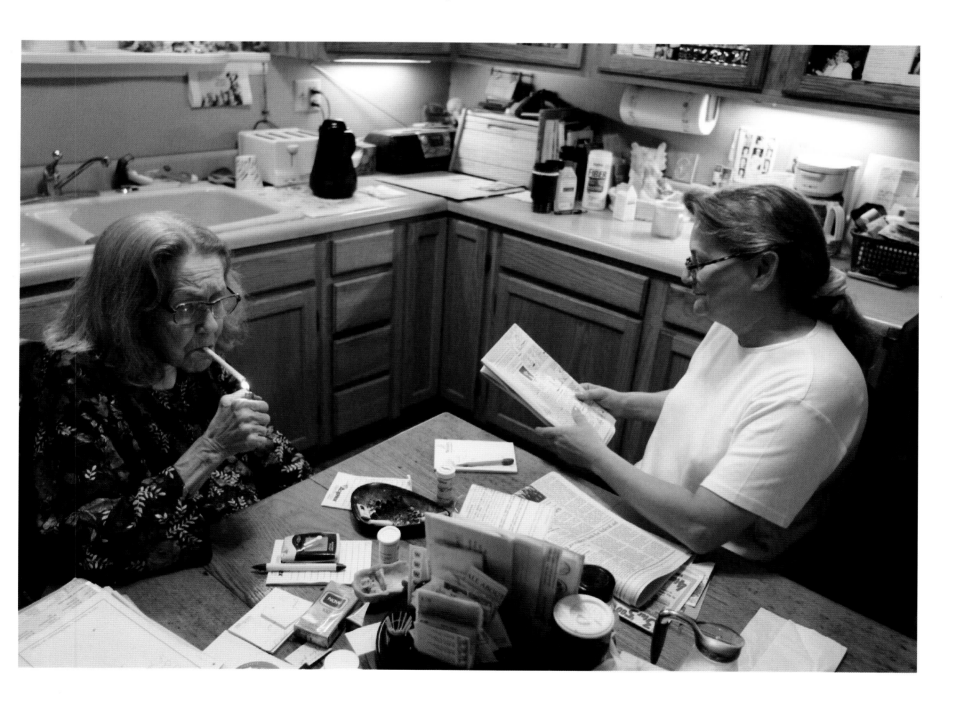

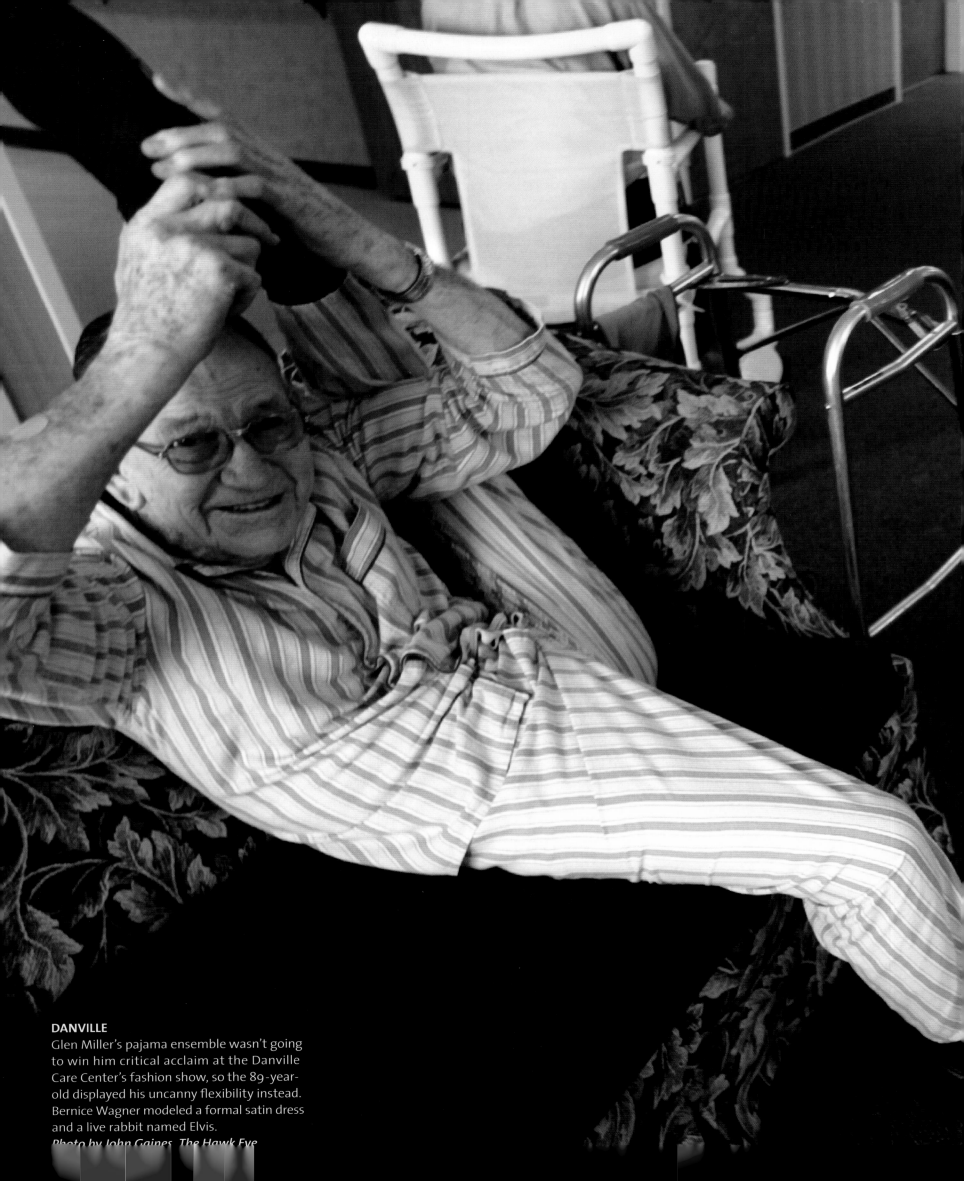

**DANVILLE**
Glen Miller's pajama ensemble wasn't going to win him critical acclaim at the Danville Care Center's fashion show, so the 89-year-old displayed his uncanny flexibility instead. Bernice Wagner modeled a formal satin dress and a live rabbit named Elvis.
*Photo by John Gaines, The Hawk Eye*

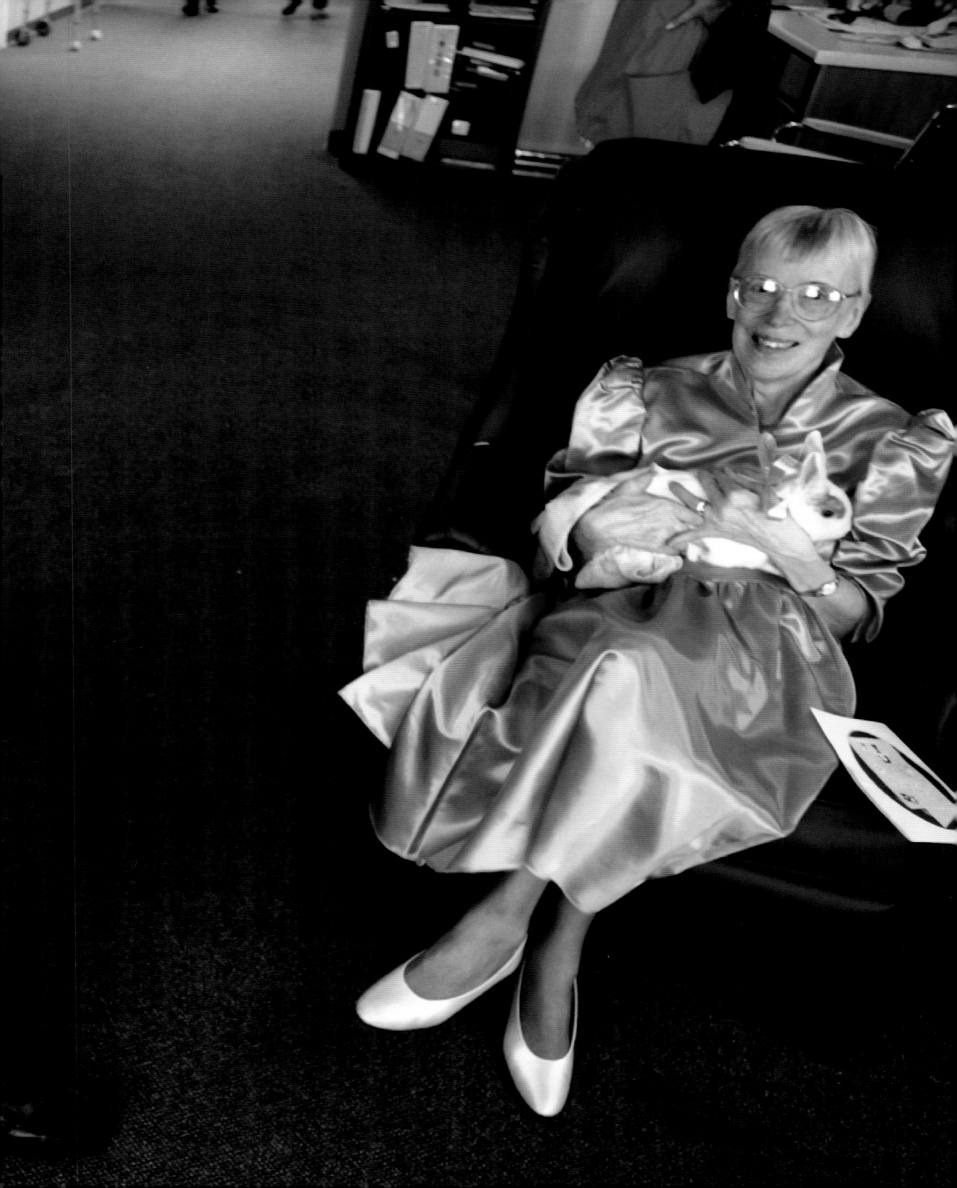

**IOWA CITY**

Surrounded by her mom, brother, aunts, uncles, great-aunts, great-uncles, and cousins, Natasha Anders beams after singing the national anthem at her University of Iowa graduation ceremony. The only music major in her close-knit family of music-lovers, Anders will begin her pursuit of a Masters degree next semester.

*Photo by Mike Brunette*

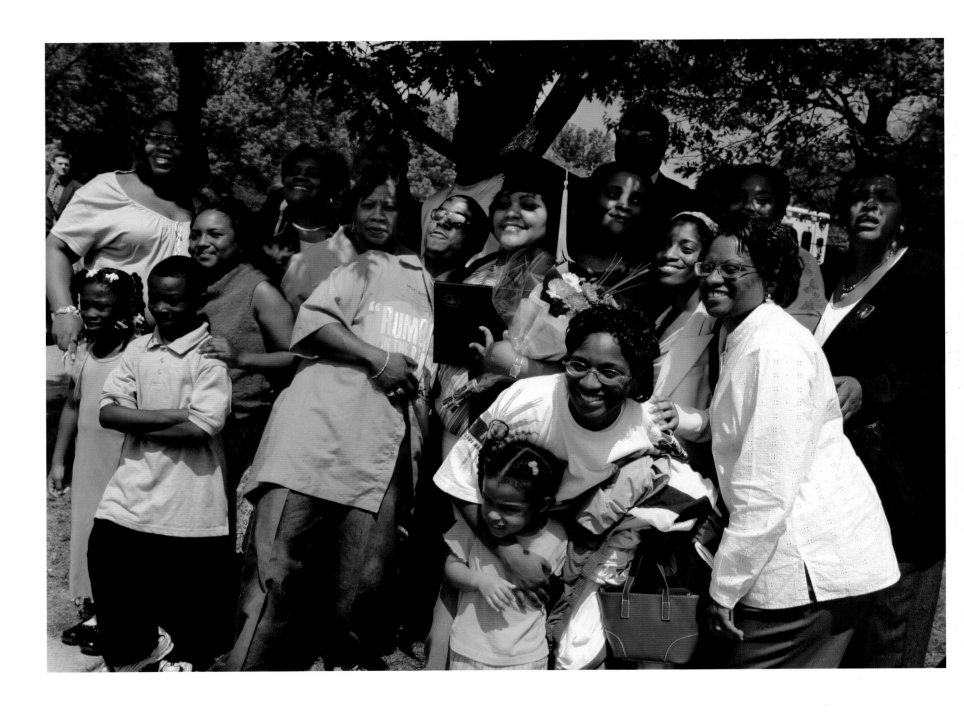

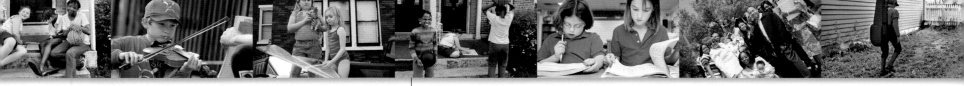

**DUBUQUE**

On Saturday afternoons, sisters Marquita (left) and Dorothy Whitehead and neighbor Sara Brandenburg (center) converge on the front stoop of Sara's row house to decide on the afternoon's recreation. The playmates rarely agree. Marquita insists on dodge ball, Sara on board games, and Dorothy on basketball. In the end, arguing is just another way to spend time together.

*Photo by Sarah Ehrler*

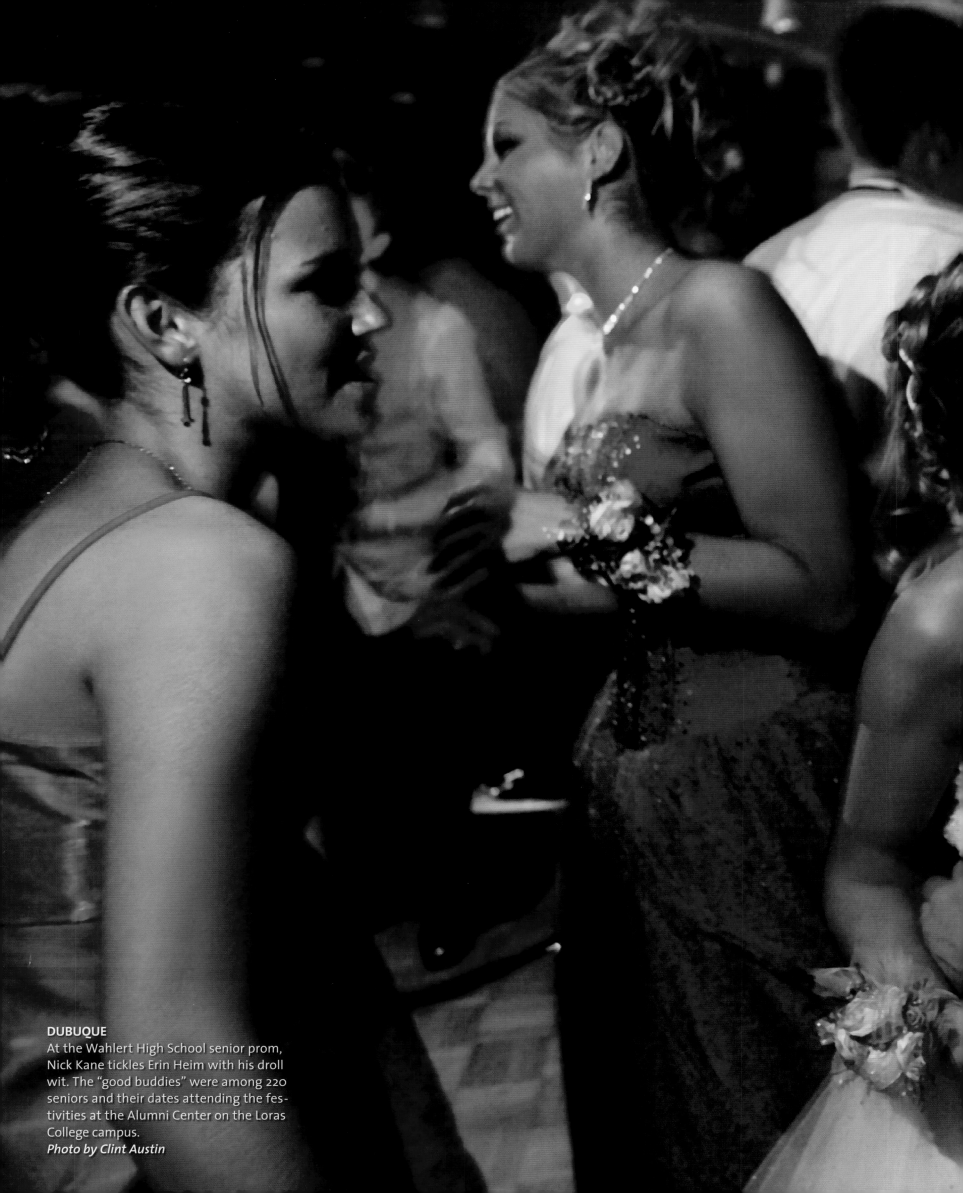

**DUBUQUE**
At the Wahlert High School senior prom, Nick Kane tickles Erin Heim with his droll wit. The "good buddies" were among 220 seniors and their dates attending the festivities at the Alumni Center on the Loras College campus.
*Photo by Clint Austin*

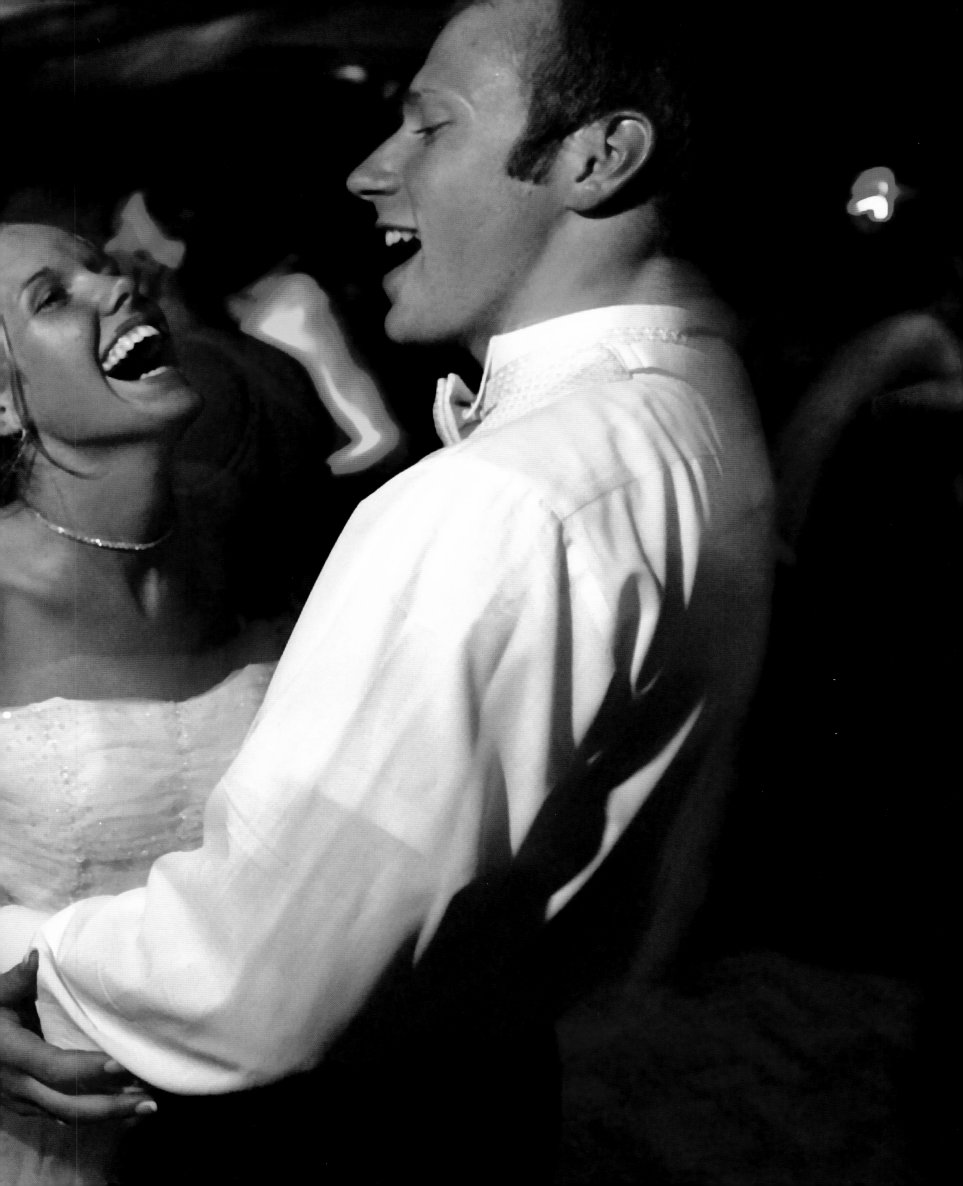

## DUBUQUE

Erin Heim and her date Corey Sloscher begin the first leg of prom-day festivities. The schedule is as follows: 5 p.m. Catholic mass, followed by family photo sessions, dinner, and then the prom. When the dance finishes at midnight, a stretch limo will whisk Erin and friends to the post-prom party at a local hotel. "It's the last time we'll all be together," she says.

**Photos by Clint Austin**

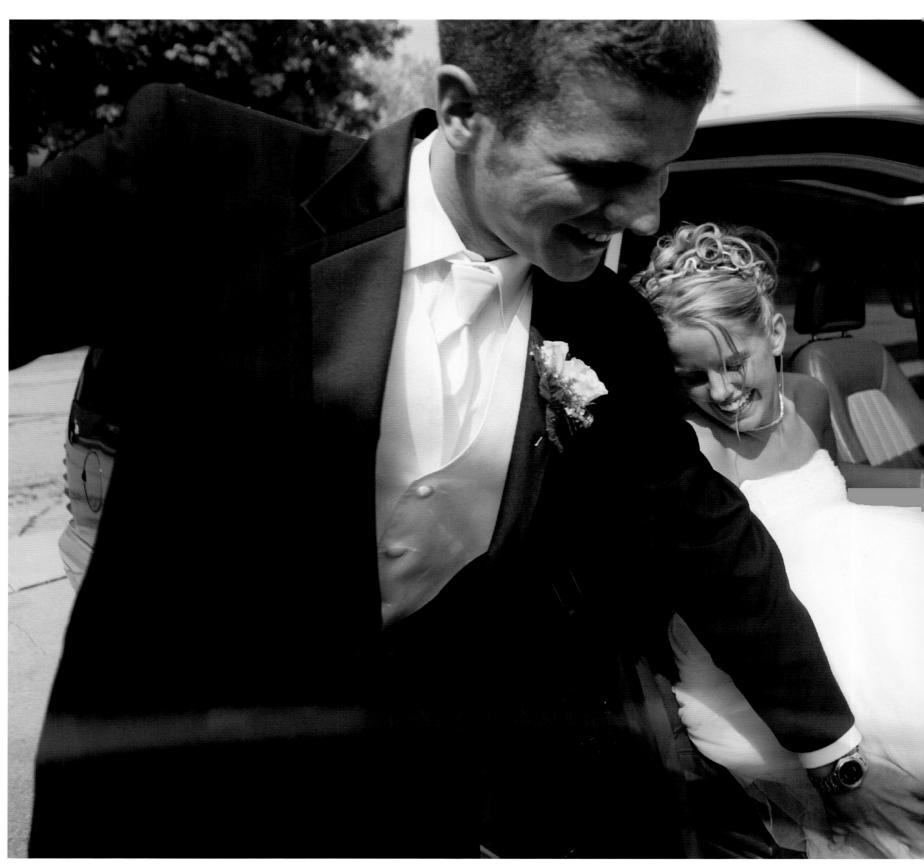

**DUBUQUE**

Dave Heim snaps pre-prom photos of daughter Erin and her date Corey Sloscher. Were there any words of wisdom from dad before the big evening? According to Erin, "He just said, 'Have fun—it is your last high school prom.' My dad is very easy going and very cool."

**DUBUQUE**

During a class portrait, Erin kisses her close friend Teeney Shroeder. For most high school girls, prom evening does not come cheap. The dress, shoes, hair styling, makeup, accessories, prom ticket, dinner, and camera come to an average of $711, according to *Seventeen* magazine.

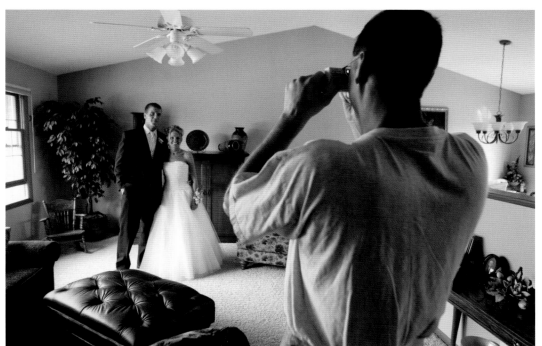

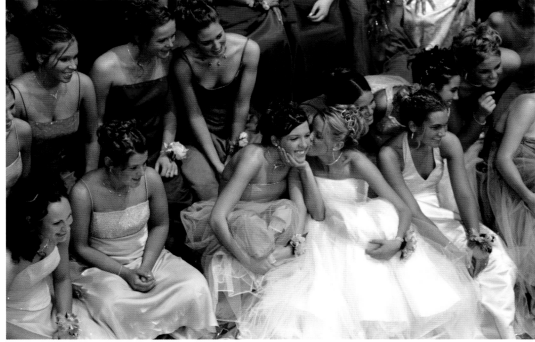

The year 2003 marked a turning point in the history of photography: It was the first year that digital cameras outsold film cameras. To celebrate this unprecedented sea change, the *America 24/7* project invited amateur photographers—along with students and professionals—to shoot and, via the Internet, submit digital images. Think of it as audience participation. Their visions of community are interspersed with the professional frames throughout this book. On the following four pages, however, we present a gallery produced exclusively by amateur photographers.

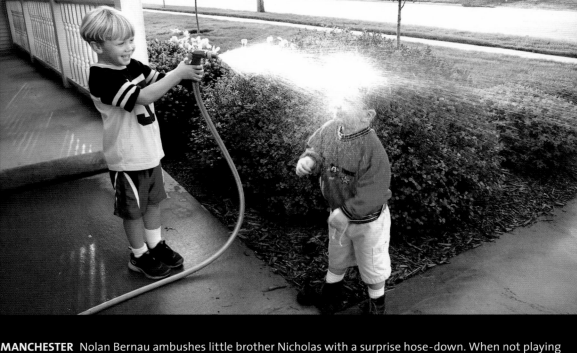

**MANCHESTER**  Nolan Bernau ambushes little brother Nicholas with a surprise hose-down. When not playing pranks on each other, the two pretend to be superheroes or dig for dinosaur bones. *Photo by John Bernau*

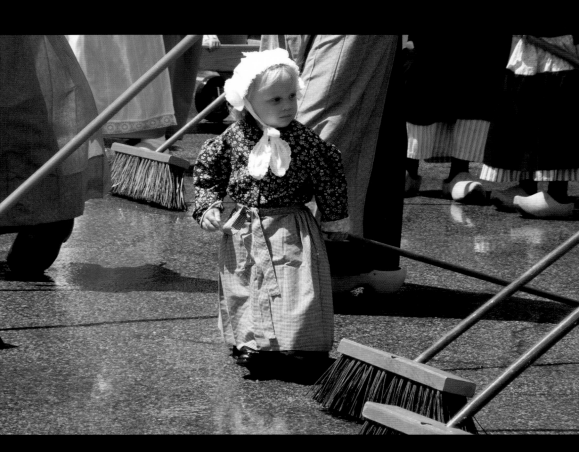

**ORANGE CITY**  Wearing an outfit from Holland's Gelderland province, a tiny Dutch-American girl tries to keep up during the street scrubbing ritual at the annual Tulip Festival. The party celebrates the city's Dutch roots. *Photo by Rob O'Keefe*

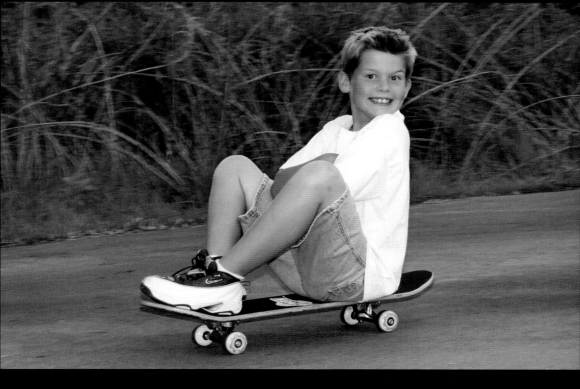

**DES MOINES** Sk8tr Boi: Downhill skateboarding isn't always easy in vertically challenged Iowa. But Bryce Plew managed to suss out a slight decline in his Des Moines subdivision. *Photo by J J Gerlitz*

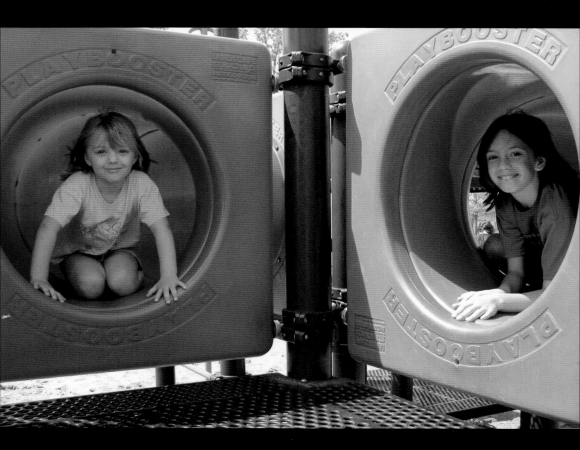

**PALO** Megan Mishmash and her sister Katelyn see light at the end of the tunnel slide at Pleasant Creek State Recreation Area in eastern Iowa. *Photo by Brian Mishmash*

**DAVENPORT** House painter Mark Fredericton studied color theory in college and applied his knowledge on a grand scale to his barn/workshop, a study in tone and harmony. *Photo by Angela Smith*

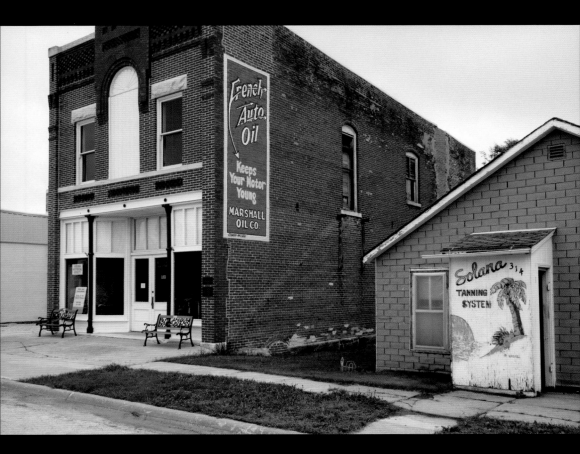

**AURORA** A typical small town, Aurora (pop. 194) is trying to hold on to its buildings in the face of a declining rural population. "The Old Hardware Store" was recently converted into the Aurora Historical Society. *Photo by Thomas Payne*

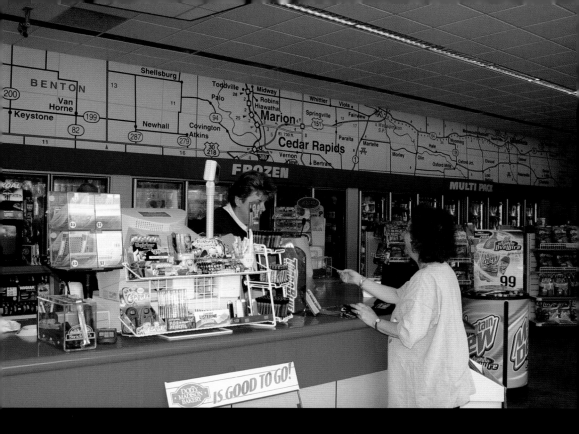

**MARION** Proud to be part of the Marion–Cedar Rapids community, the ShortShop convenience store has a you-are-here slice of Iowa painted on the wall. *Photo by Scott Frisch*

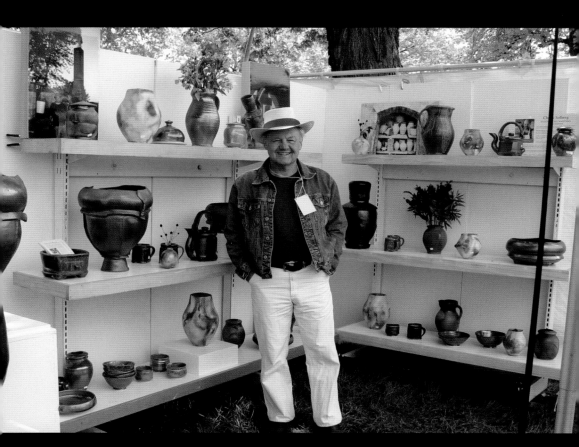

**MARION** Noted ceramist Chuck Solberg was one of 50 finalists chosen to exhibit at the 11th Annual Marion Arts Festival. Solberg fires his pottery in a wood-burning kiln. "Flame and ash flow through the kiln, leaving unexpected patterns and surfaces," says the artist. "Each piece is unique—a record of the firing." *Photo by Scott Frisch*

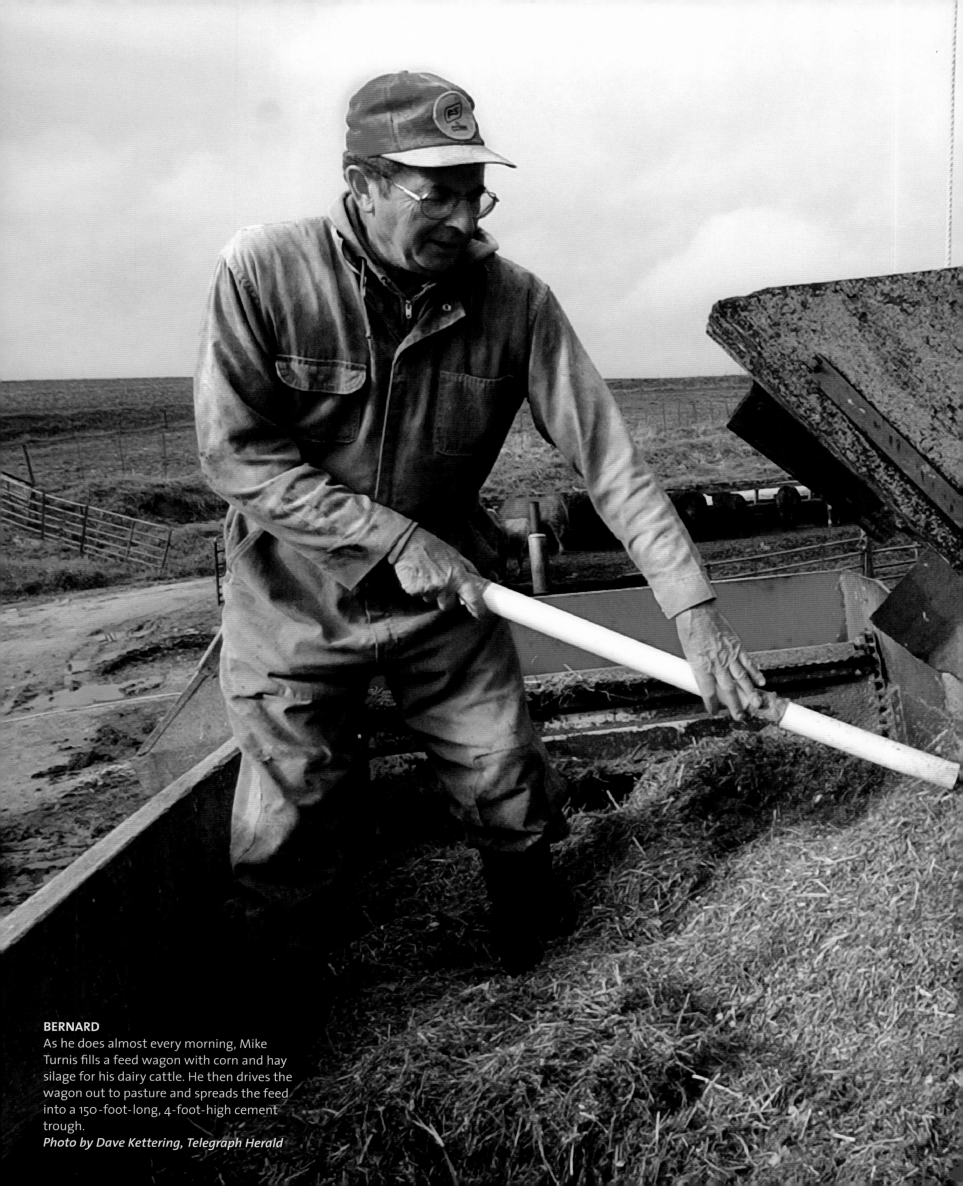

**BERNARD**
As he does almost every morning, Mike Turnis fills a feed wagon with corn and hay silage for his dairy cattle. He then drives the wagon out to pasture and spreads the feed into a 150-foot-long, 4-foot-high cement trough.
*Photo by Dave Kettering, Telegraph Herald*

**PLEASANT HILL**
A truck full of corn heads toward the Country-wide Grain Terminal, where 140 trucks from central Iowa offload a total of 140,000 pounds of corn each day.
*Photos by Charlie Neibergall, Associated Press*

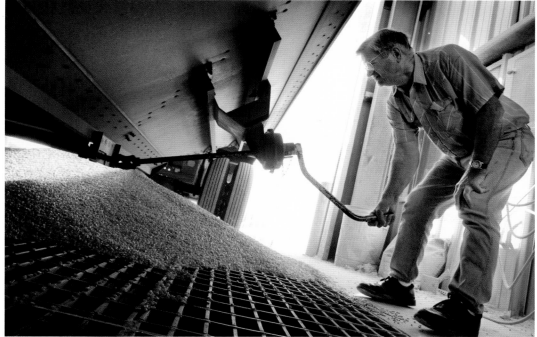

**BELLEVUE**

On a weekend trip home from the University of Northern Iowa in Cedar Rapids, Ryan Putman lays tramel nets in the backwaters of the Mississippi River with his father Larry, a fourth-generation commercial fisherman.

*Photos by Mark Hirsch, Telegraph Herald*

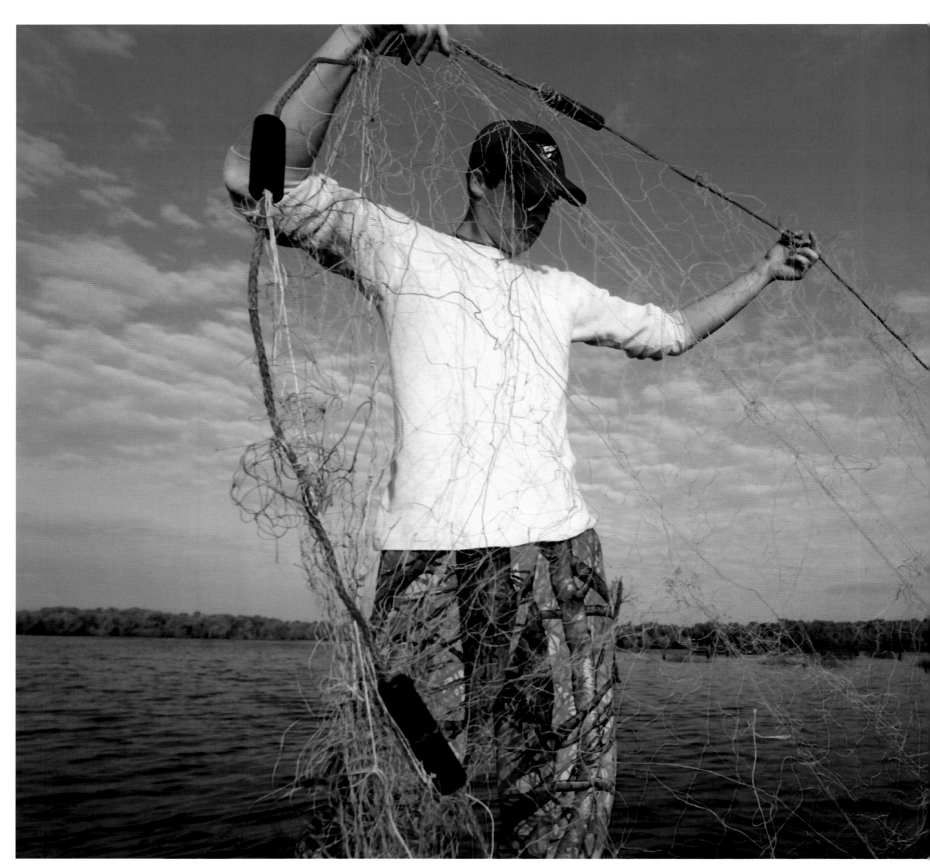

**BELLEVUE**

The Putmans have developed their own approach to untangling buffalo, carp, catfish, and sturgeon from their net webbing: Place a thumb and middle finger in the eye socket of the fish to immobilize it and pull as you slide the webbing off its fins with a screwdriver. "My dad's the only one that does it that way," says Ryan, "but it works."

**BELLEVUE**

Chilly morning fog clings to "The Bottoms," a series of shallow lakes created by floodwaters from the Mississippi. Larry Putman rarely encounters other fishermen in these parts. When he does, it's usually a Putman—his father, brothers, and nephews are the only Bellevue residents who still fish commercially.

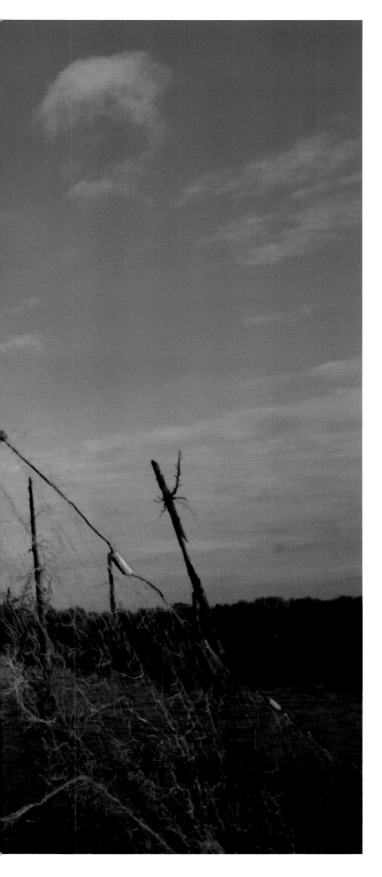

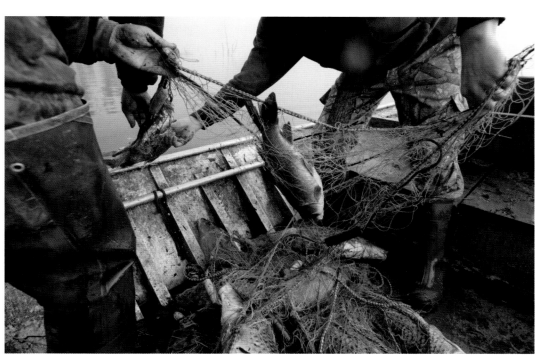

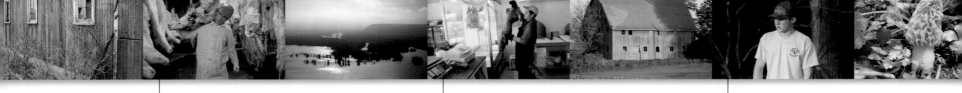

**DES MOINES**

Each week, Amend Packing Company co-owner Kent Wiese and three employees slaughter 8,000 pounds of local cattle and process the beef for distribution throughout Iowa. The company has been run by Wiese's in-laws, the Amends, since 1928.
*Photo by Gary Fandel*

**DES MOINES**

Regulars come in every week for the succulent roasted pig and duck at Le's Chinese Bar-B-Q. Tri Le got the recipe for the Chinese delicacy from his cousin who owns a similar restaurant in Los Angeles. Le opened his restaurant two years ago and is doing well enough to work just five days a week.
*Photo by John Gaps III,*
*The Des Moines Register*

**CRAWFORD COUNTY**

Joe Michael Poggensee and other 'shroomers know what to do the first two weeks of May: head to the woods and hunt for the noble morels. The preferred recipe? Dipped in eggs and bread crumbs and fried.
*Photo by Don Poggensee*

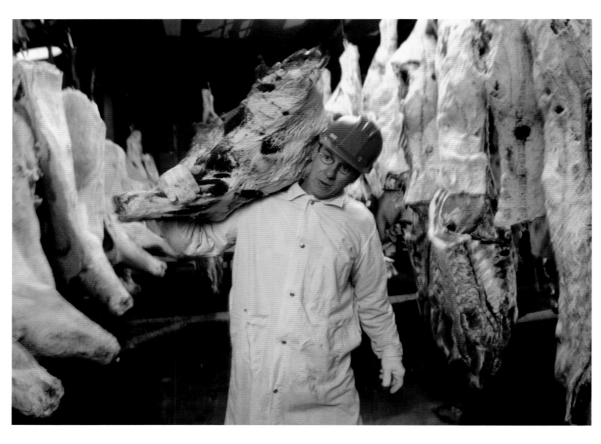

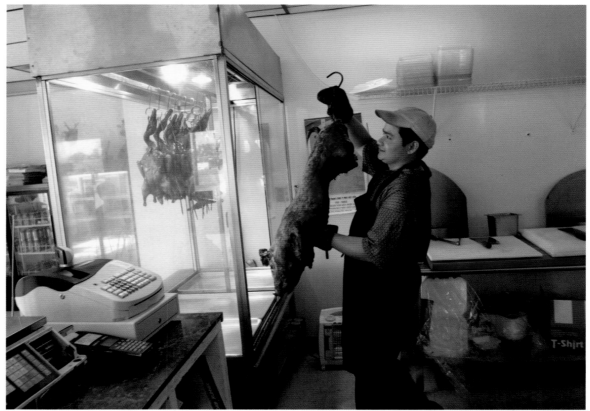

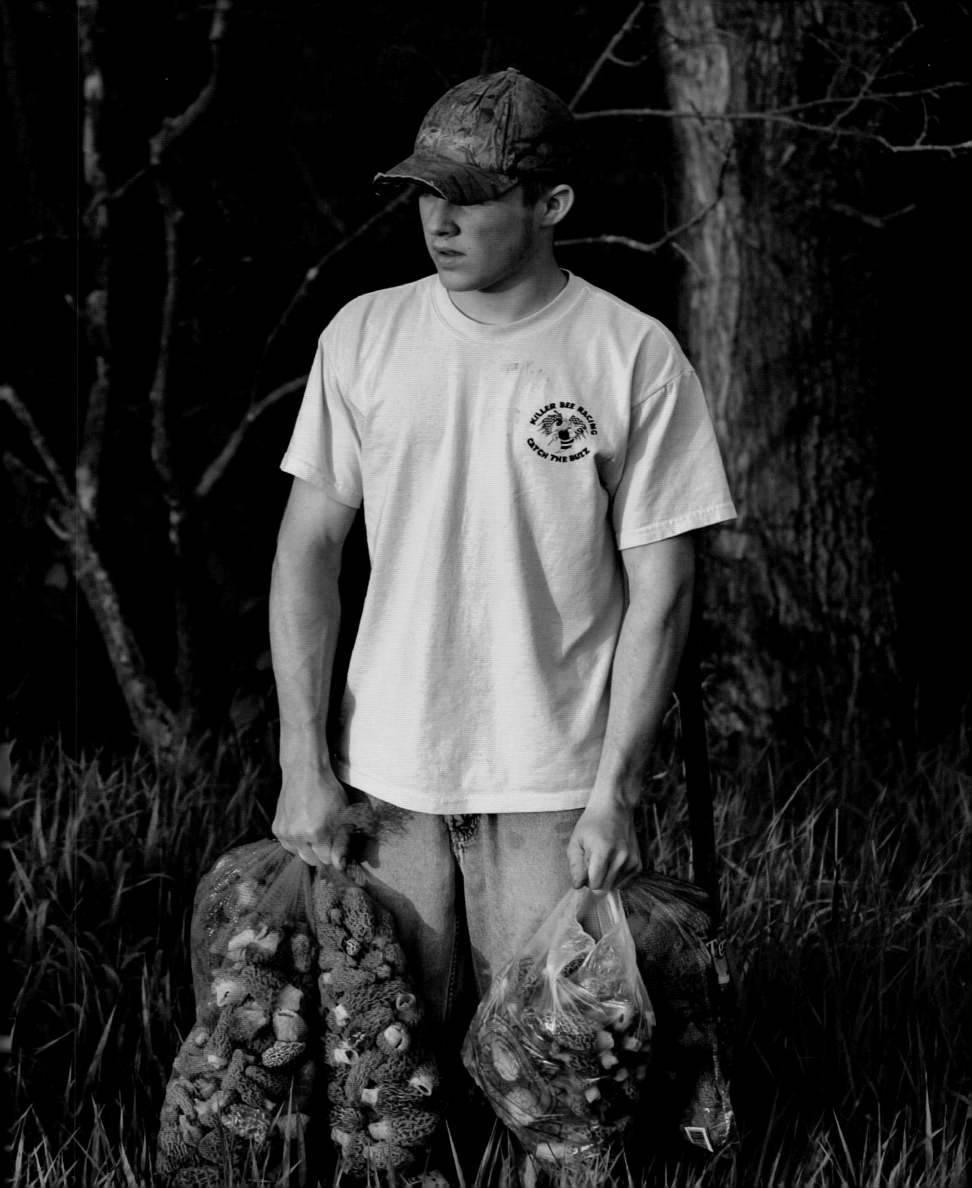

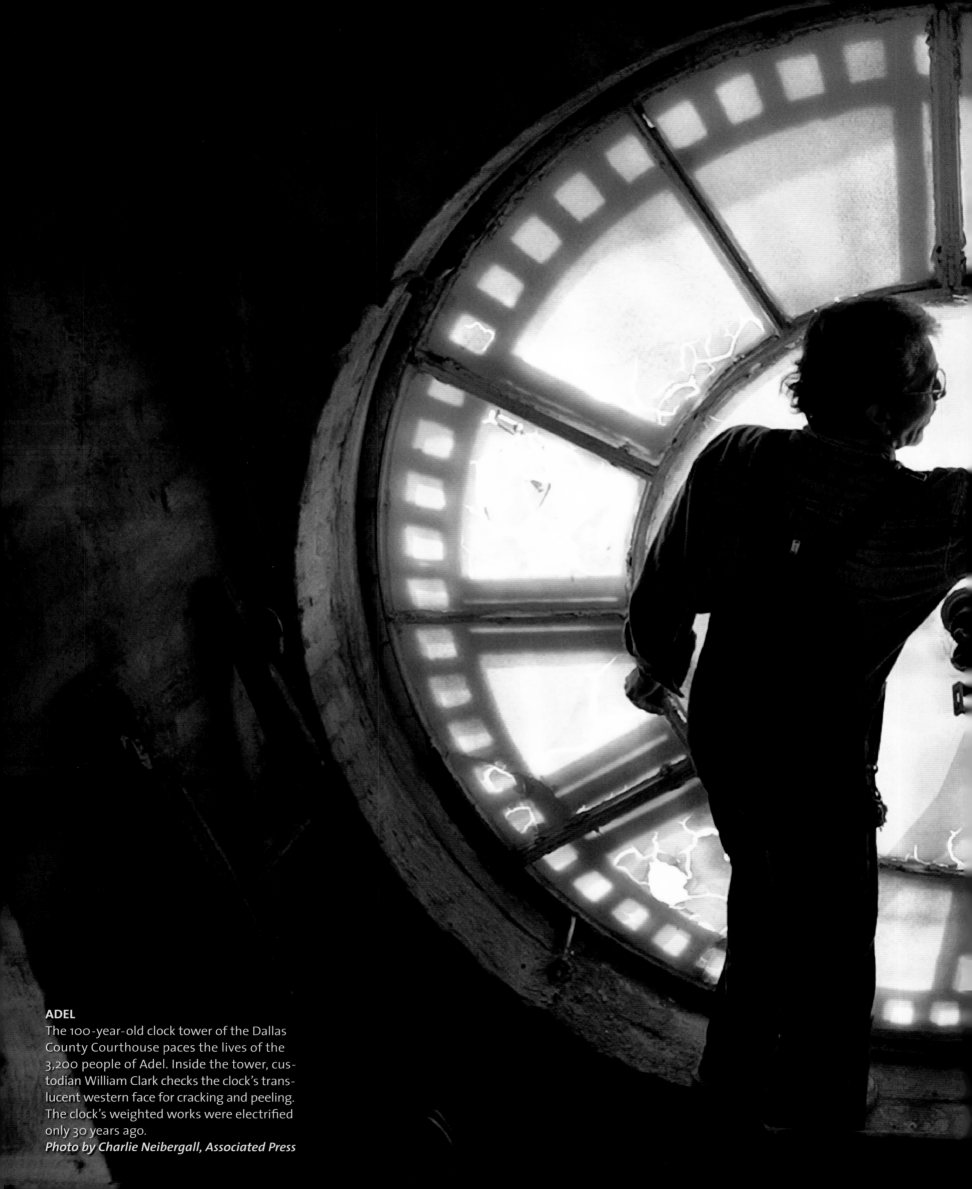

**ADEL**
The 100-year-old clock tower of the Dallas County Courthouse paces the lives of the 3,200 people of Adel. Inside the tower, custodian William Clark checks the clock's translucent western face for cracking and peeling. The clock's weighted works were electrified only 30 years ago.
*Photo by Charlie Neibergall, Associated Press*

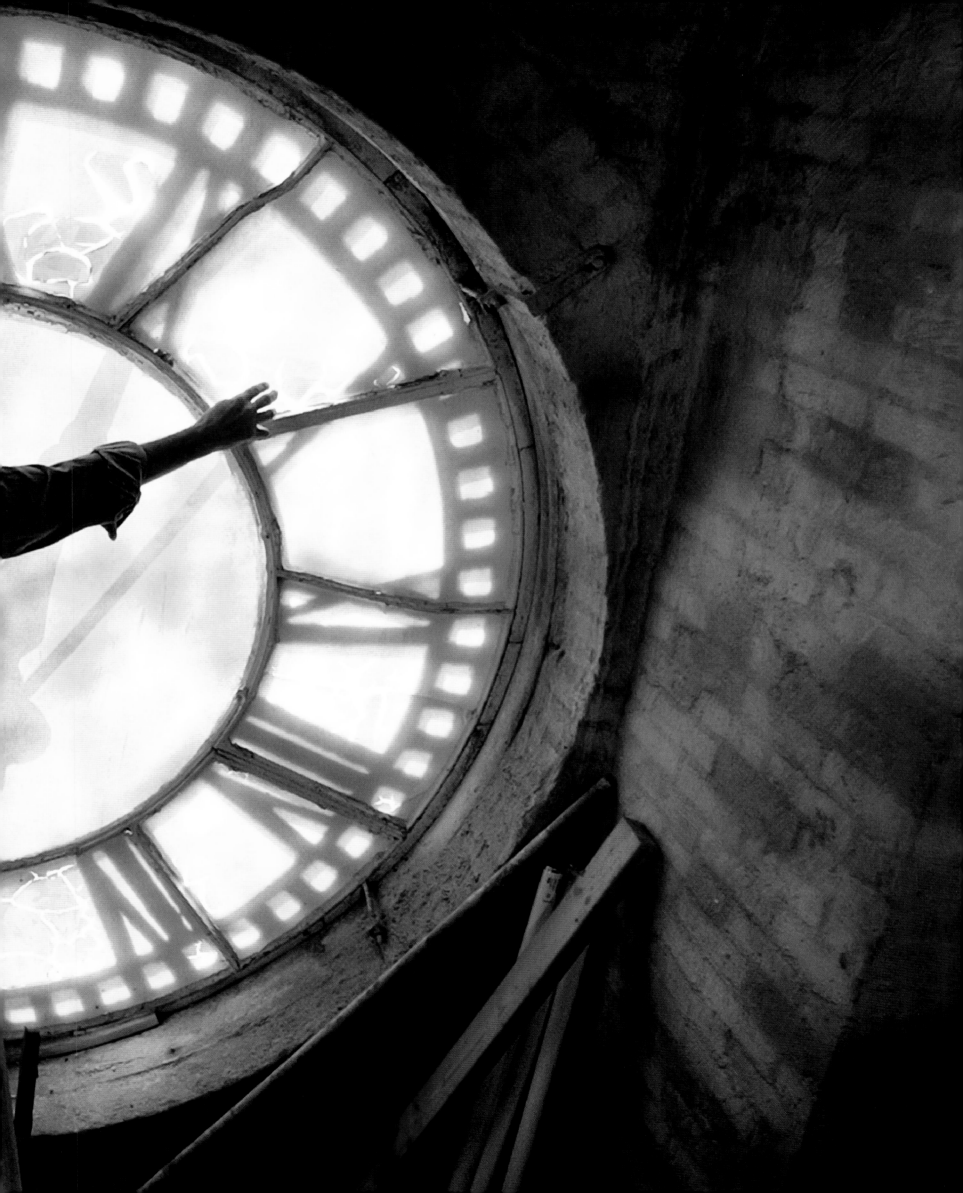

**JOHNSTON**

Retired grocer Leonard Skow, 83, trims rhubarb stalks for his daughter. He always shares produce from his one-third-acre garden with his kids and neighbors. "I got a new garden hat," he explains, "but haven't gotten around to wearing it. This old one has been bringing me good luck."

*Photo by Rodney White*

**ELMA**

Although Iowa encompasses only 1.6 percent of the nation's land, if its rich soil were used solely to grow grains, it could theoretically produce enough plant protein to meet the nutritional needs of all Americans.

*Photo by Charlie Neibergall, Associated Press*

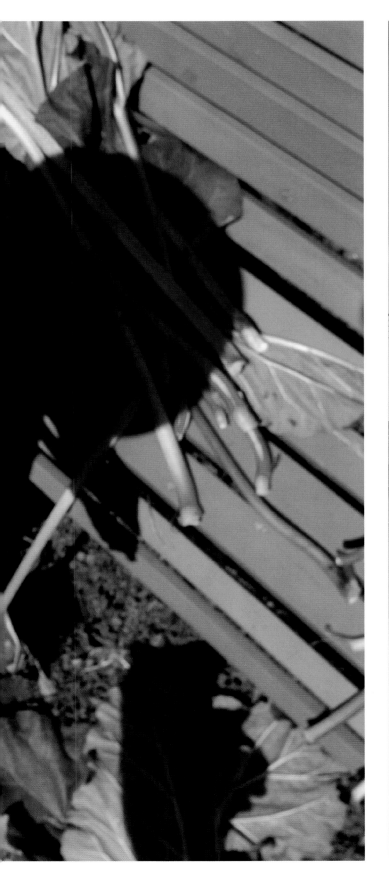

## BALLTOWN

Ron Auderer changes the spark plugs in the pick-up he uses to deliver feed and farm supplies. Employed by the Skip Breitbach Feed Store for 15 years, Auderer is also the owner of a 160-acre farm a few miles down the road, but it lays fallow in the Conservation Reserve Program. "The government pays me to keep it out of production," says Auderer.

*Photos by Dave Kettering, Telegraph Herald*

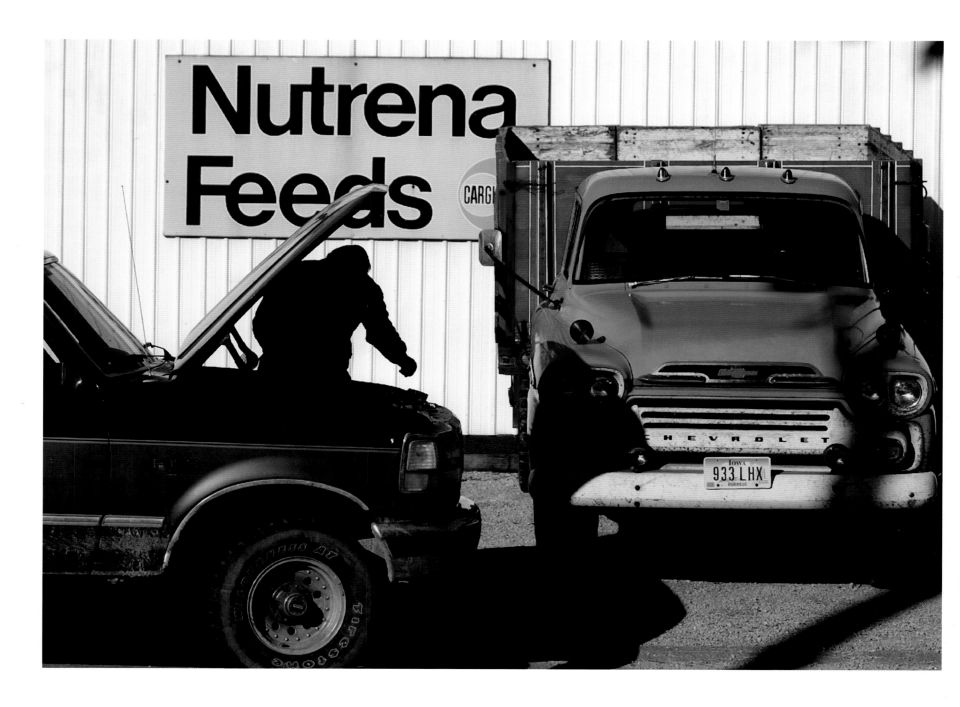

## BALLTOWN

Auderer does some heavy lifting under the feed store's dried flowers, which it sells to tourists. Tour buses disgorge the hungry at Breitbach's Country Dining, Iowa's oldest bar and restaurant, located across the street. Opened in 1852, the eatery has been in the Breitbach family since 1863.

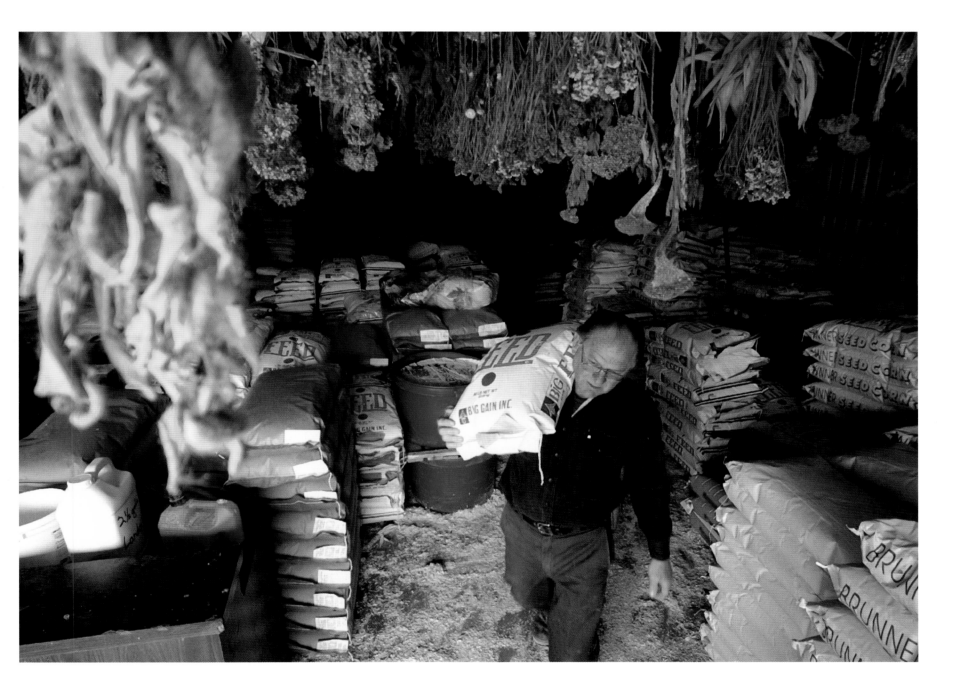

**BLOOMFIELD**
A worker at Brodhead Collar Shop shapes wet leather before feeding it into a machine (front) that forms and presses it into horse collars. The Amish-run enterprise sells its collars around the world and has been a fixture in Davis County since 1990.
*Photo by Gary Fandel*

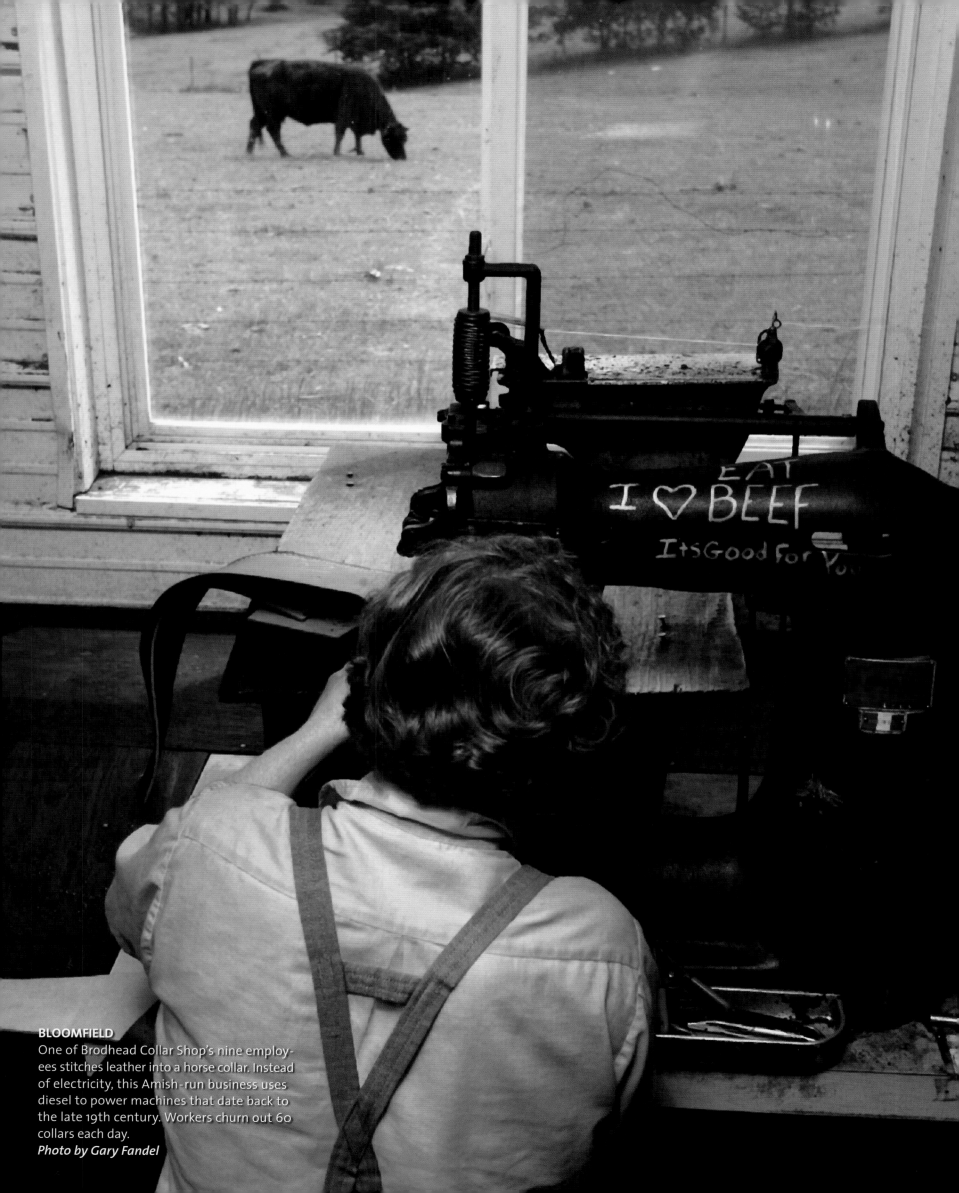

**BLOOMFIELD**
One of Brodhead Collar Shop's nine employees stitches leather into a horse collar. Instead of electricity, this Amish-run business uses diesel to power machines that date back to the late 19th century. Workers churn out 60 collars each day.
*Photo by Gary Fandel*

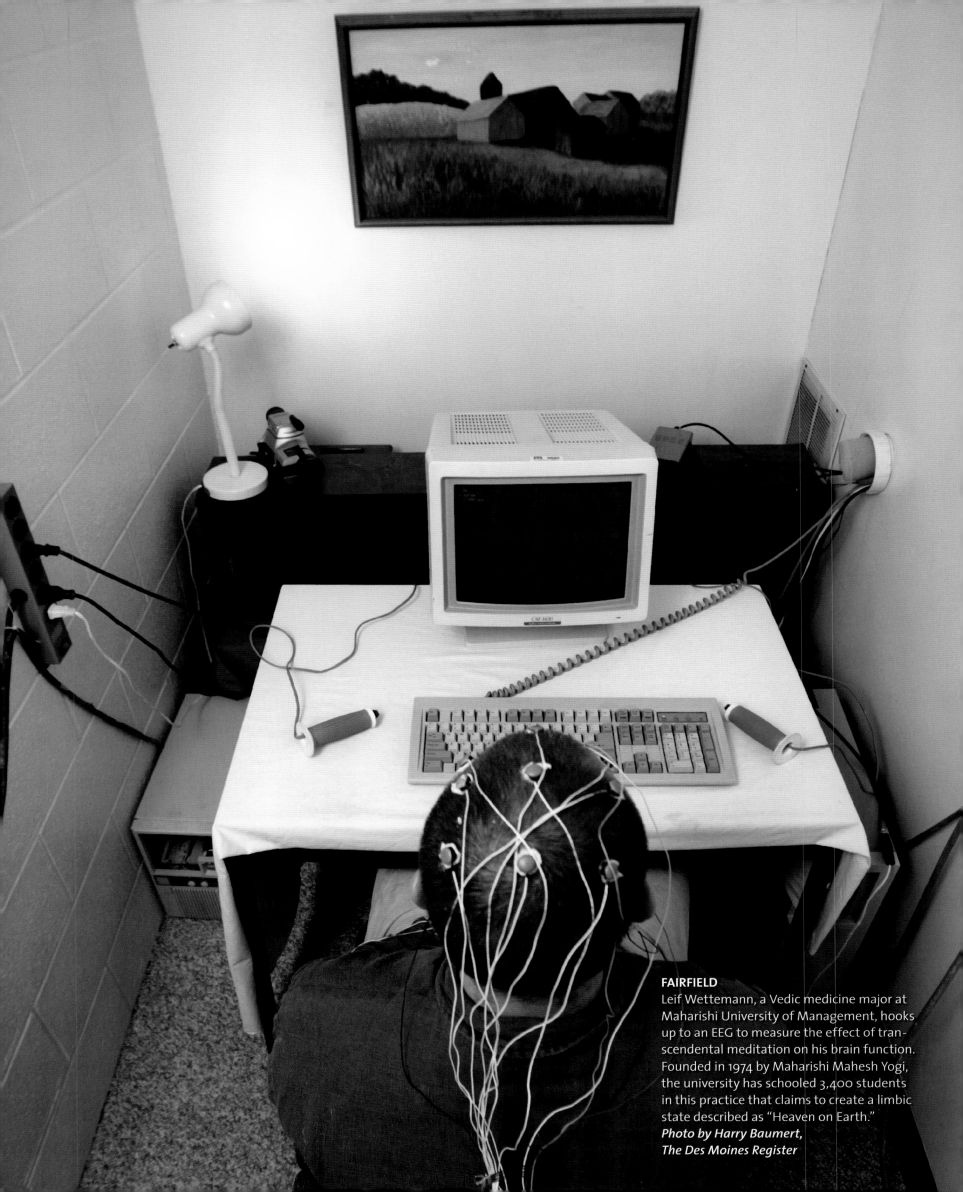

**FAIRFIELD**
Leif Wettemann, a Vedic medicine major at Maharishi University of Management, hooks up to an EEG to measure the effect of transcendental meditation on his brain function. Founded in 1974 by Maharishi Mahesh Yogi, the university has schooled 3,400 students in this practice that claims to create a limbic state described as "Heaven on Earth."
*Photo by Harry Baumert,*
*The Des Moines Register*

## DUBUQUE

Bed head: Business at the Verlo Mattress Store on Dodge Street jumps 30 percent on Saturdays, when 12-year-old Cameron Hall clocks in for his $6-per-hour shift. How'd he get the gig? Networking. Cameron's father Rich referred him after borrowing a mattress from the store for a community theater production of *Once Upon A Mattress*.

*Photo by Mark Hirsch, Telegraph Herald*

## IOWA CITY

When work slows down in the theater business, stagehand Roman Antolic works odd jobs around Iowa City. In exchange for touching up these restaurant chairs, Antolic and his friends earned five free Cajun lunches at the Lou Henry diner in midtown. "It was a fair barter," says Antolic.

*Photo by Buzz Orr*

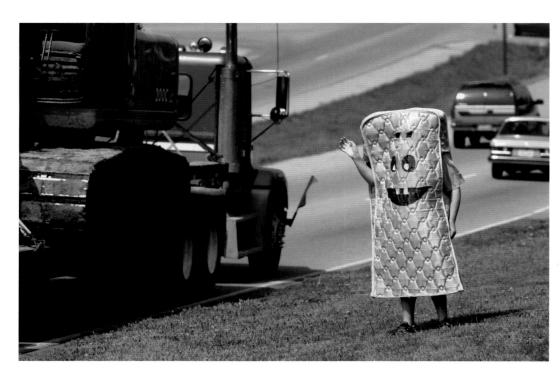

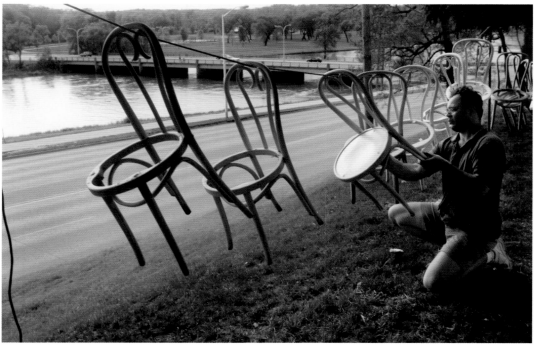

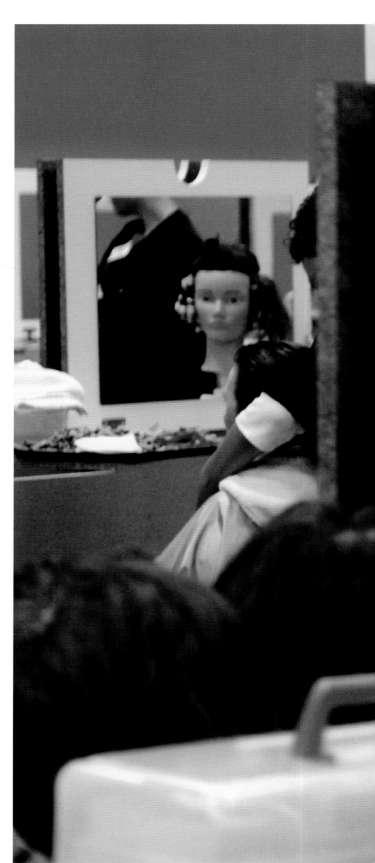

**URBANDALE**

Iowa School of Beauty student Kristy Bradley hones her skills on Sara Carter. At the school's clinic, clients like Carter get their hair done at a reduced price. The cosmetology course lasts 12 to 14 months.
*Photo by Heidi Zeiger*

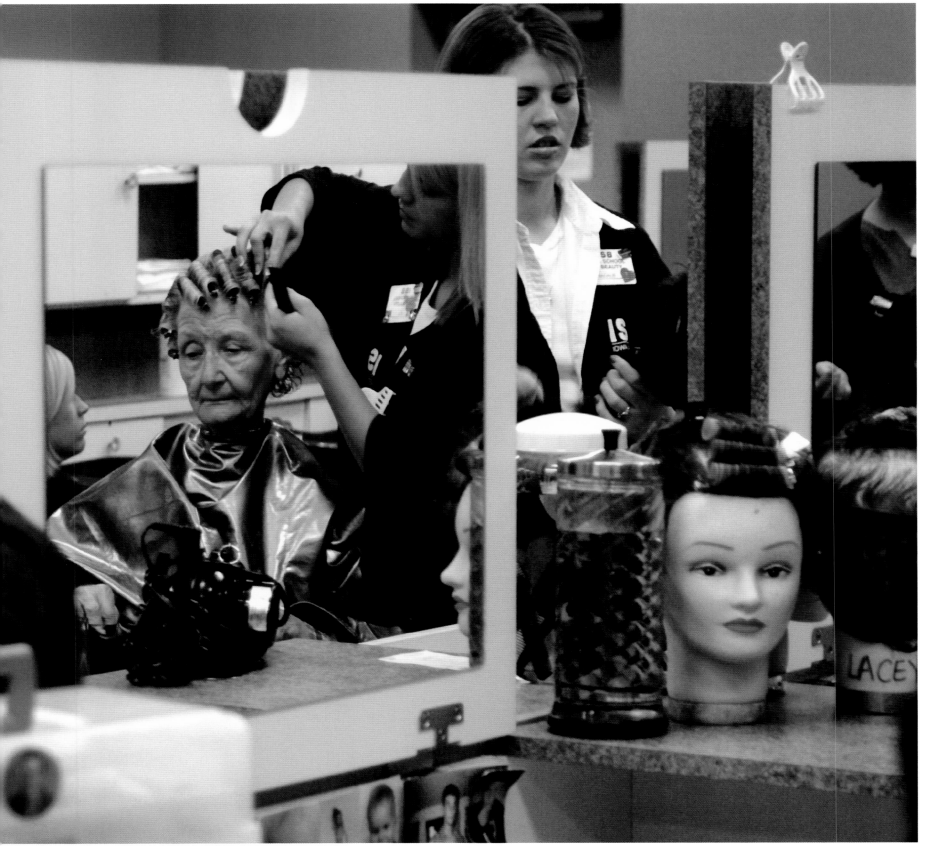

**OSKALOOSA**

At Fred's Muffler Shop, Dan Gordy helps unload
mufflers. The business was started in 1963 and
over the years developed into a local hangout.
Gordy, a buddy of current owners Tim and Terry
De Jong (Fred's sons), often drops by to lend a
hand and chew the fat.
*Photo by Kim Seang Poam*

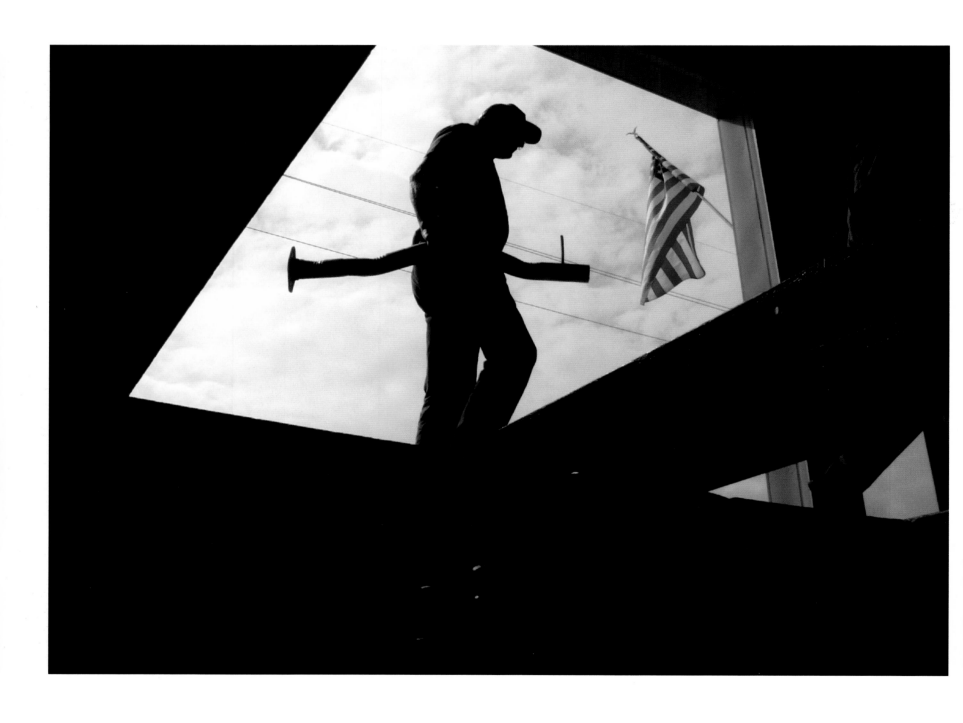

**ST. DONATUS**

Blacksmith Ron Hilkin makes sign brackets, railings, and chandeliers the old way—with an anvil and forge in his backyard shop. "Ironworking is really a lost art," says Hilkin, who collects antique hammers, tongs, line shafts, and grinders. "When we moved to mass production, we lost all of the craftmanship and quality."

*Photo by Mark Hirsch, Telegraph Herald*

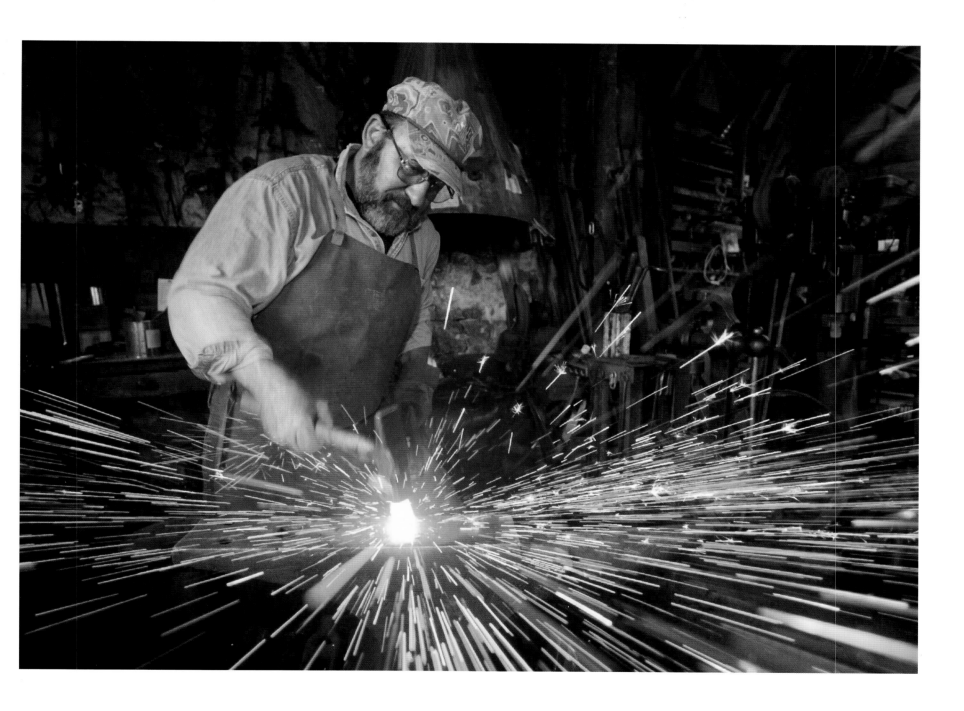

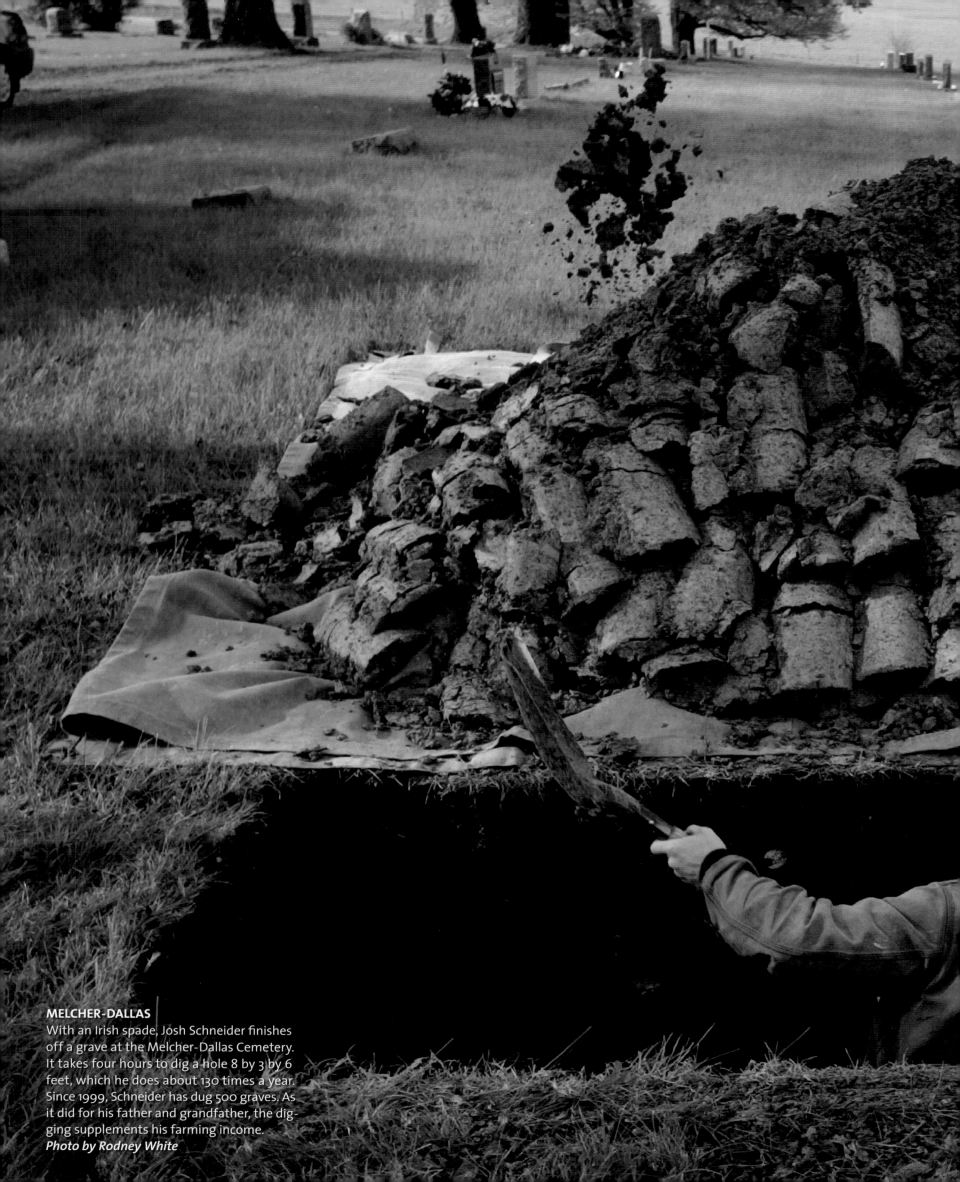

**MELCHER-DALLAS**
With an Irish spade, Josh Schneider finishes off a grave at the Melcher-Dallas Cemetery. It takes four hours to dig a hole 8 by 3 by 6 feet, which he does about 130 times a year. Since 1999, Schneider has dug 500 graves. As it did for his father and grandfather, the digging supplements his farming income.
*Photo by Rodney White*

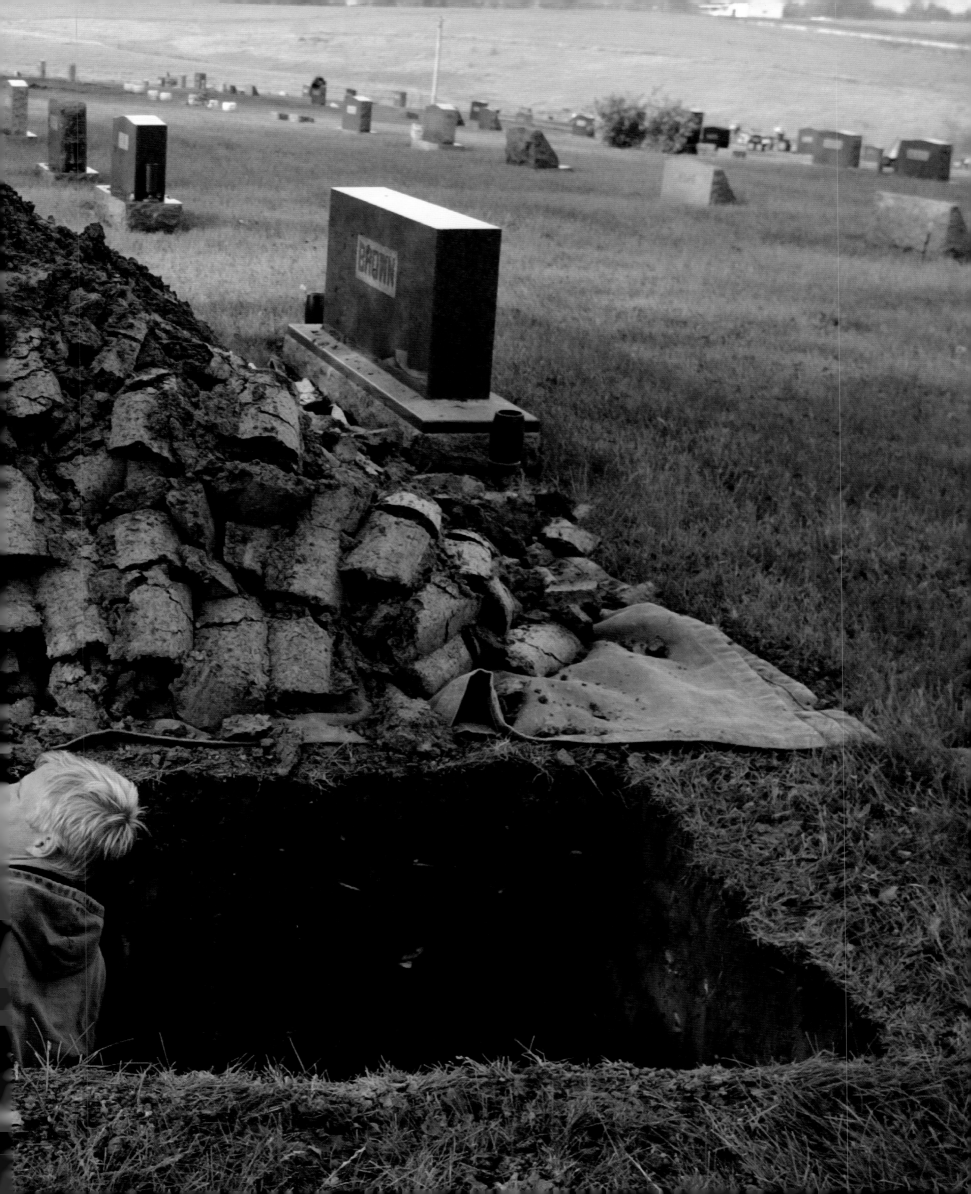

**PRAIRIE CITY**
At the Neil Smith National Wildlife Refuge, naturalist Pauline Drobney (far left) directs a group of Knoxville High School students who have volunteered to clear undesirable trees and brush. Native savanna and tallgrass prairie remnants within the refuge boundaries are protected by mowing, brush cutting, and prescribed burns.
*Photo by Rodney White*

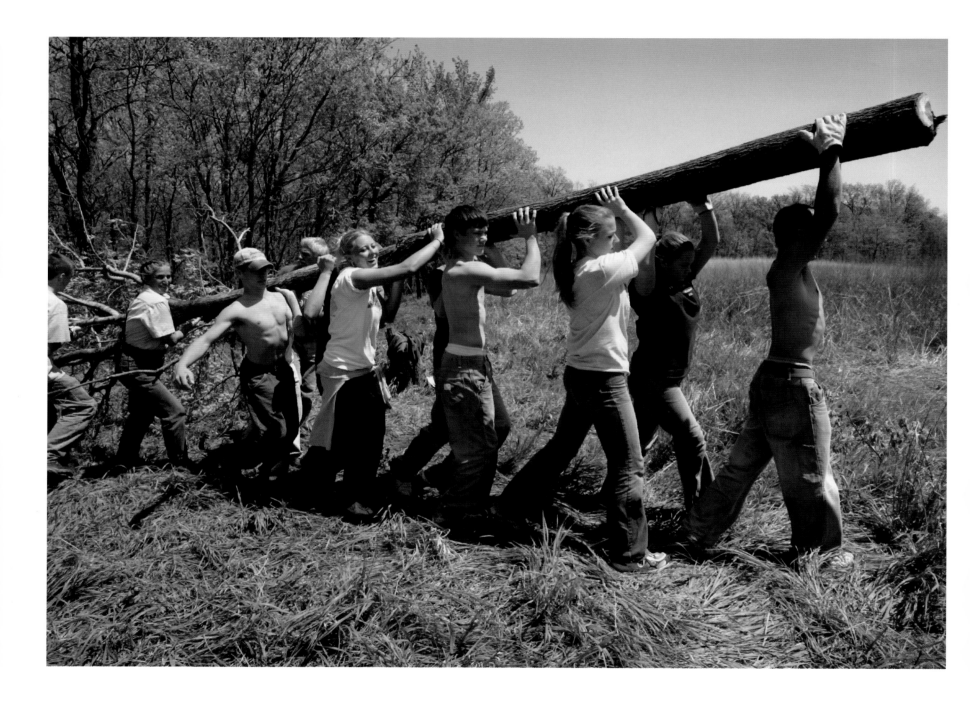

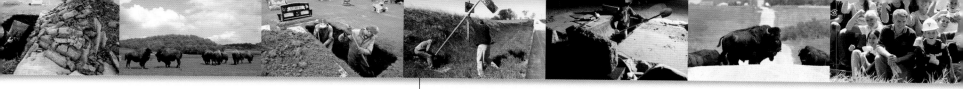

**FERGUSON**

Marshall County employees Allen Huston and David Eubanks install a street sign in the tiny town of Ferguson, pop. 126, where the road signs are replaced every 12 years.
*Photo by Alex Dorgan-Ross*

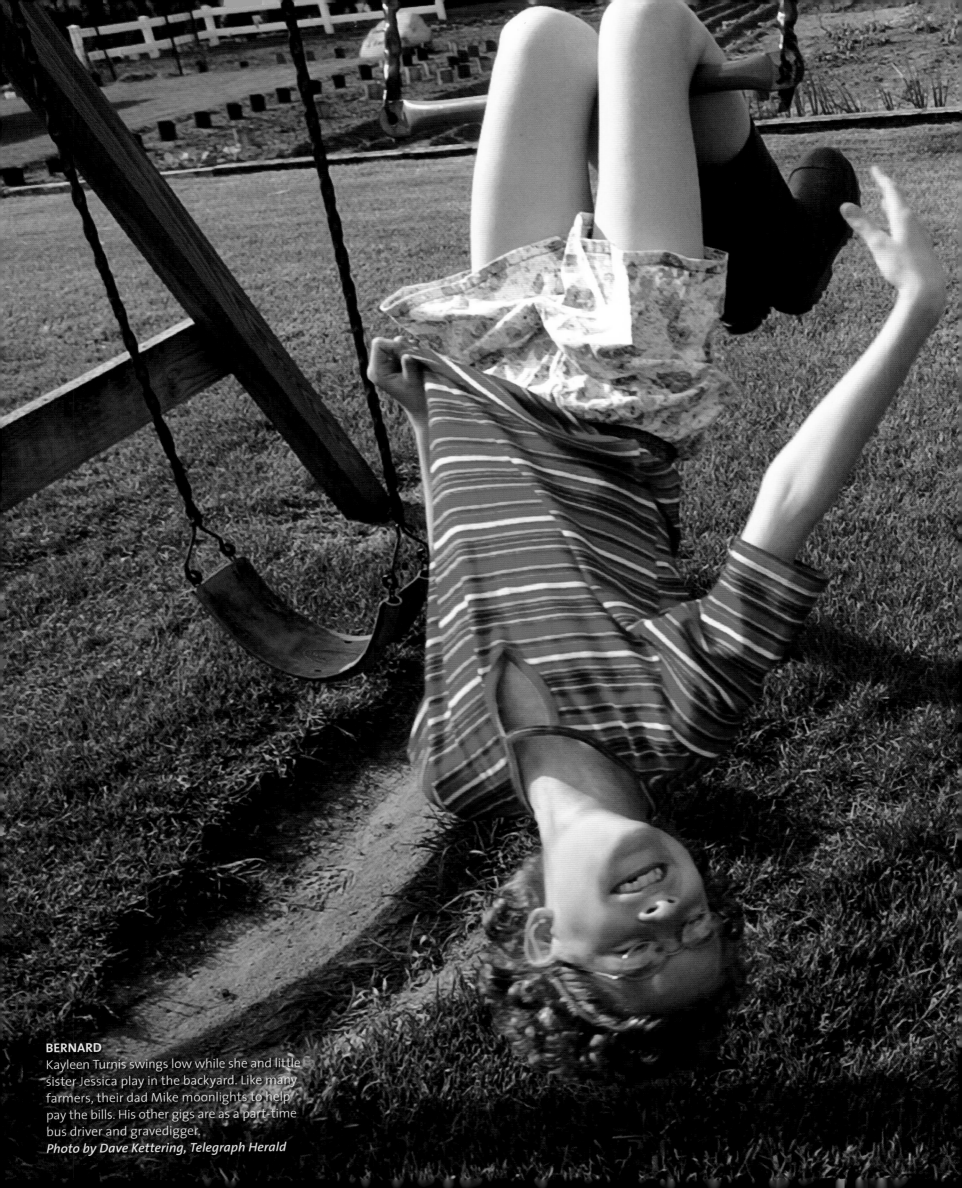

**BERNARD**
Kayleen Turnis swings low while she and little sister Jessica play in the backyard. Like many farmers, their dad Mike moonlights to help pay the bills. His other gigs are as a part-time bus driver and gravedigger.
*Photo by Dave Kettering, Telegraph Herald*

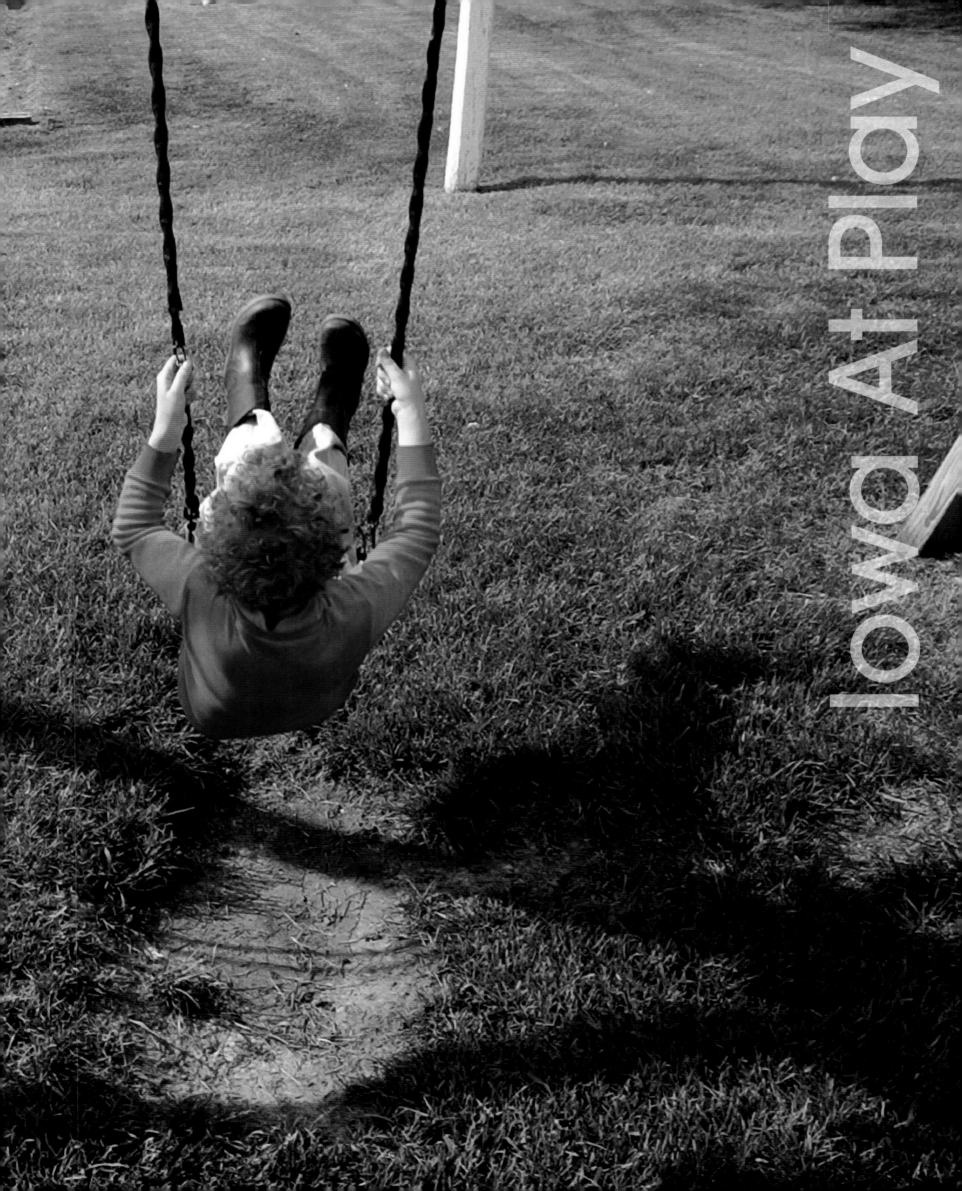

Iowa At Play

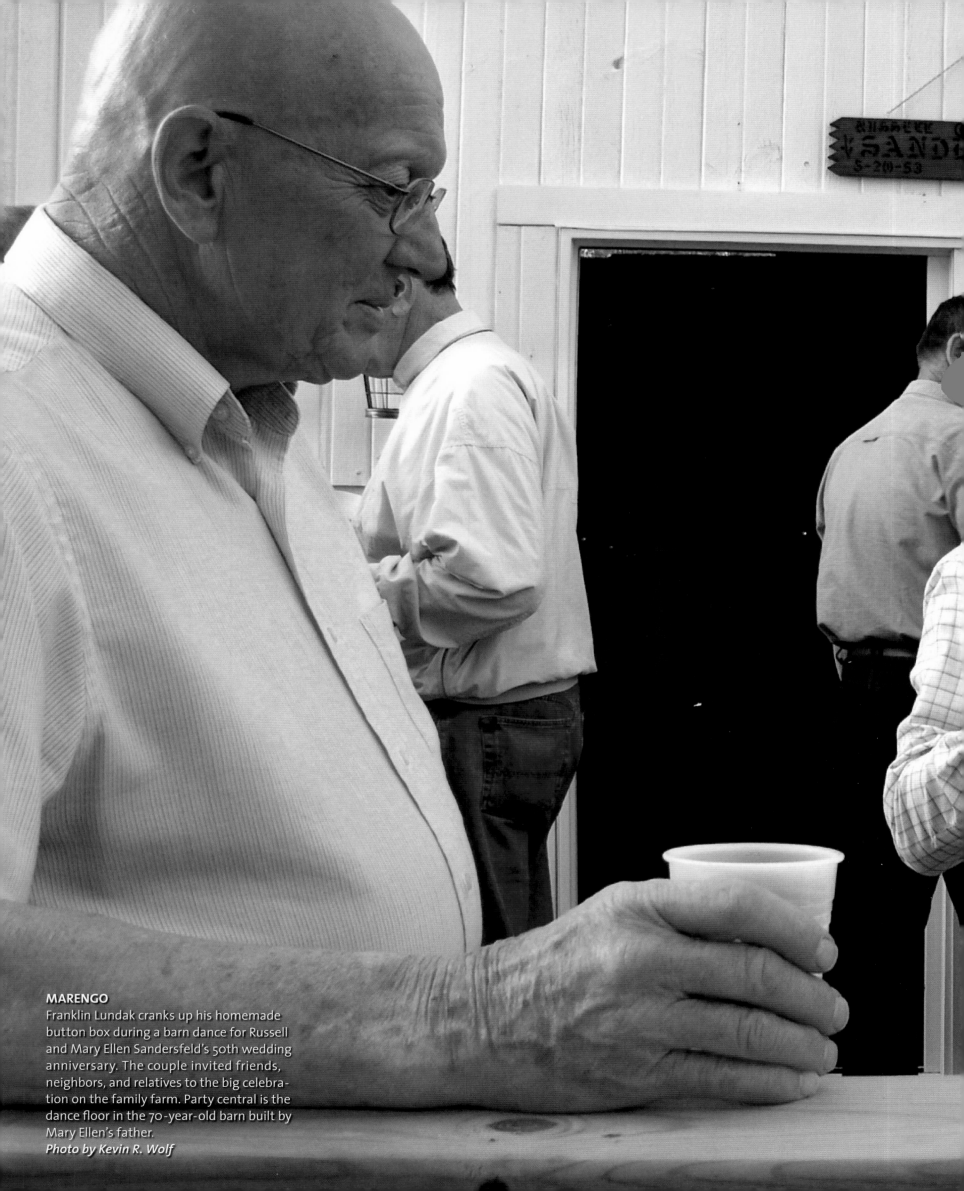

**MARENGO**

Franklin Lundak cranks up his homemade button box during a barn dance for Russell and Mary Ellen Sandersfeld's 50th wedding anniversary. The couple invited friends, neighbors, and relatives to the big celebration on the family farm. Party central is the dance floor in the 70-year-old barn built by Mary Ellen's father.

*Photo by Kevin R. Wolf*

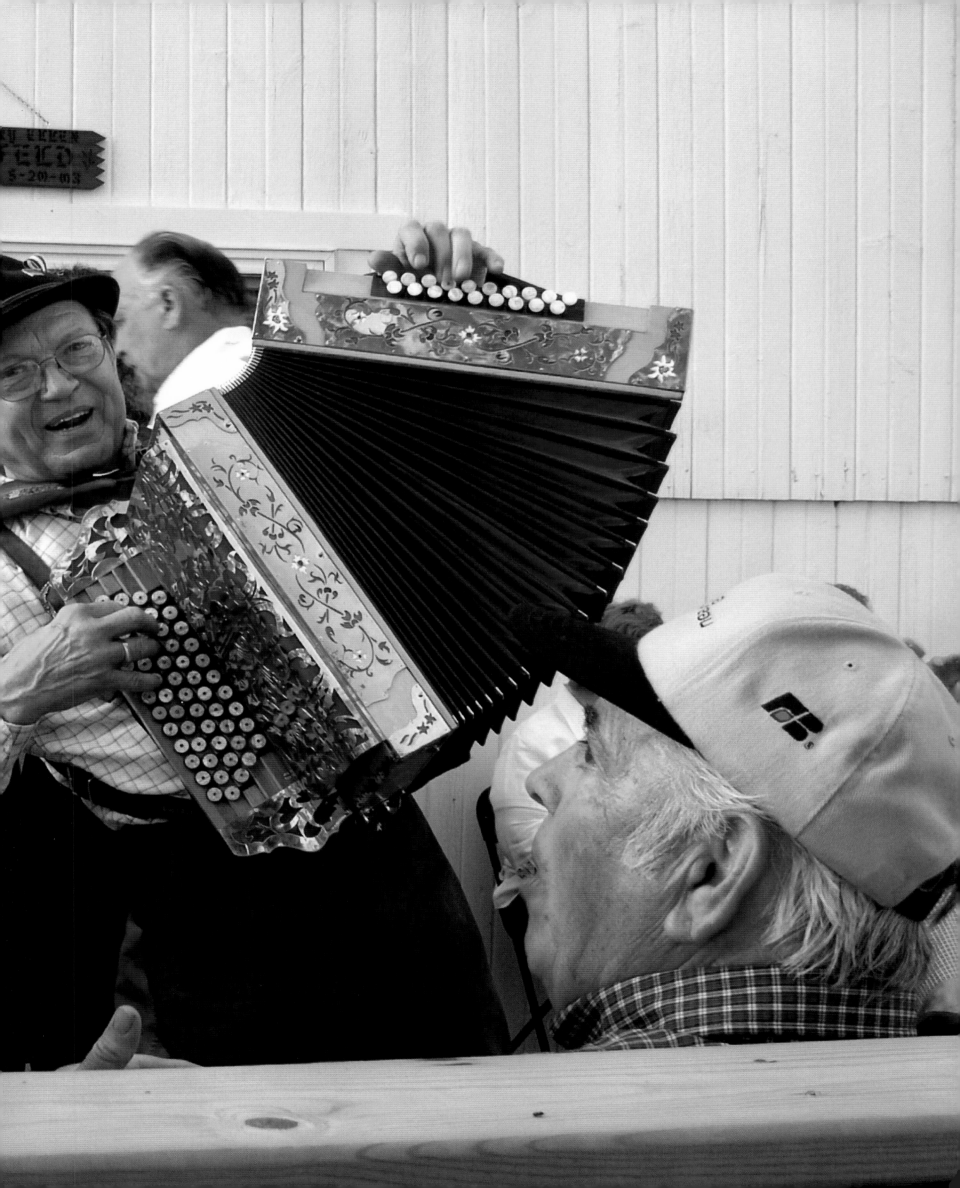

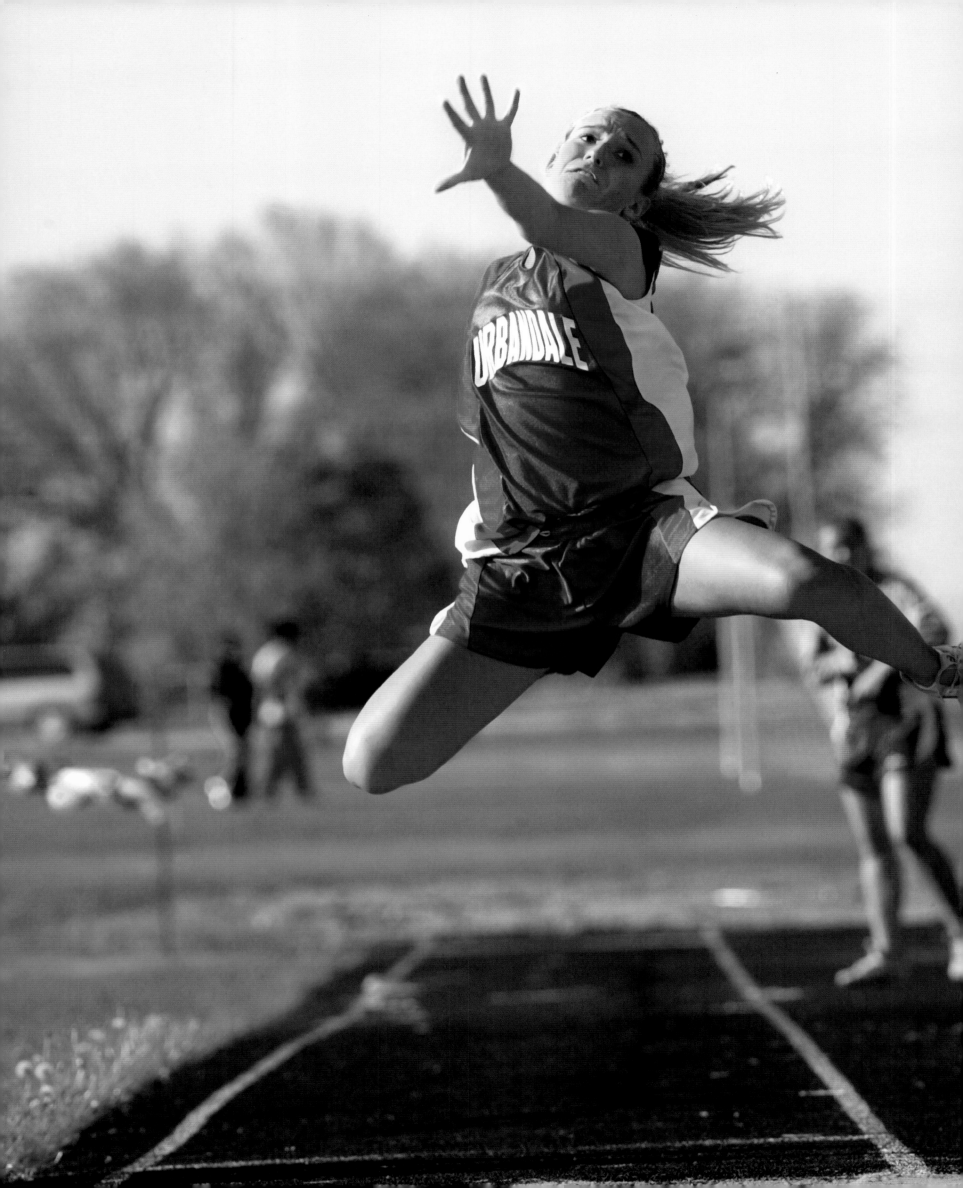

**WAUKEE**

Every inch counts for Urbandale High School long jumper Erica Heiden. The senior vaulted and stretched her way to third place at the district track meet, which earned her a trip to the state finals in Des Moines.

*Photo by David Peterson*

**RUNNELS**

Timers clock a race during a Central Iowa Metro League (CIML) girls' track meet at Southeast Polk High School. The CIML is one of the six Iowa high school athletic conferences that feed into the regional championships and the state finals.

*Photo by Heidi Zeiger*

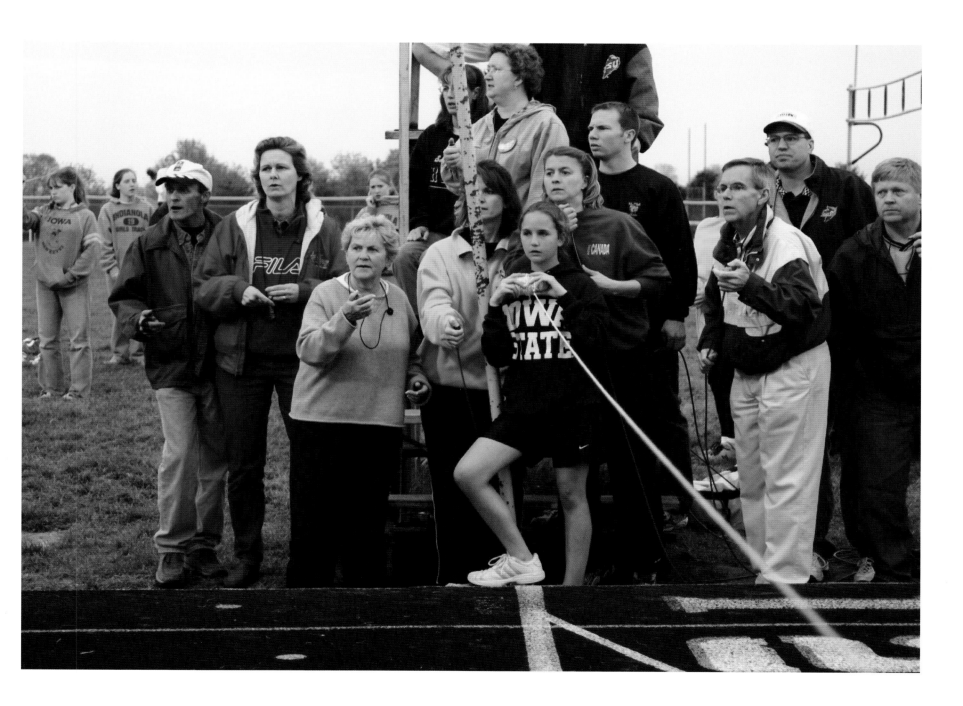

## IOWA CITY

Arnold Kim, an instructor from a local sporting goods store, teaches Zoe Lewis and her brother Ben the fundamentals of slacklining. A distant cousin of tightrope walking, the sport is executed on a piece of nylon webbing strung loosely between two objects. Walking the walk takes balance, strength, and concentration.
***Photo by Brian Ray, The Gazette***

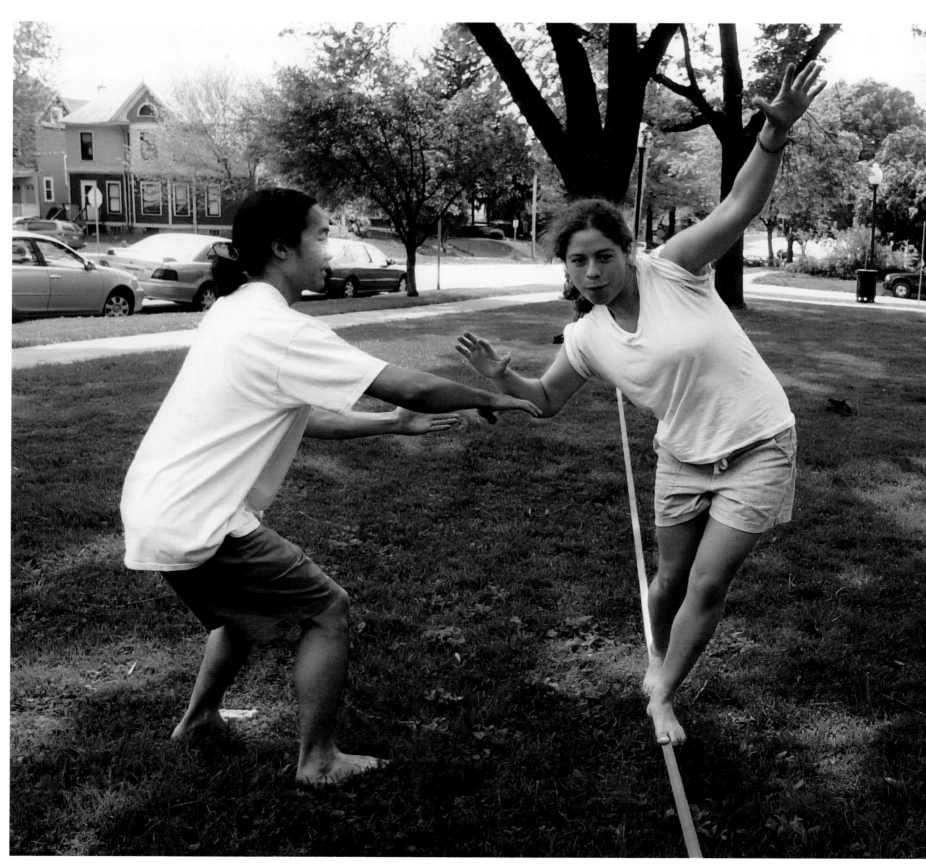

**ORANGE CITY**

After marching in five parades during the annual Tulip Festival, Mallory Richards (foreground) and Morgan Achterhoff tune up their trumpets for number six, the final parade of the day. The MOC-Floyd Valley middle schoolers are aspiring members of the Pride of the Dutchmen Marching Band, one of the nation's top high school bands.
*Photo by David Peterson*

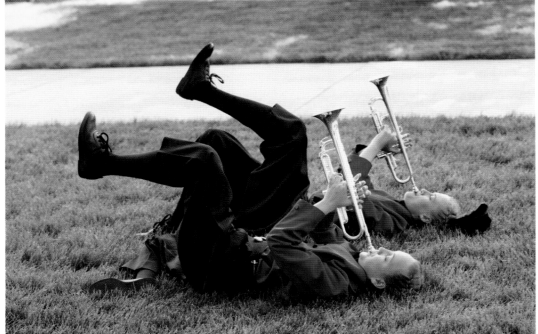

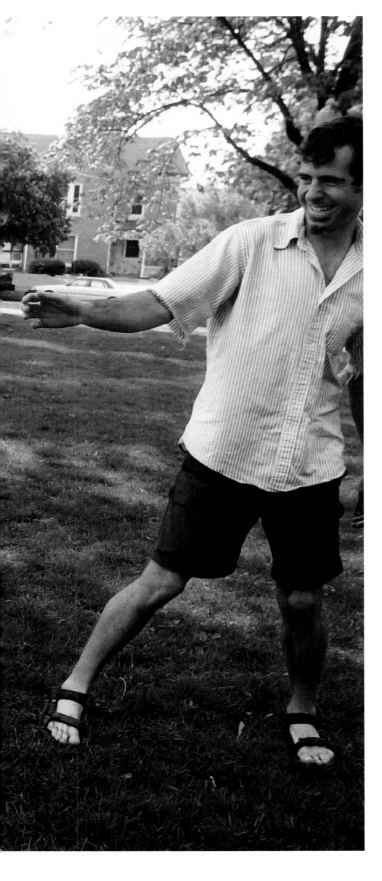

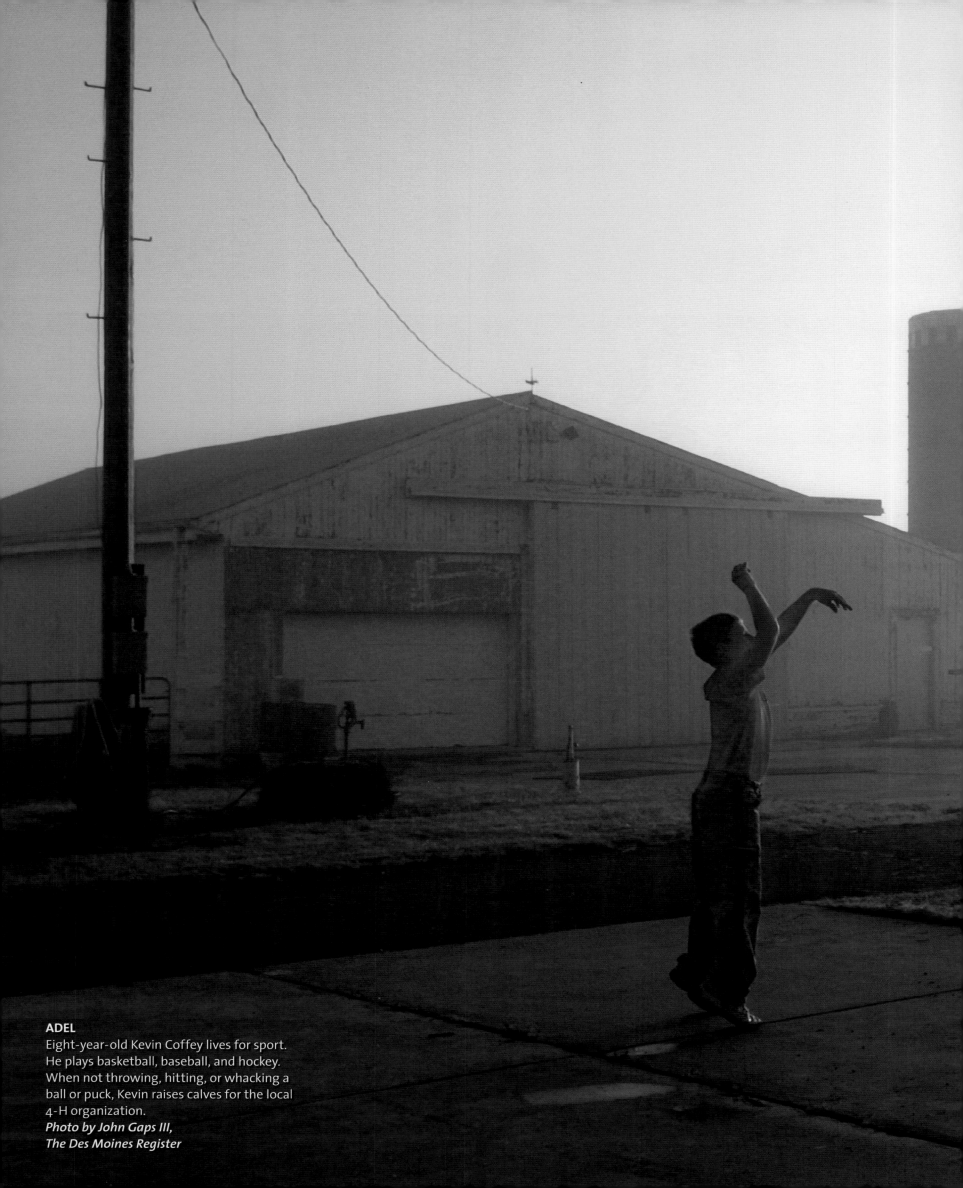

**ADEL**
Eight-year-old Kevin Coffey lives for sport.
He plays basketball, baseball, and hockey.
When not throwing, hitting, or whacking a
ball or puck, Kevin raises calves for the local
4-H organization.
*Photo by John Gaps III,*
*The Des Moines Register*

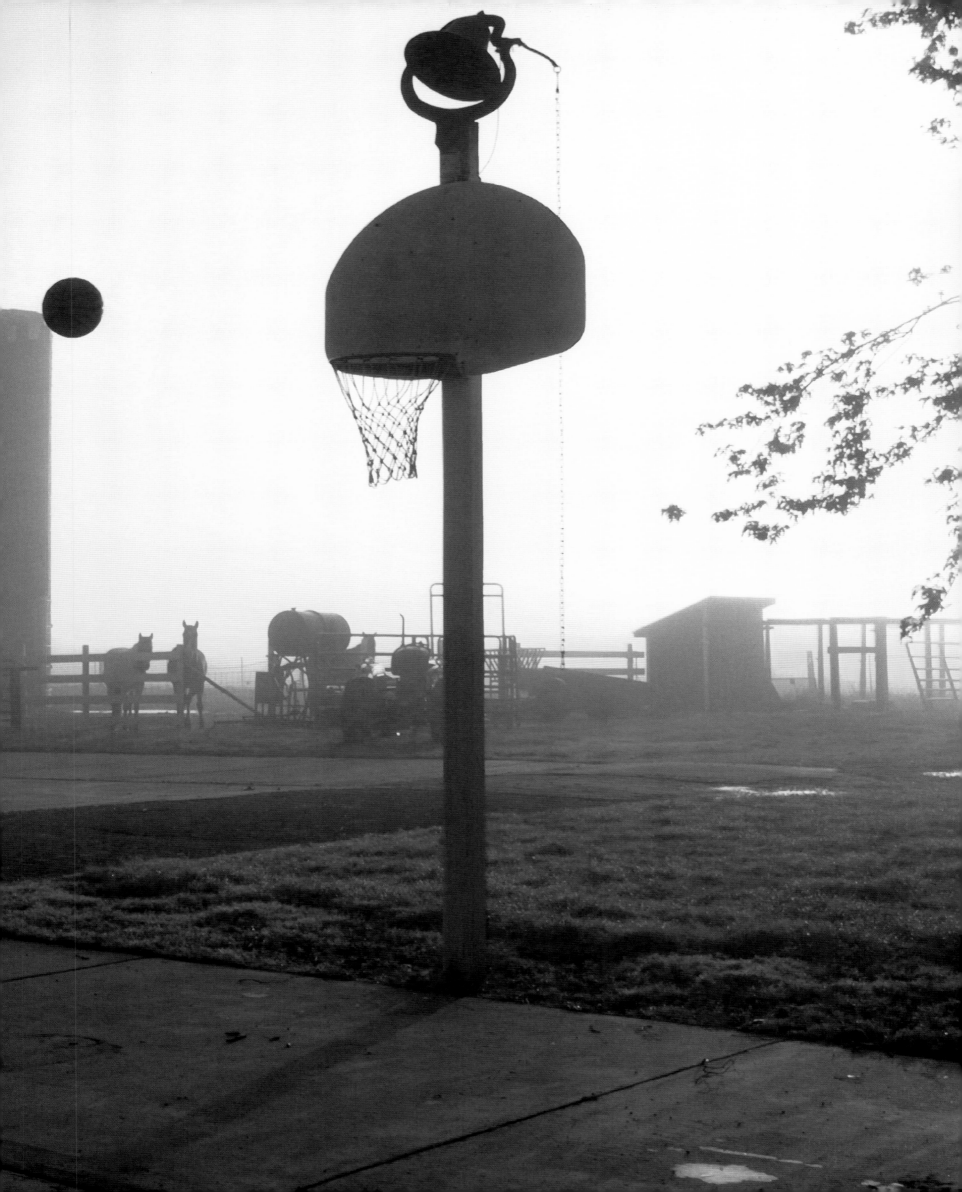

**DES MOINES**

After passing through two simulated biomes—a high alpine zone occupied by a Siberian lynx and a subterranean cave teeming with Egyptian fruit bats—visitors to the Blank Park Zoo arrive in this misting rainforest exhibit. A pacu (right), the piranha's vegetarian cousin, is the main attraction.
*Photos by David Peterson*

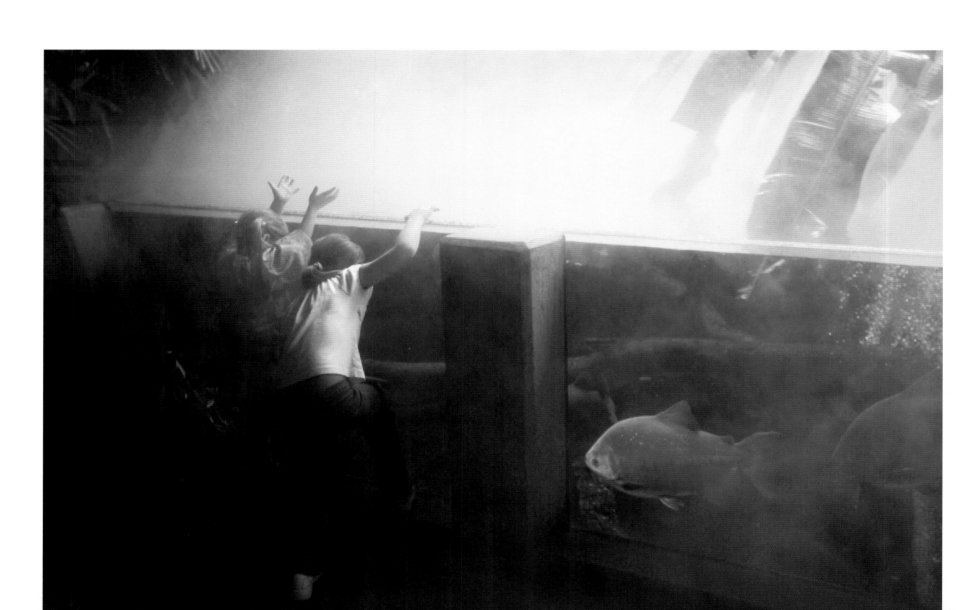

**GREENFIELD**

Small-fry Cody Long (foreground) used a worm and a hook to snag this foot-long bass at a nearby pond, but all three boys, including Gabe Dowden and Keegan Williams, bragged about it. They exhibited their catch to their teacher and kindergarten classmates, who were on a field trip to learn about farm life and fishing.

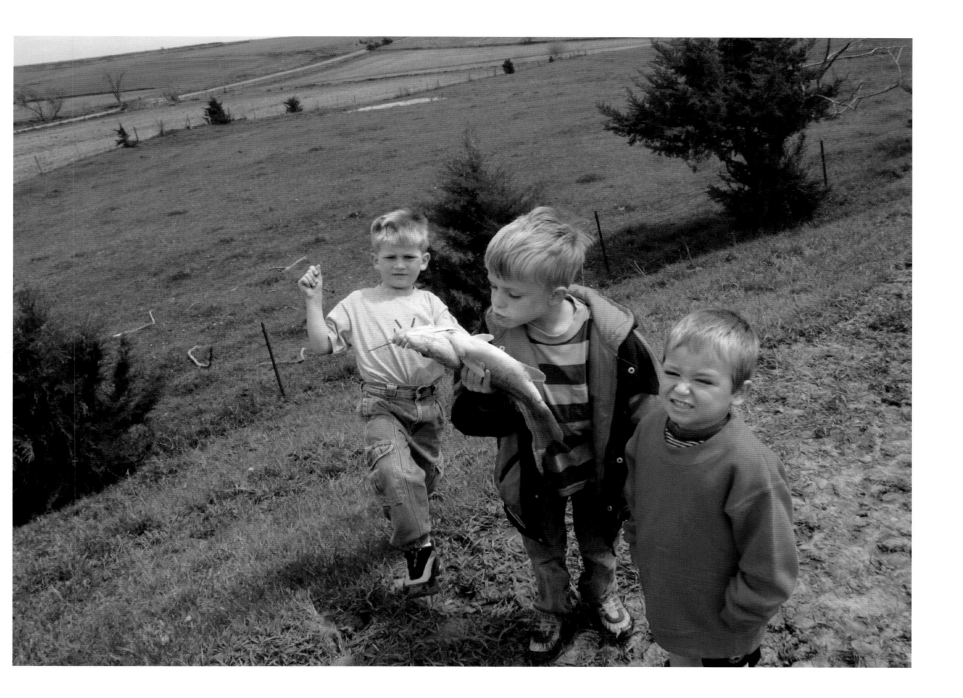

## KNOXVILLE

Professional driver Mike Moore rolls his winged sprint car during a race at the Knoxville Raceway and lives to tell about it. Known as the "Sprint Car Capital of the World," the half-mile, semi-banked oval track started as a weed-strewn venue for quarter horse races in 1954.

**Photos by Rodney White**

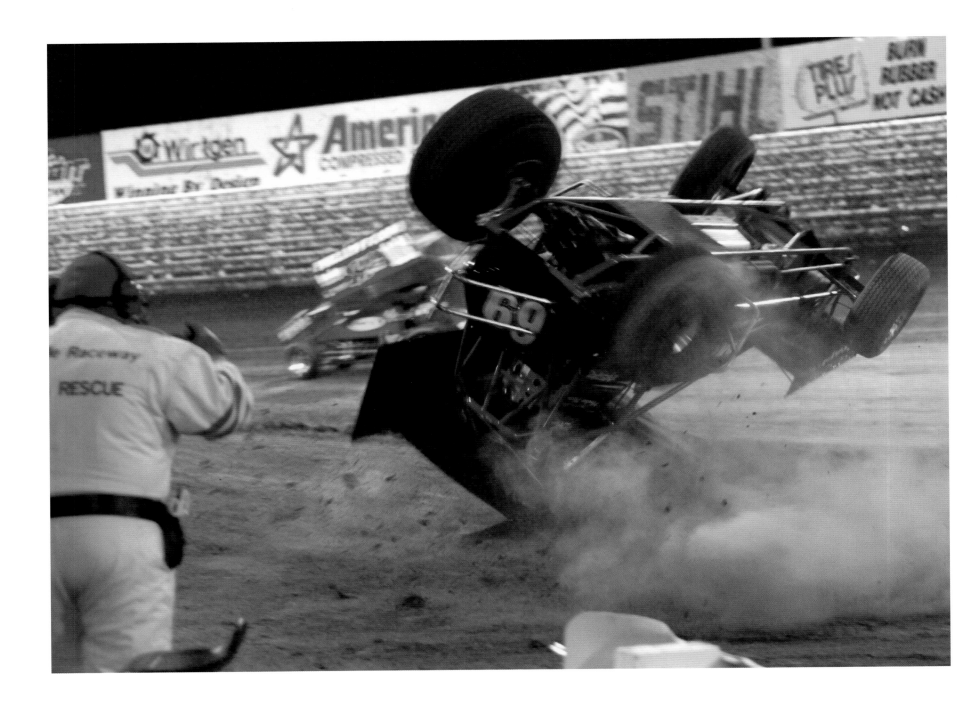

**WEST DES MOINES**

In an effort to earn their Scientist activity badges, Webelo-level Cub Scouts Alex Thompson, R.J. White, and Bryan Zylstra launch model rockets at a local high school. The boys built the solid-fuel rockets from kits during den meetings.

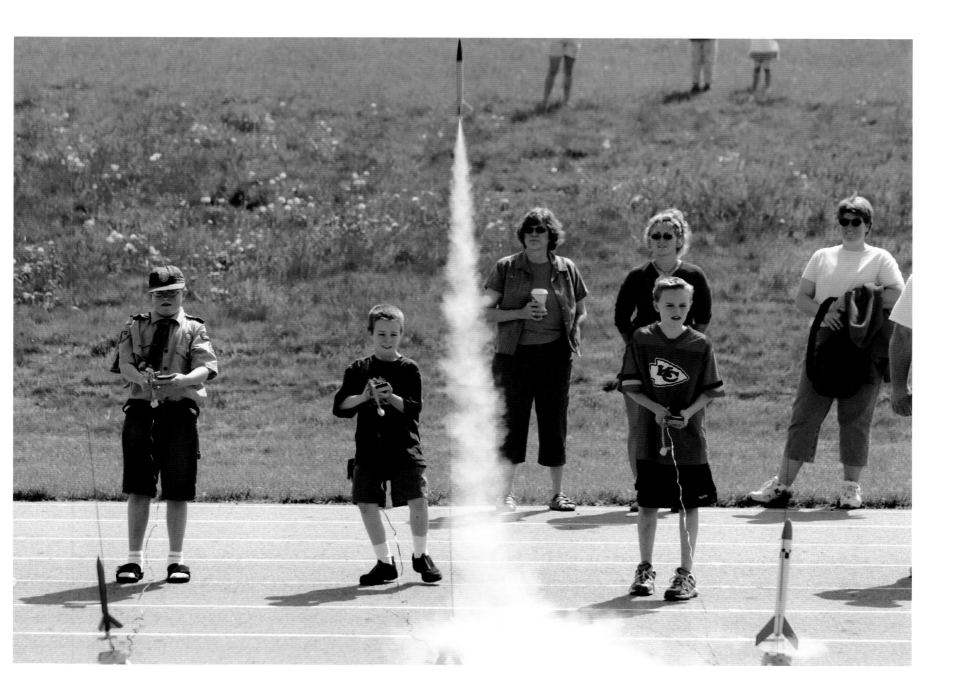

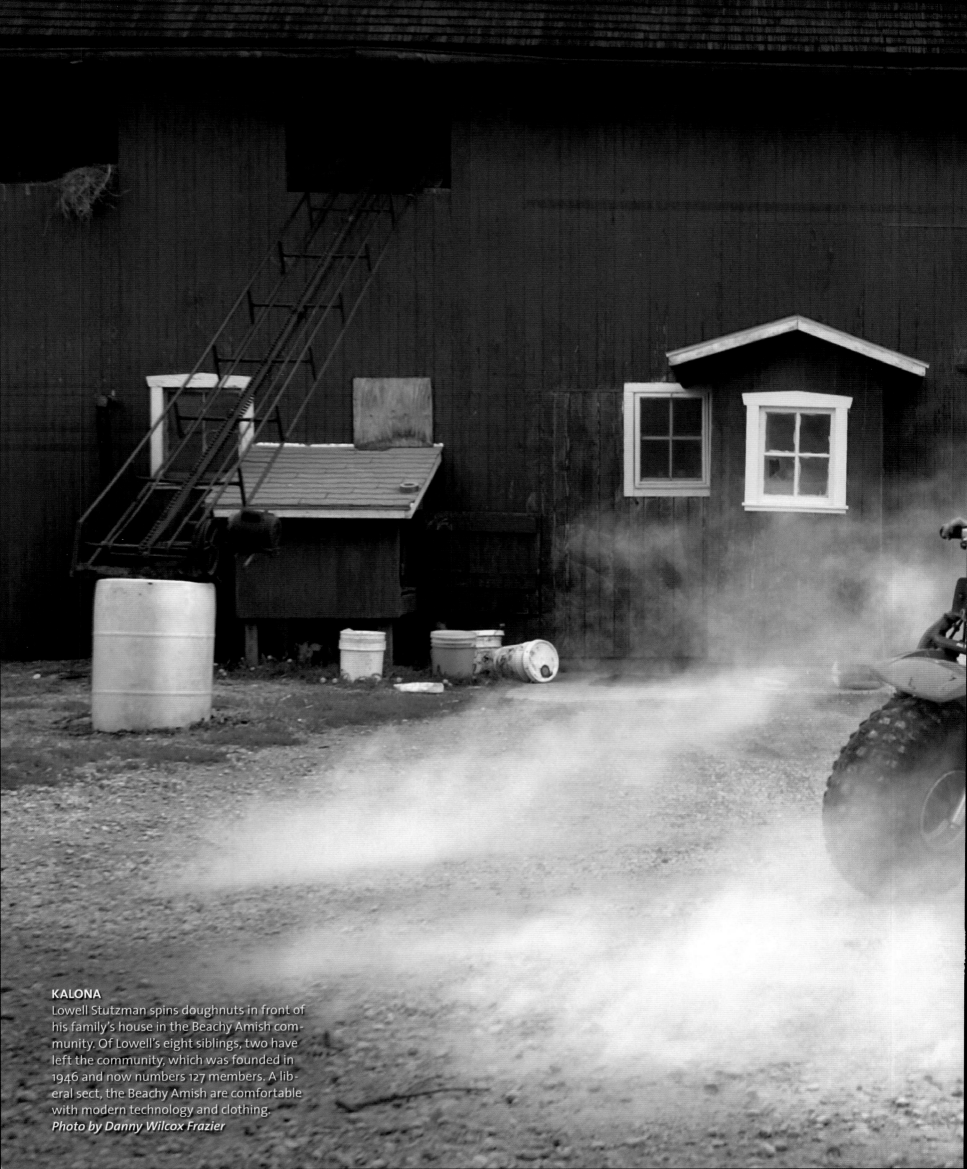

**KALONA**
Lowell Stutzman spins doughnuts in front of his family's house in the Beachy Amish community. Of Lowell's eight siblings, two have left the community, which was founded in 1946 and now numbers 127 members. A liberal sect, the Beachy Amish are comfortable with modern technology and clothing.
*Photo by Danny Wilcox Frazier*

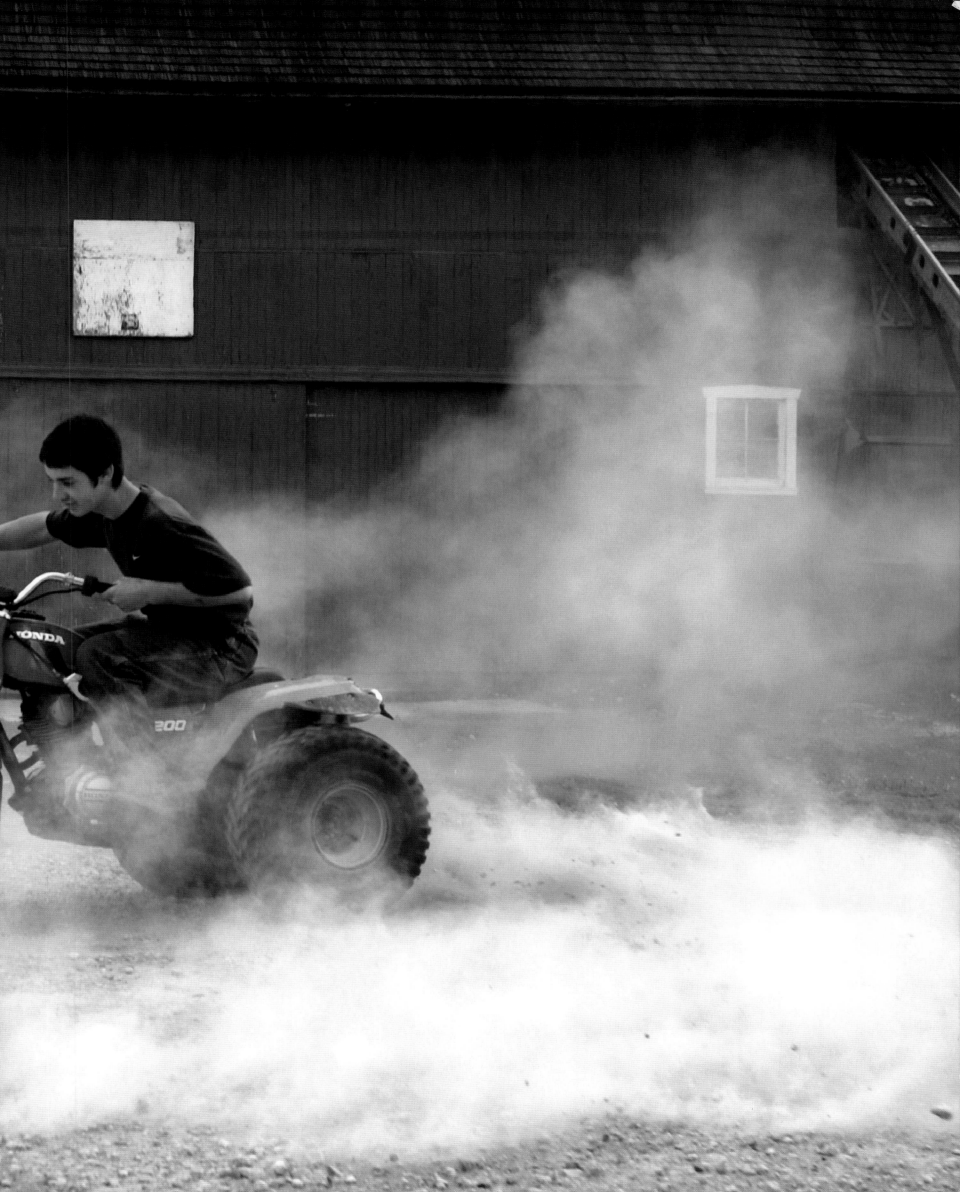

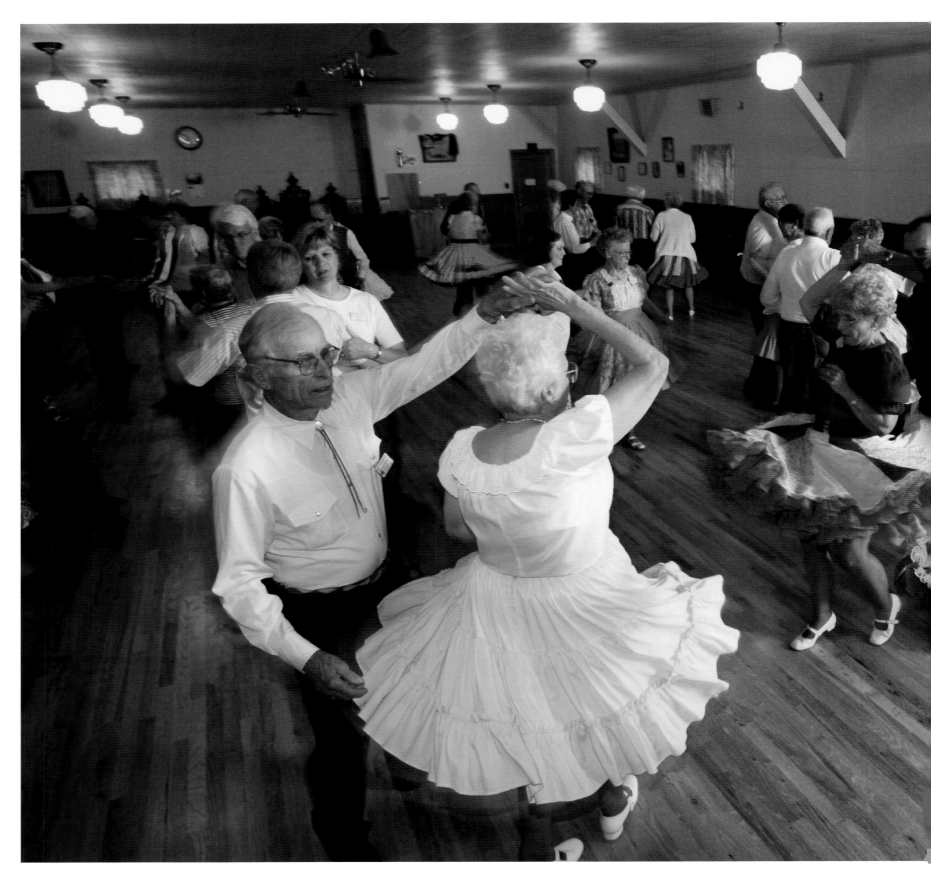

**WEAVER**
Pettipants and cancan skirts fly at the Organization of Odd Fellows Hall on Tuesday nights. The Circle Square B Promenaders, a group of mostly older couples, come here to practice their right and left grands and allemands. "It's really addictive," says Pat Christe (far right.)
*Photo by John Gaines, The Hawk Eye*

**DAVENPORT**

Although it is good for kayaking, the Mississippi regularly floods Davenport. Still, residents say they prefer open access to the river and occasionally dealing with flood damage to having their waterfront views cut off by dikes and levees.

*Photo by Charlie Neibergall, Associated Press*

**DES MOINES**

Della Pierce (left), 95, tees up every Wednesday at the Woodland Hills golf course. She's been playing the club's nine holes for 42 years. What she lacks in length off the tee, she makes up for in her chip and putt game, Pierce says.

*Photo by David Peterson*

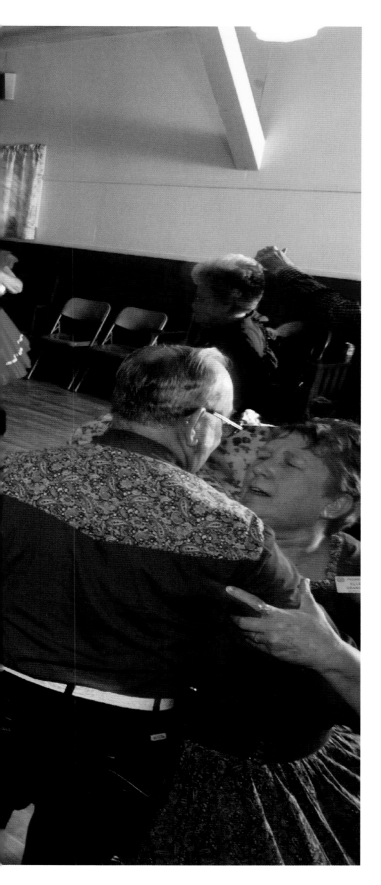

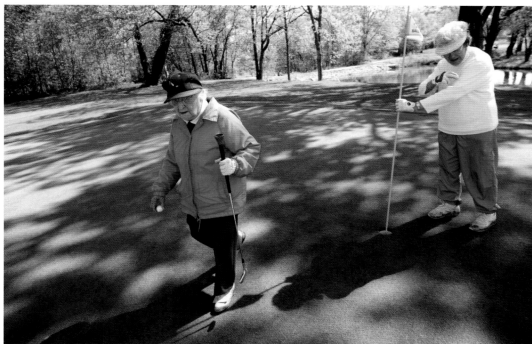

## CLIVE

Brewskis for a good cause: "Clive after Five" is a weekly summer event hosted by the Clive Jaycees to raise money for local and national charities. Each Friday from 5 to 7:30 p.m. at Linnan Park, $6 buys three drinks and live entertainment. Since 1999, the local Jaycees have donated $250,000 to charity.

*Photo by Heidi Zeiger*

## BURLINGTON

The Dirty Dozen Power Boat Club is the antidote to the private Shoquoquon Boat Club, two miles farther down the Mississippi River. A group of speedboaters and their friends—including Lawanna Greenstreet and Terry Houseal—gather here on Friday evenings for conversation, beer, and cards. The "clubhouse" is located in an old storage barn next to the river.

*Photo by John Gaines, The Hawk Eye*

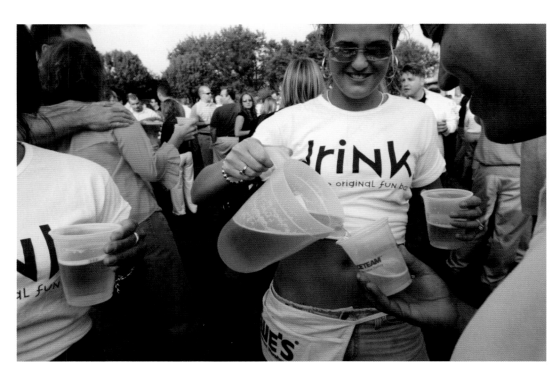

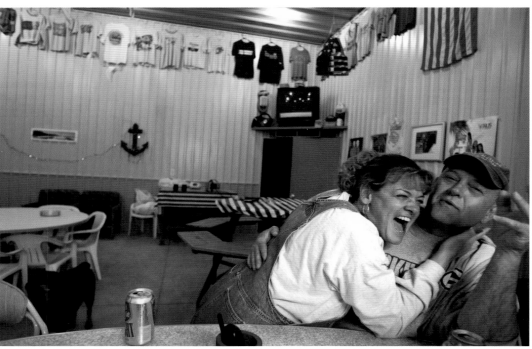

**DES MOINES**

"It's in the sauce," says Harry Flipping, explaining Down South Barbeque's success. Offering free samples of sweet Alabama boneless ribs helps, too. The mobile restaurant is the top-selling barbecue vendor at the Valley Junction Farmers Market, held every Sunday in West Des Moines.
*Photo by David Peterson*

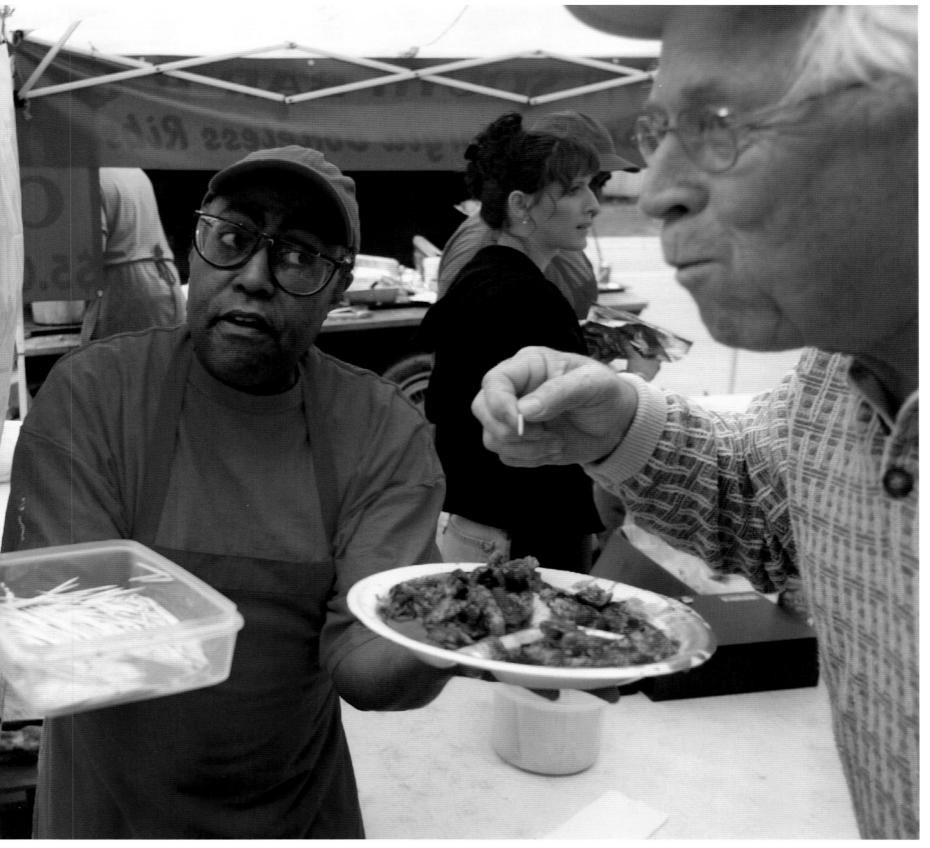

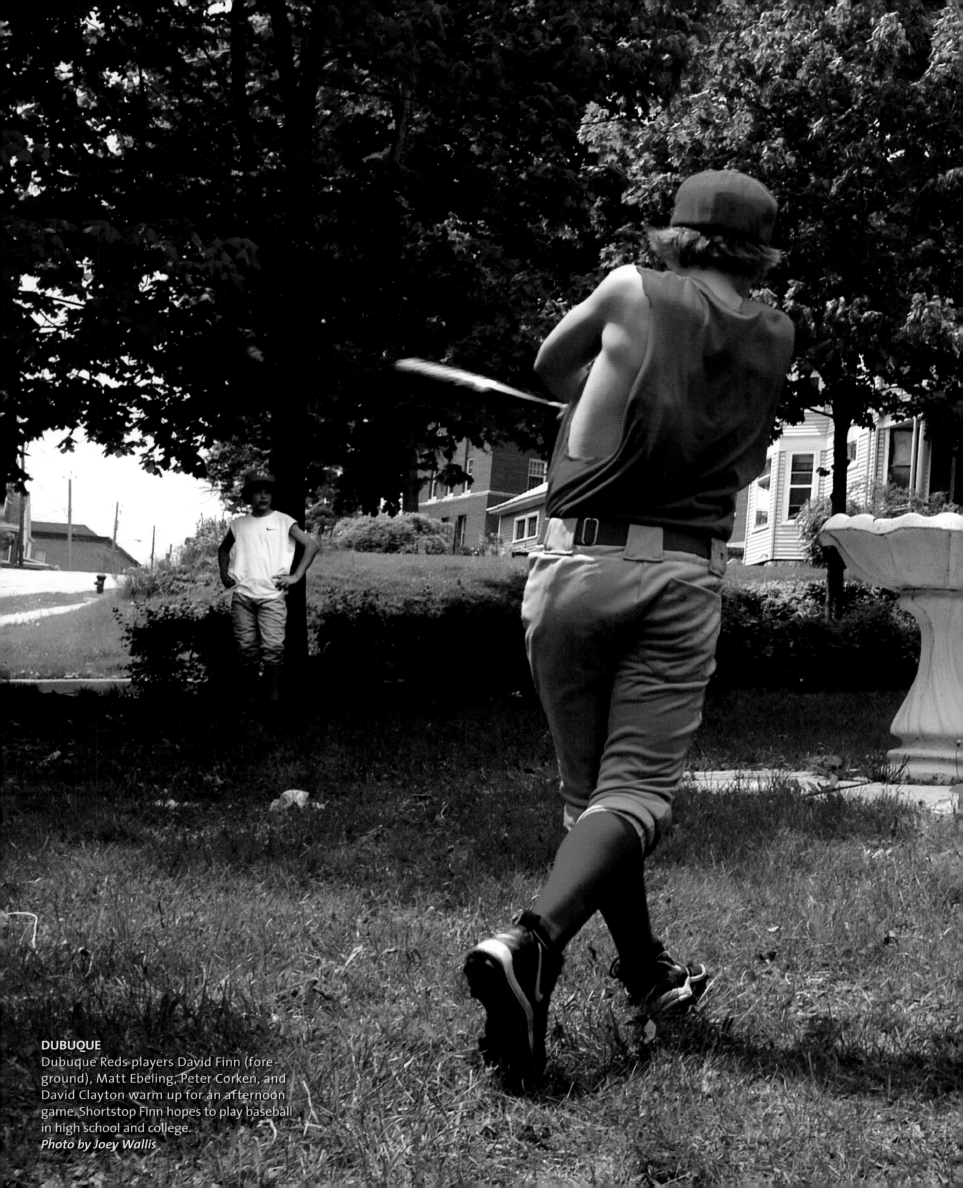

**DUBUQUE**
Dubuque Reds players David Finn (foreground), Matt Ebeling, Peter Corken, and David Clayton warm up for an afternoon game. Shortstop Finn hopes to play baseball in high school and college.
*Photo by Joey Wallis*

**DES MOINES**

Six-year-old Kaytlyn MacVilay of the Young Taidem Dance Group waits in the wings at the Iowa Asian Heritage Festival. In November of 1975, Governor Robert D. Ray invited the Taidem people, refugees from North Vietnam and Laos, to resettle in Iowa. Since then, the state has become home to 90 percent of Taidem and is called the "Taidem Capital of the World."

*Photo by Heidi Zeiger*

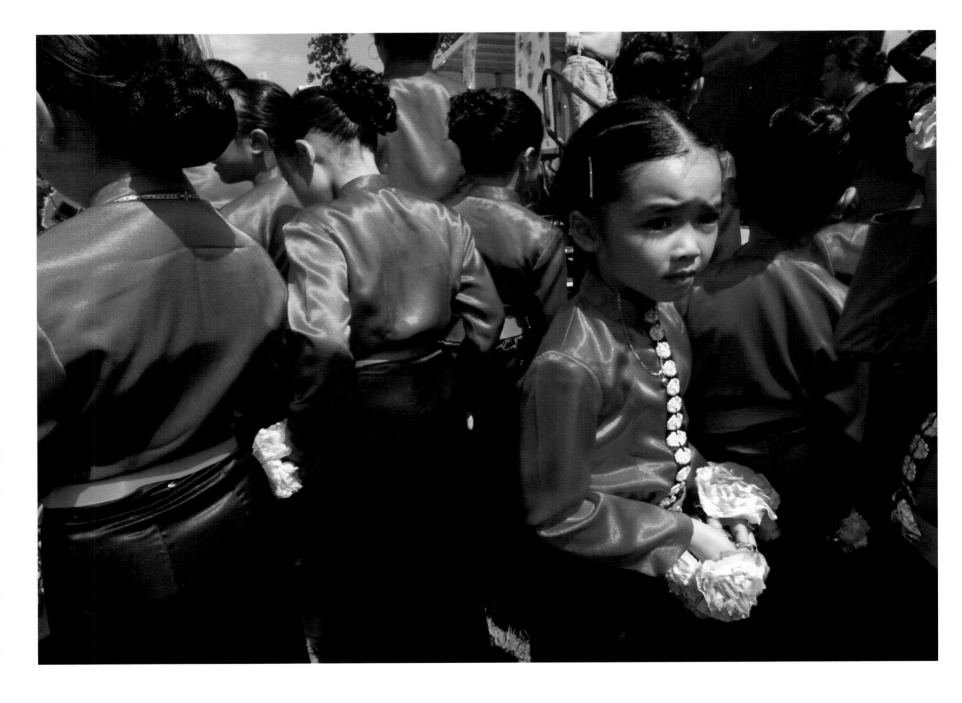

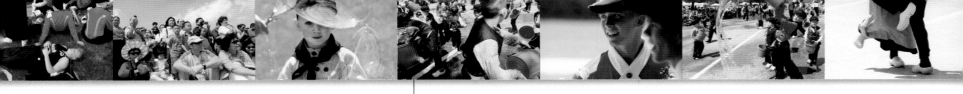

## ORANGE CITY

After a lunch of *poffertjes* (Dutch pancakes), children don their wooden *klompen* and head downtown for the Tulip Festival's street cleaning event. Every year, the town crier declares the streets unfit for the Tulip Queen and asks residents to wash and sweep them clean. For the under-18 crowd, the civic free-for-all includes a water fight.

*Photo by David Peterson*

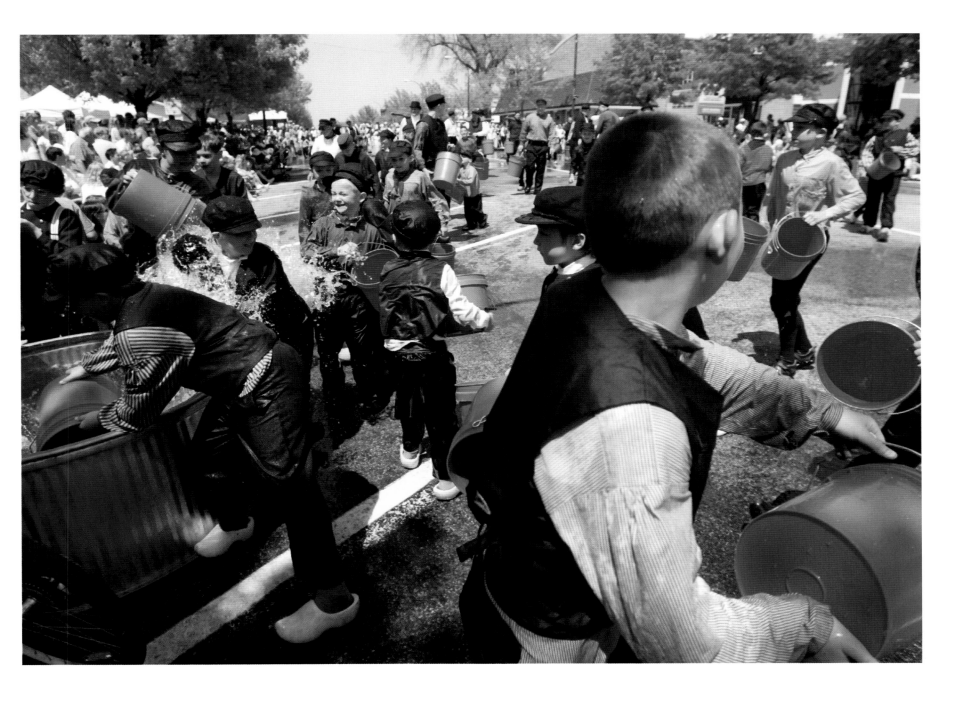

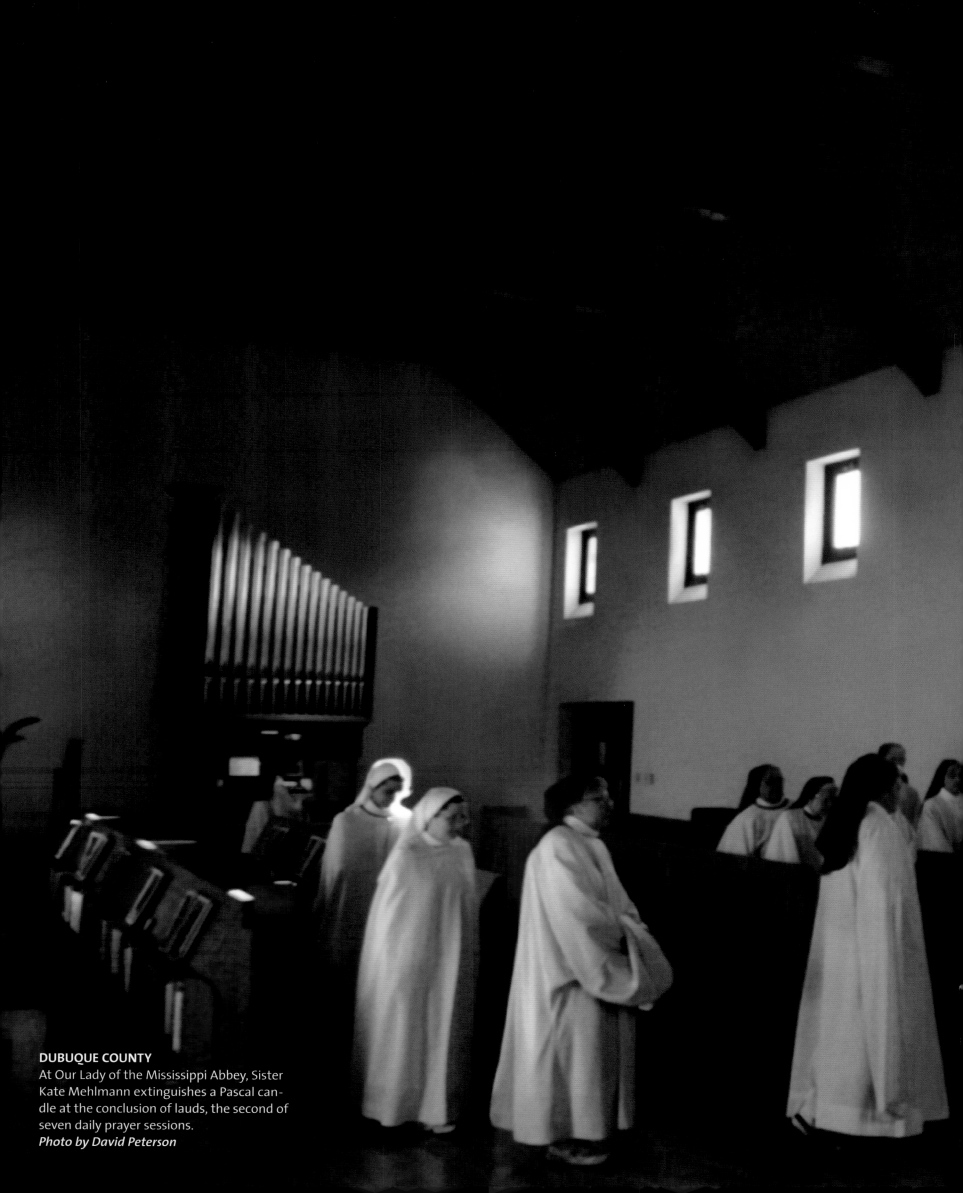

**DUBUQUE COUNTY**
At Our Lady of the Mississippi Abbey, Sister Kate Mehlmann extinguishes a Pascal candle at the conclusion of lauds, the second of seven daily prayer sessions.
*Photo by David Peterson*

Reason To Believe

PEOSTA
Brother Ephrem Poppish tolls the chapel bell, calling the 36 monks living at the New Melleray Abbey to morning mass. The monastery's spacious, neo-Gothic complex affords the monks plenty of room for solitude and contemplation.
*Photo by Mark Hirsch, Telegraph Herald*

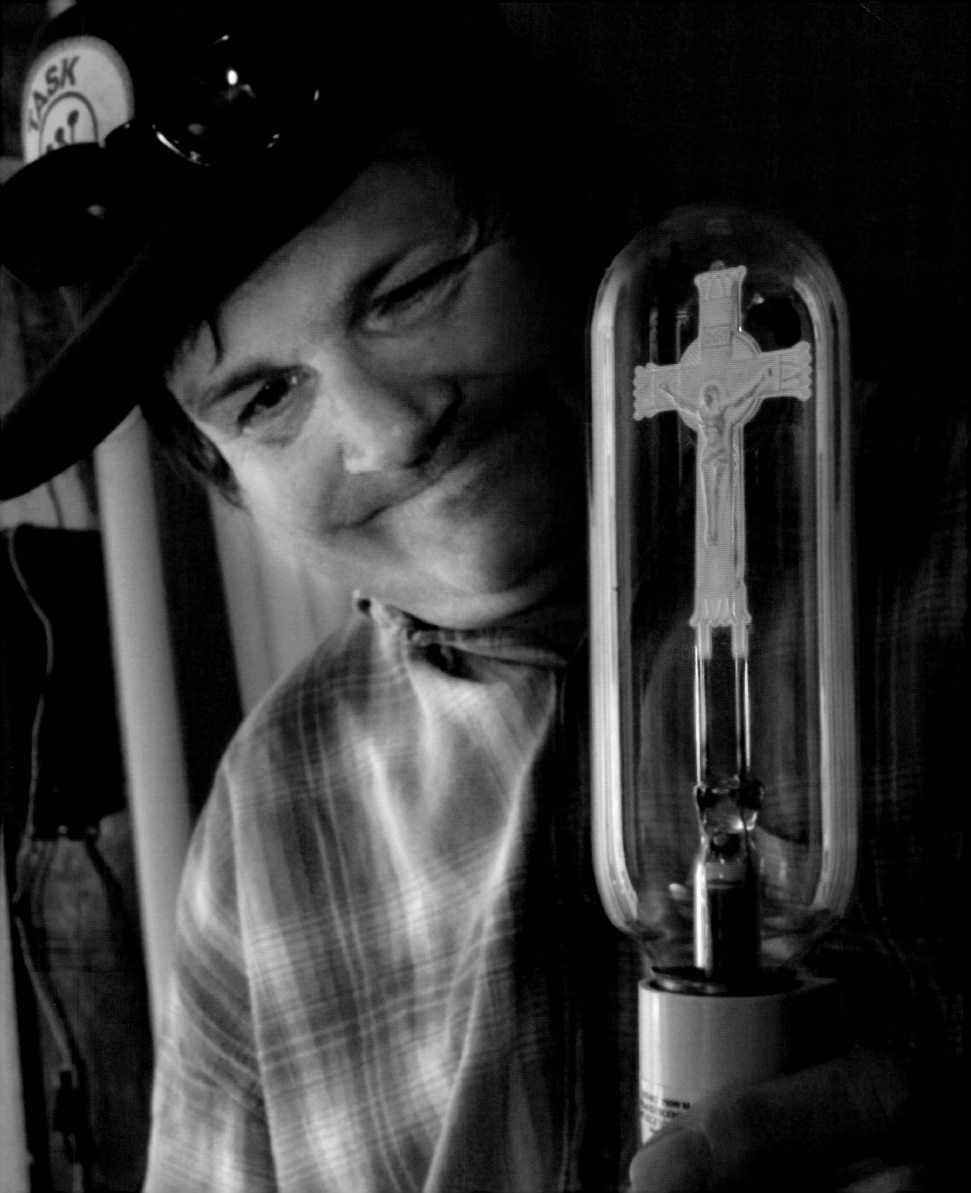

### DUBUQUE

"This one cost me $45 and was made in 1920," says Ray Hutchinson of his vintage cross lightbulb. Born with only partial sight in one eye, Hutchinson was dazzled by Christmas tree lights as a child and has pursued his passionate interest in electric bulbs. He calls antique shops for treasures like the rare 1897 Edison National lightbulb in his collection.
*Photo by Joey Wallis*

### INDIANOLA

Groundskeeper Richard Simmons trims grass in the Gentle Giants area of the LovingRest Funeral Home, where 25 horses have been laid to rest. The cemetery offers burial services for dogs, cats, rabbits and—in a free, unmarked graveyard—fish, gerbils, and mice.
*Photo by Charlie Neibergall,
Associated Press*

### CLIVE

From his billboard/mobile home in the Menards parking lot, Willard Van Zandt spends the afternoon testifying to anyone within earshot. "God told me to build this bus," he says.
*Photo by John Gaps III,
The Des Moines Register*

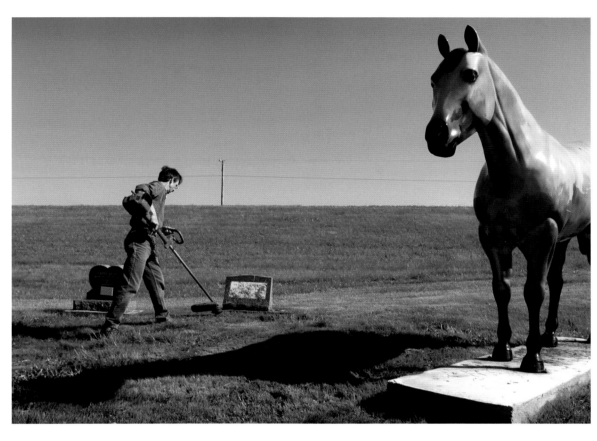

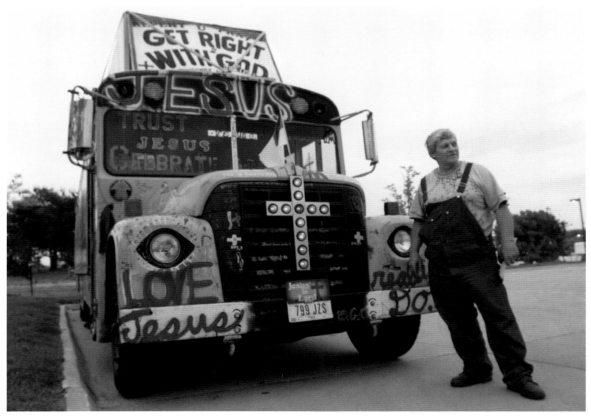

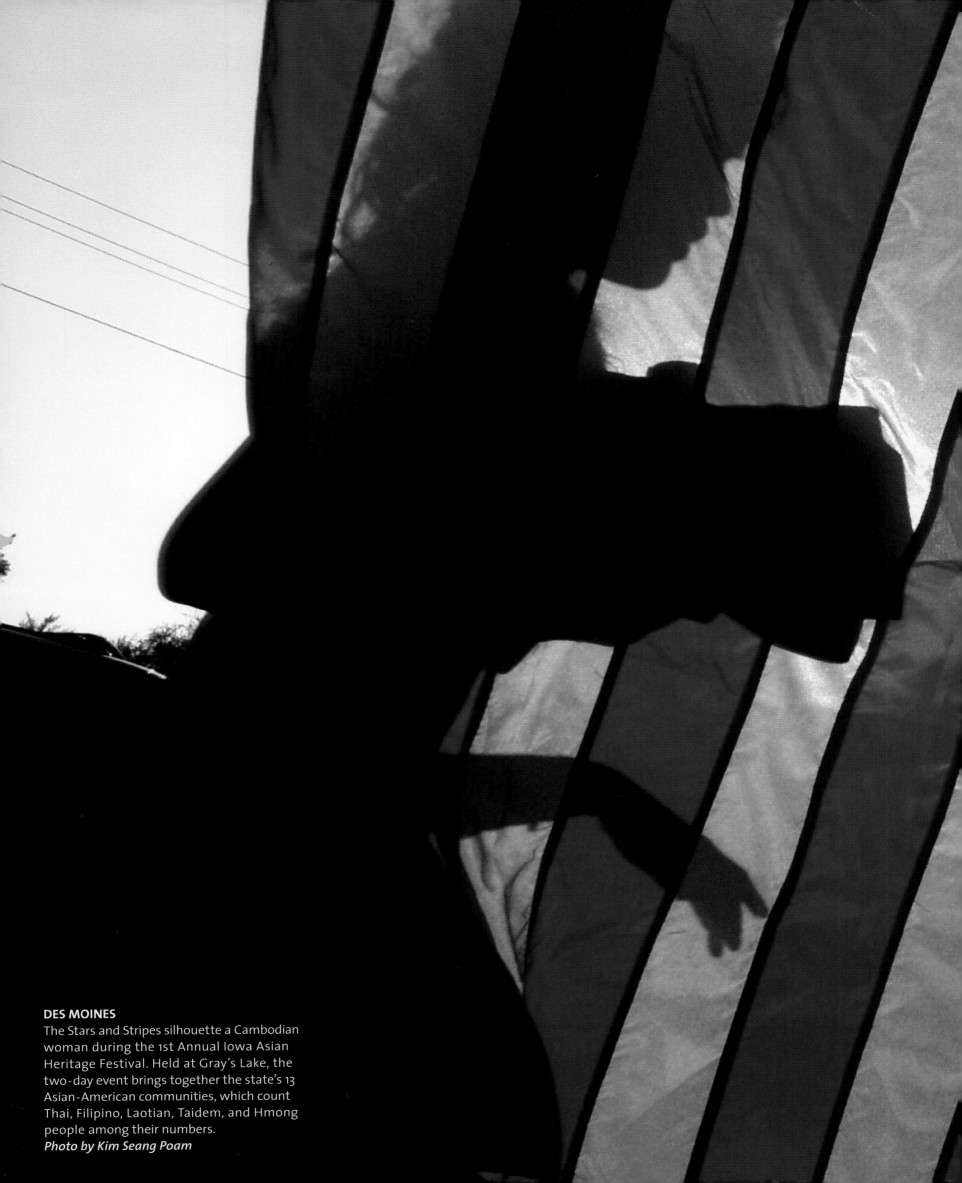

**DES MOINES**
The Stars and Stripes silhouette a Cambodian woman during the 1st Annual Iowa Asian Heritage Festival. Held at Gray's Lake, the two-day event brings together the state's 13 Asian-American communities, which count Thai, Filipino, Laotian, Taidem, and Hmong people among their numbers.
*Photo by Kim Seang Poam*

At the All Saints Catholic Church, Alice Wade places a garland on the Virgin Mary for the annual May Crowning ceremony. Church members bestow fresh flowers on the Virgin's shrine throughout the month.
*Photo by Charlie Neibergall, Associated Press*

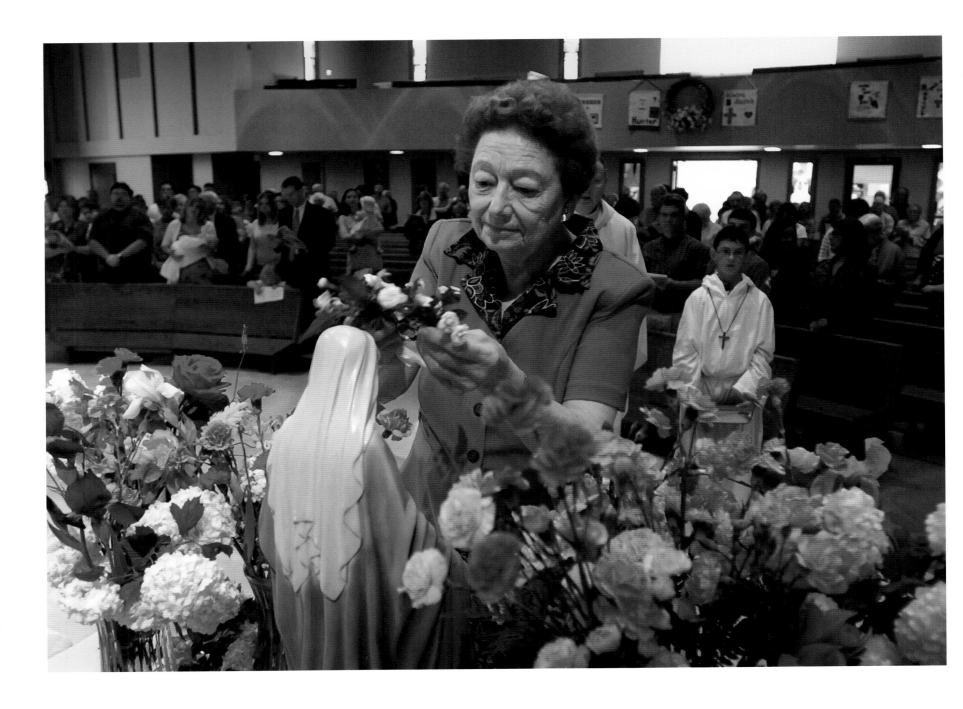

## MARENGO

Fallen angels: Discounted seraphim flutter in the window of Washington Street Exchange, where the motto is "New, Used, and Indifferent." Since opening their shop in 1994, Bill and Lois Geary have been scouring the state's garage and estate sales, flea markets, and auction houses for antiques, sporting goods, and clothing to add to their pack-rat's paradise.

*Photo by Danny Wilcox Frazier*

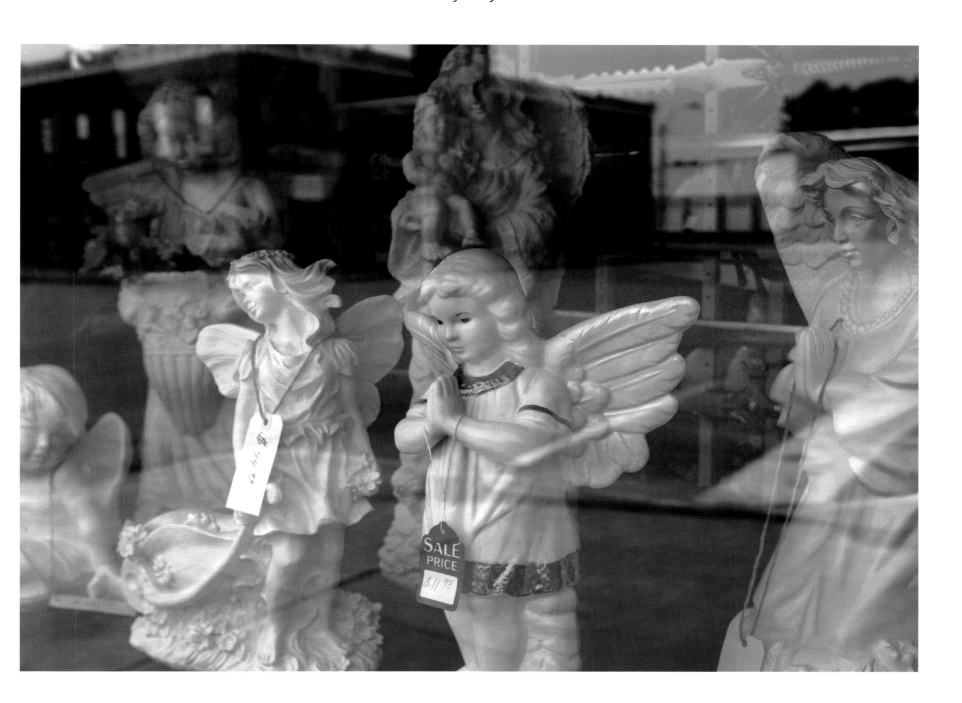

**DUBUQUE COUNTY**
Sister Grace Remington rings the chapel bell, calling to prayer the 32 nuns who reside at the Our Lady of the Mississippi Abbey.
*Photos by David Peterson*

**DUBUQUE COUNTY**
A write-up in the *Washington Post* food section and a feature segment on the *Food Network* made the Cistercian abbey's caramels famous. In 2003 the abbey sold more than $500,000 worth of caramels, mints, and truffles—enough to support its operations.

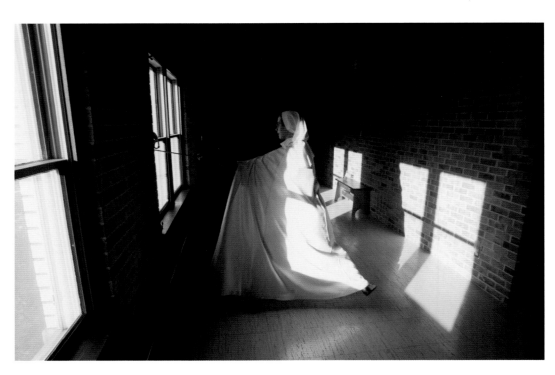

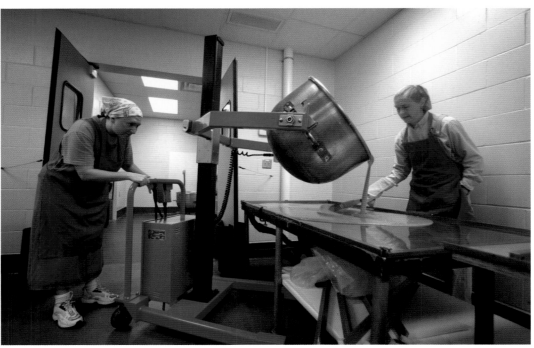

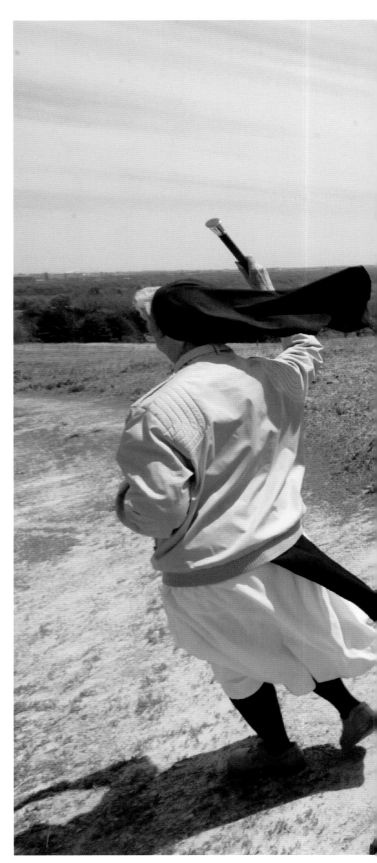

**DUBUQUE COUNTY**

Abbess Gail Fitzpatrick douses their fields with holy water on St. Isidore's feast day. The nuns grow organic oats, corn, and soybeans on the 585-acre estate 15 miles outside of Dubuque. Their yield is sold to soymilk producers, oatmeal manufacturers, and organic livestock farmers.

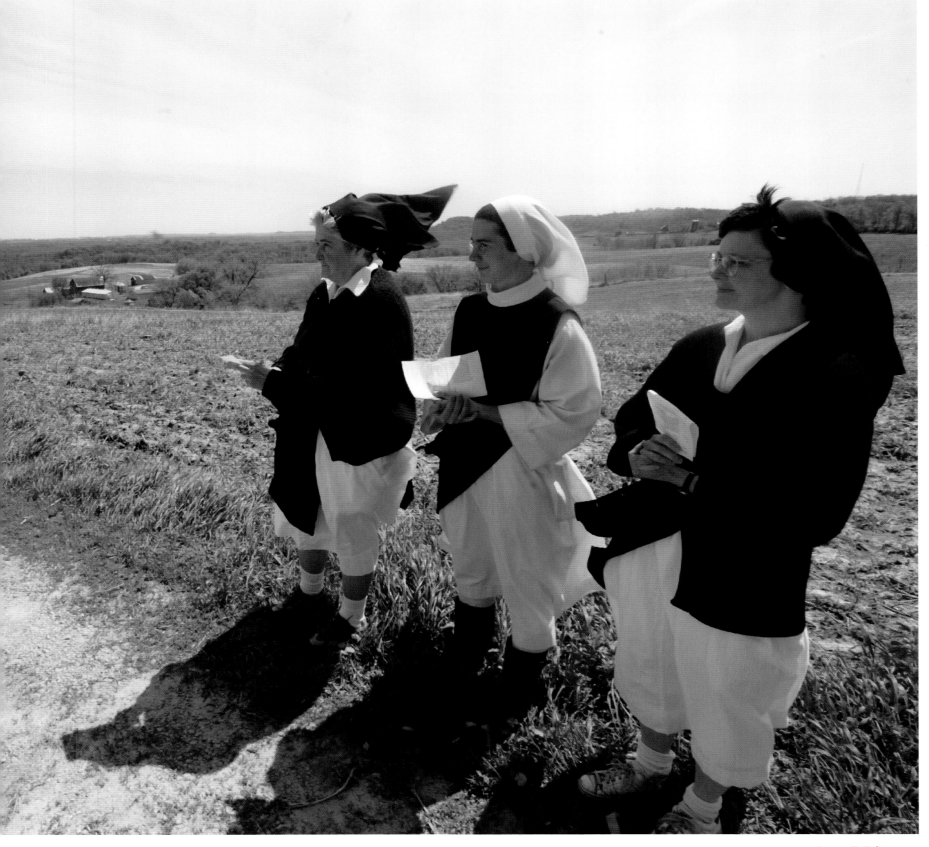

**MT. CARMEL**

The end of an era: Christ the King Elementary School, built in 1912, was the home of Catholic education in Carroll County. The school has only 70 students and was scheduled to close at the end of the 2003 school year. Students will attend nearby Kuemper Catholic Grade School.
*Photo by Jeff Storjohann*

**MT. CARMEL**

Three servers get ready for mass at the 96-year-old Our Lady of Mt. Carmel Catholic Church. It will be the last mass before the closing of the affiliated Christ the King Elementary School. Both church and school share a gentle hill in the center of this small community.
*Photo by Jeff Storjohann*

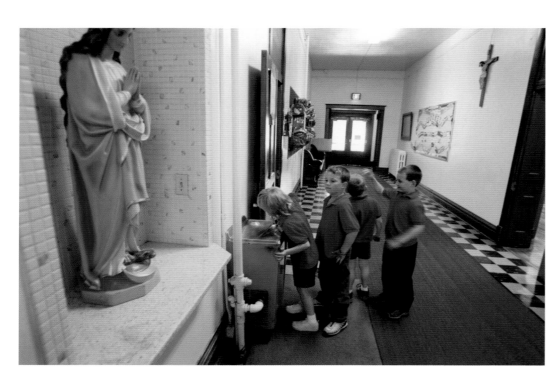

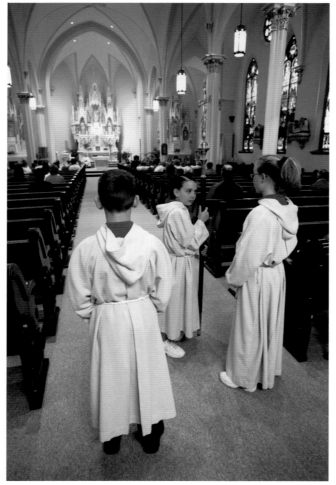

**BENTONSPORT**

Dynnette Smith helps her sons Tanner, Ty, and Tel (all named after Louis L'Amour characters) get on the same page before the opening hymn at the Bentonsport Presbyterian Church. Smith is the church's pianist during the summer months, when the unheated building is warm enough for services.
*Photo by John Gaines, The Hawk Eye*

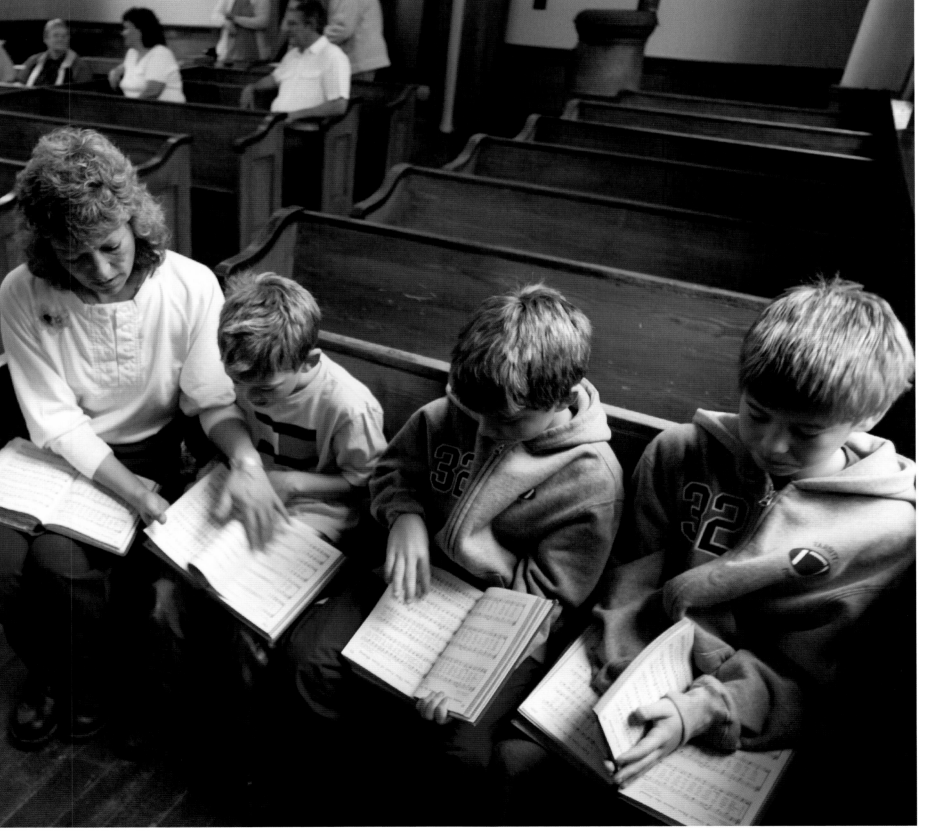

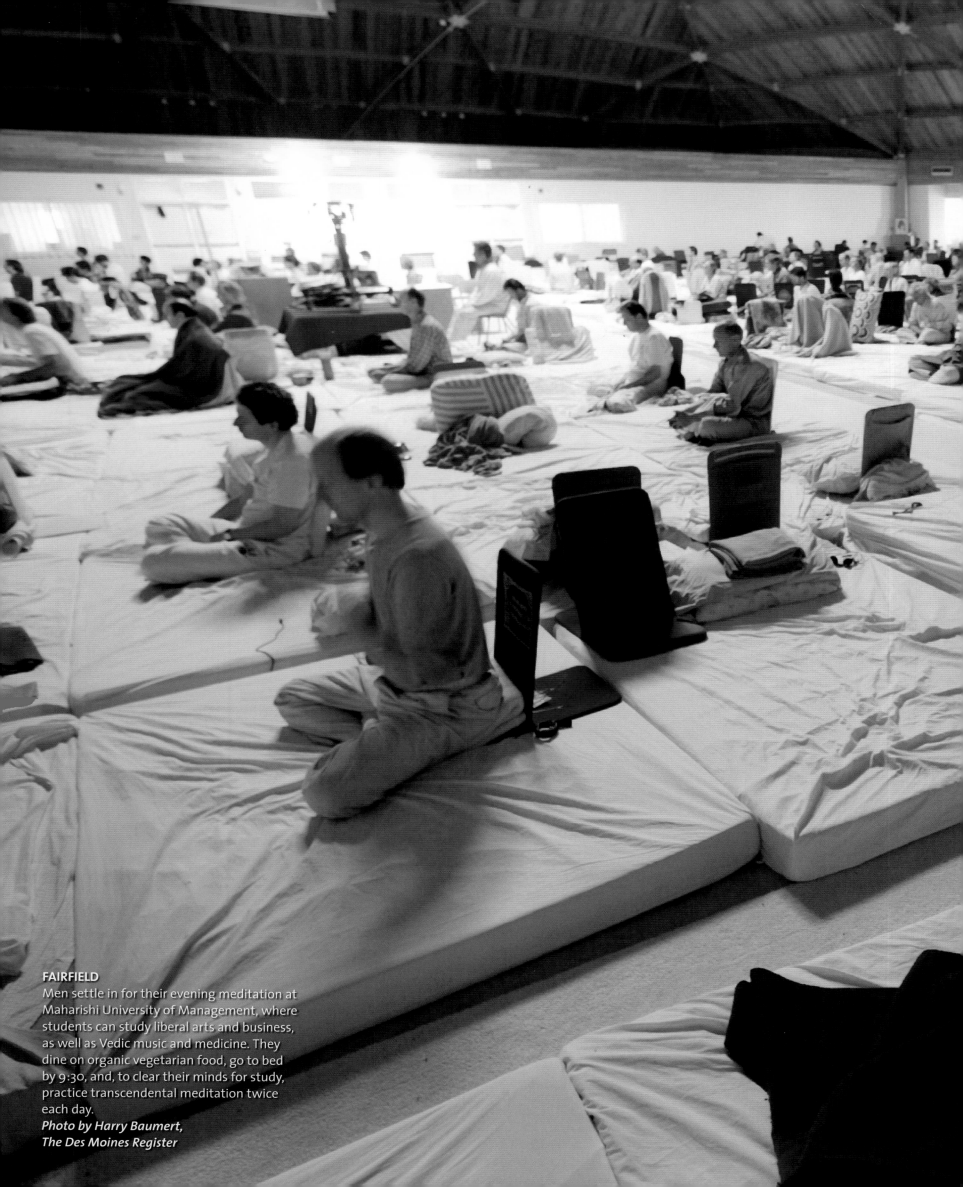

**FAIRFIELD**
Men settle in for their evening meditation at Maharishi University of Management, where students can study liberal arts and business, as well as Vedic music and medicine. They dine on organic vegetarian food, go to bed by 9:30, and, to clear their minds for study, practice transcendental meditation twice each day.
*Photo by Harry Baumert,*
*The Des Moines Register*

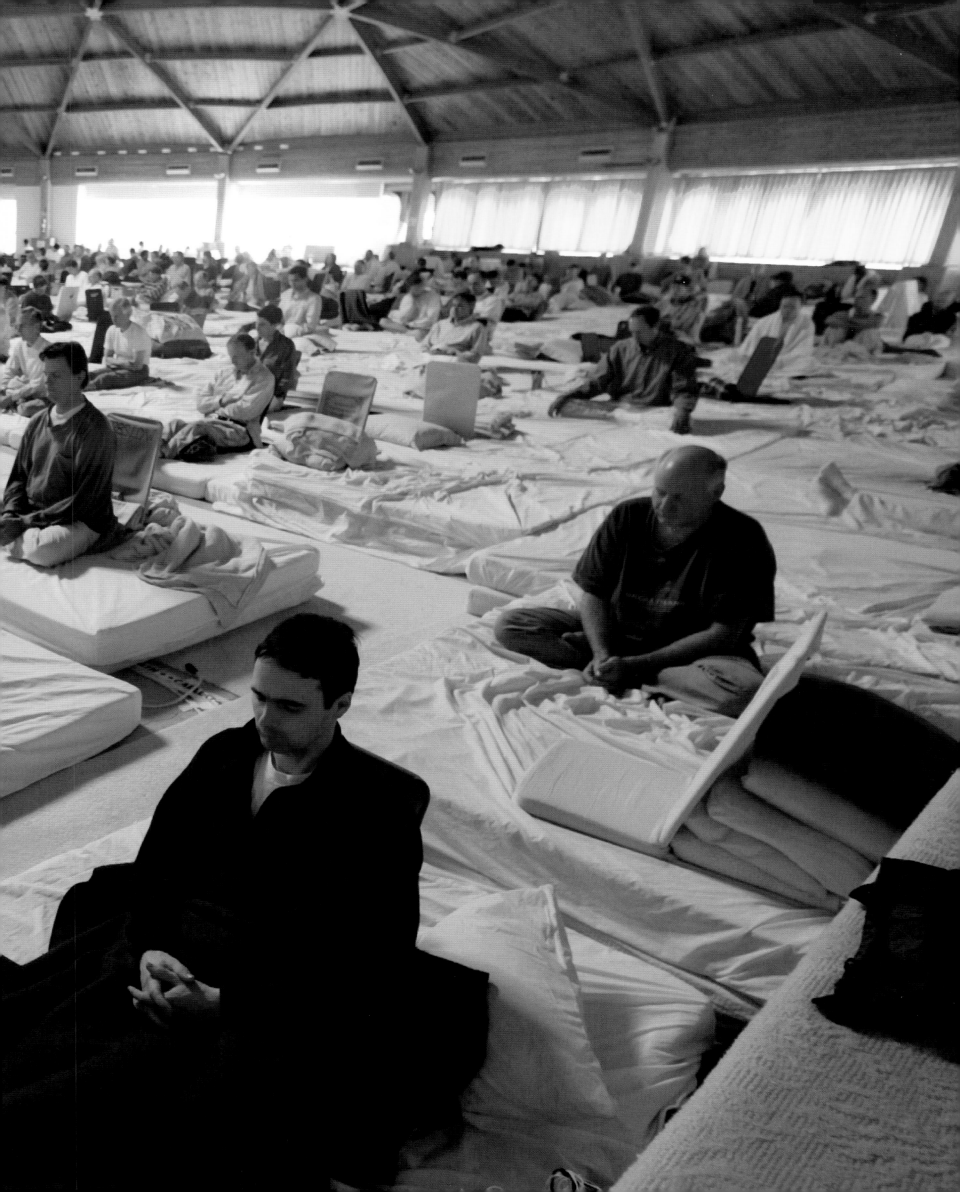

## IDA GROVE

Prominent Iowa businessman Byron Godbersen is laid to rest at the Ida Grove Cemetery. Godbersen was a prolific inventor; his creations include hydraulic hoists for farm wagons and the ubiquitous ShoreLand'r boat trailers. In recognition of Godbersen's military service, an American Legion Honor Guard attended him at his funeral.
*Photo by Don Poggensee*

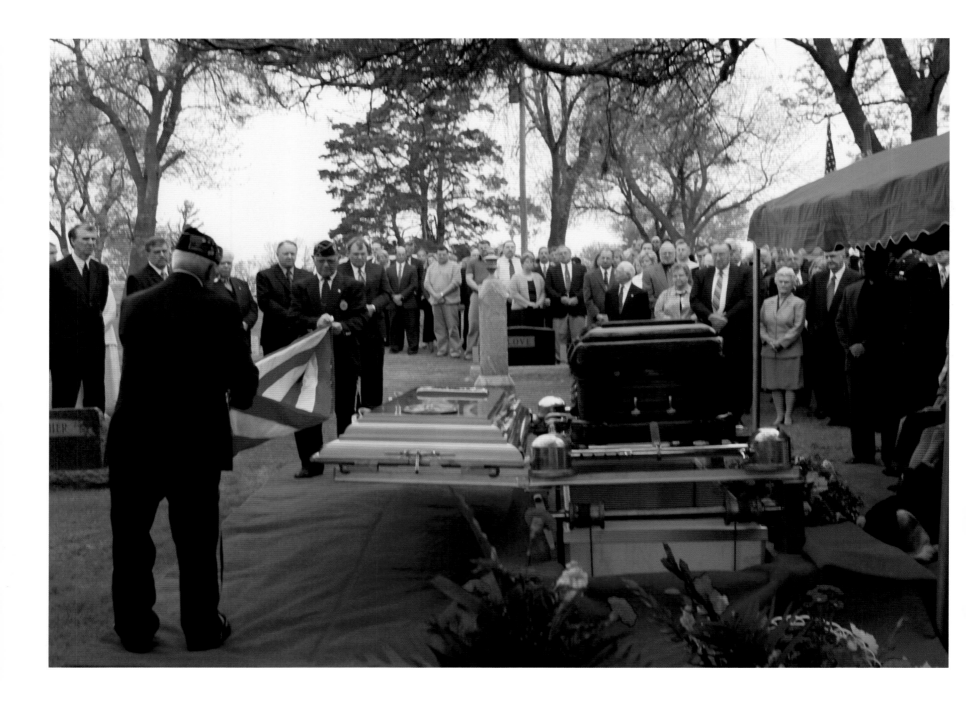

**ELKADER**

Doctors told Amy Foels she would never walk again after a November 2002 car accident left her paralyzed from the waist down. But the determined Central High School senior underwent six months of intense physical therapy and proved them wrong: With the help of crutches and a brace, she walked across the stage to receive her diploma.

*Photo by Clint Austin*

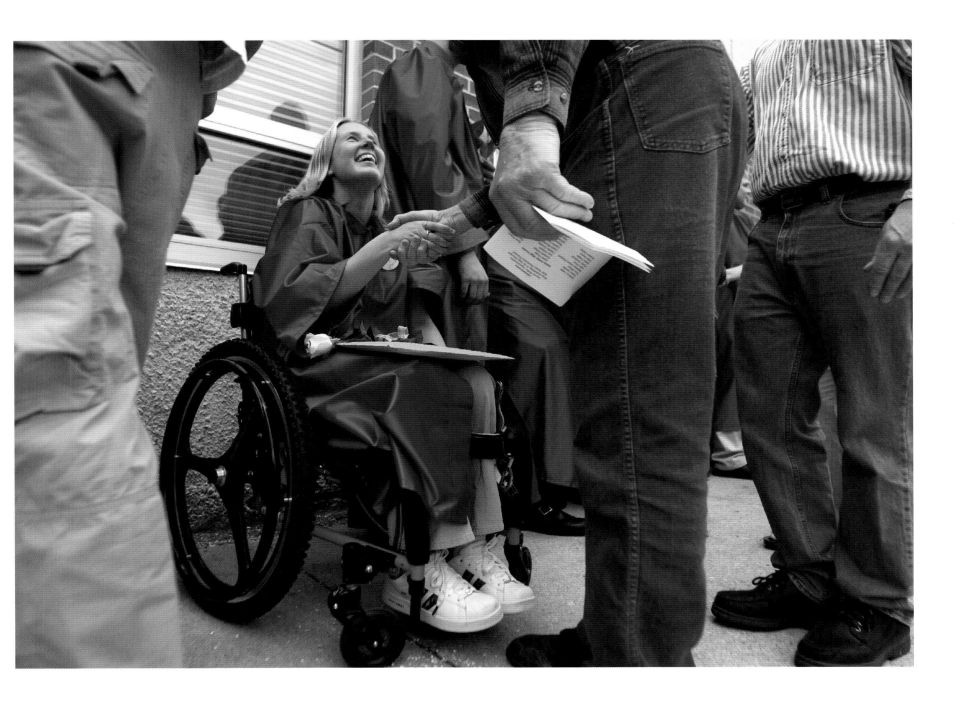

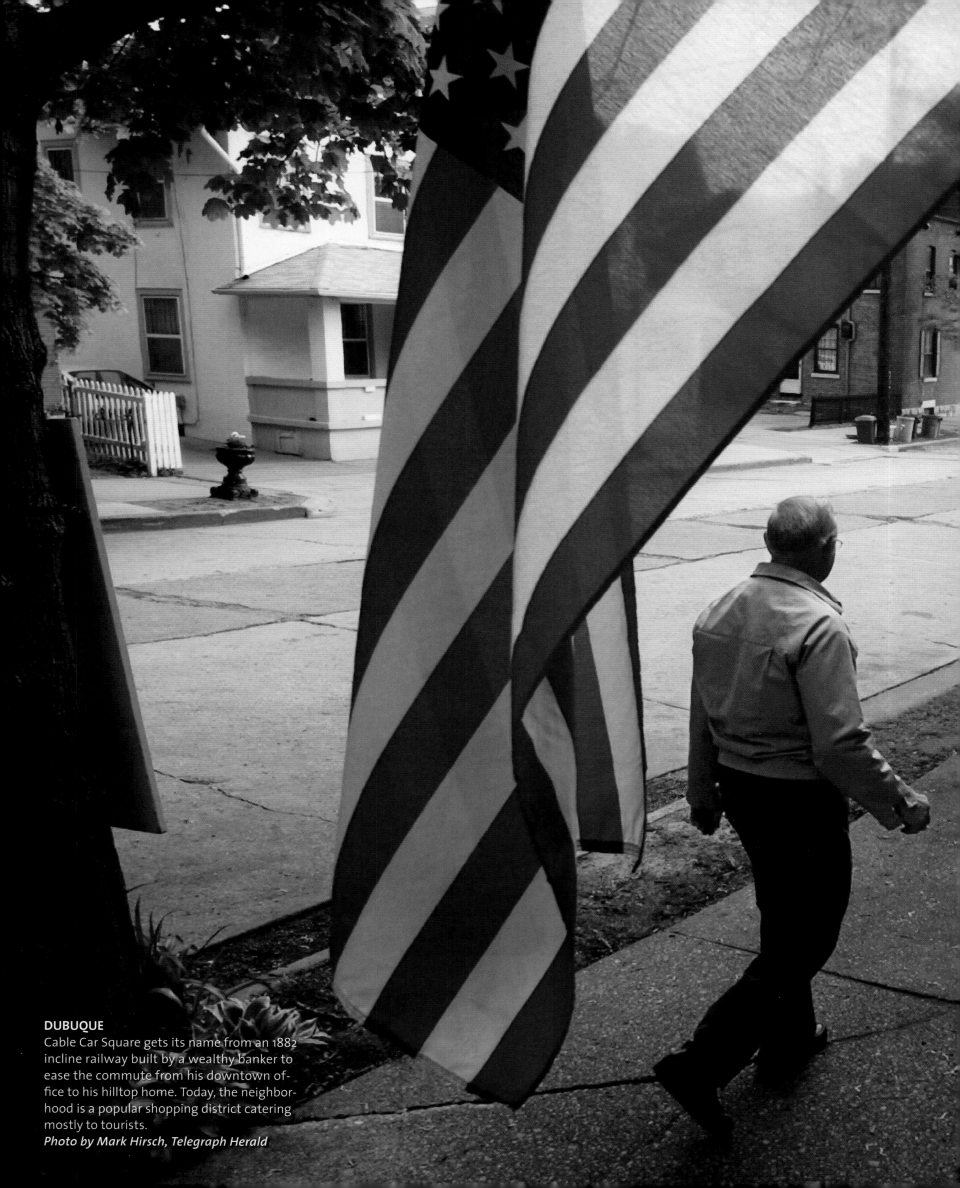

**DUBUQUE**

Cable Car Square gets its name from an 1882 incline railway built by a wealthy banker to ease the commute from his downtown office to his hilltop home. Today, the neighborhood is a popular shopping district catering mostly to tourists.

*Photo by Mark Hirsch, Telegraph Herald*

Our Town

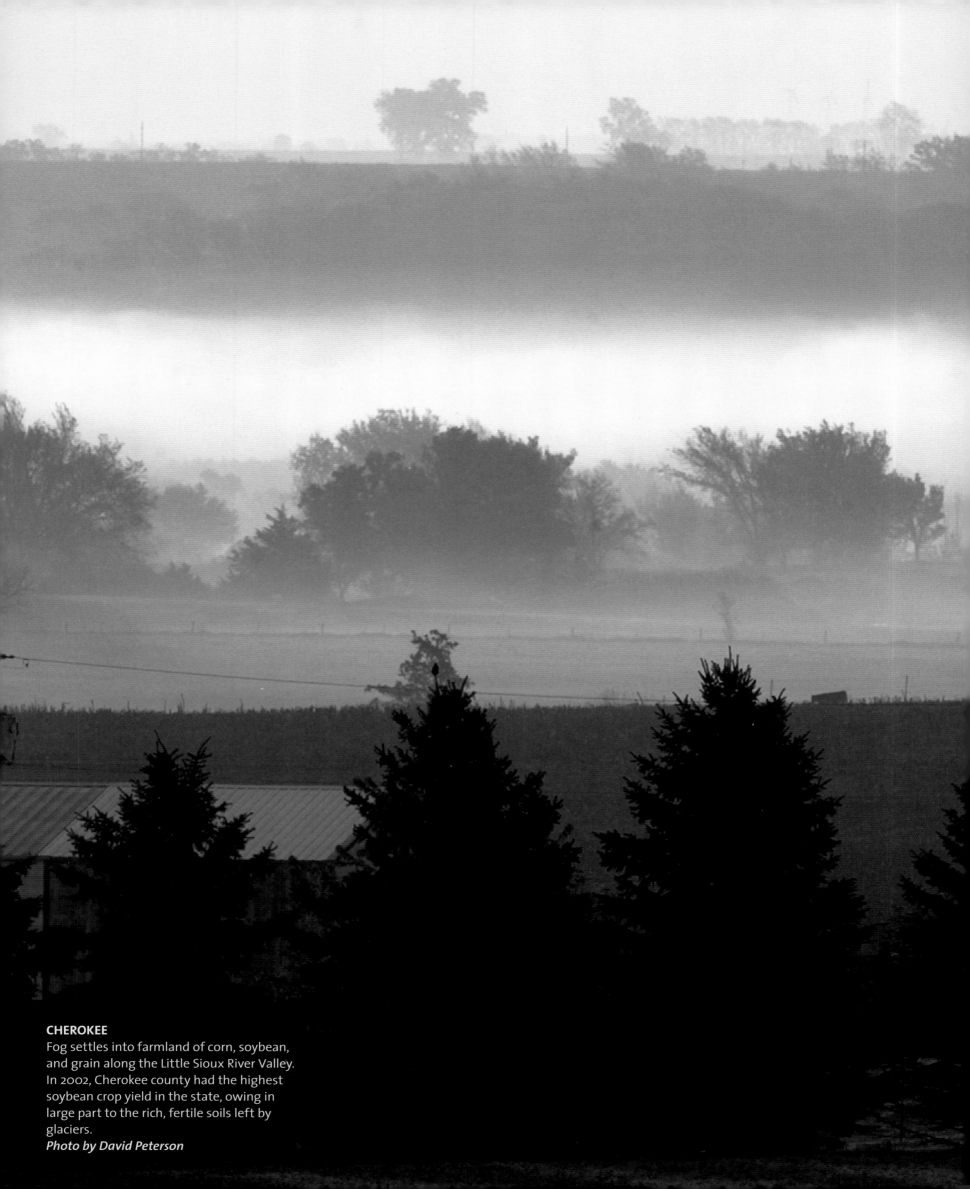

**CHEROKEE**
Fog settles into farmland of corn, soybean, and grain along the Little Sioux River Valley. In 2002, Cherokee county had the highest soybean crop yield in the state, owing in large part to the rich, fertile soils left by glaciers.
*Photo by David Peterson*

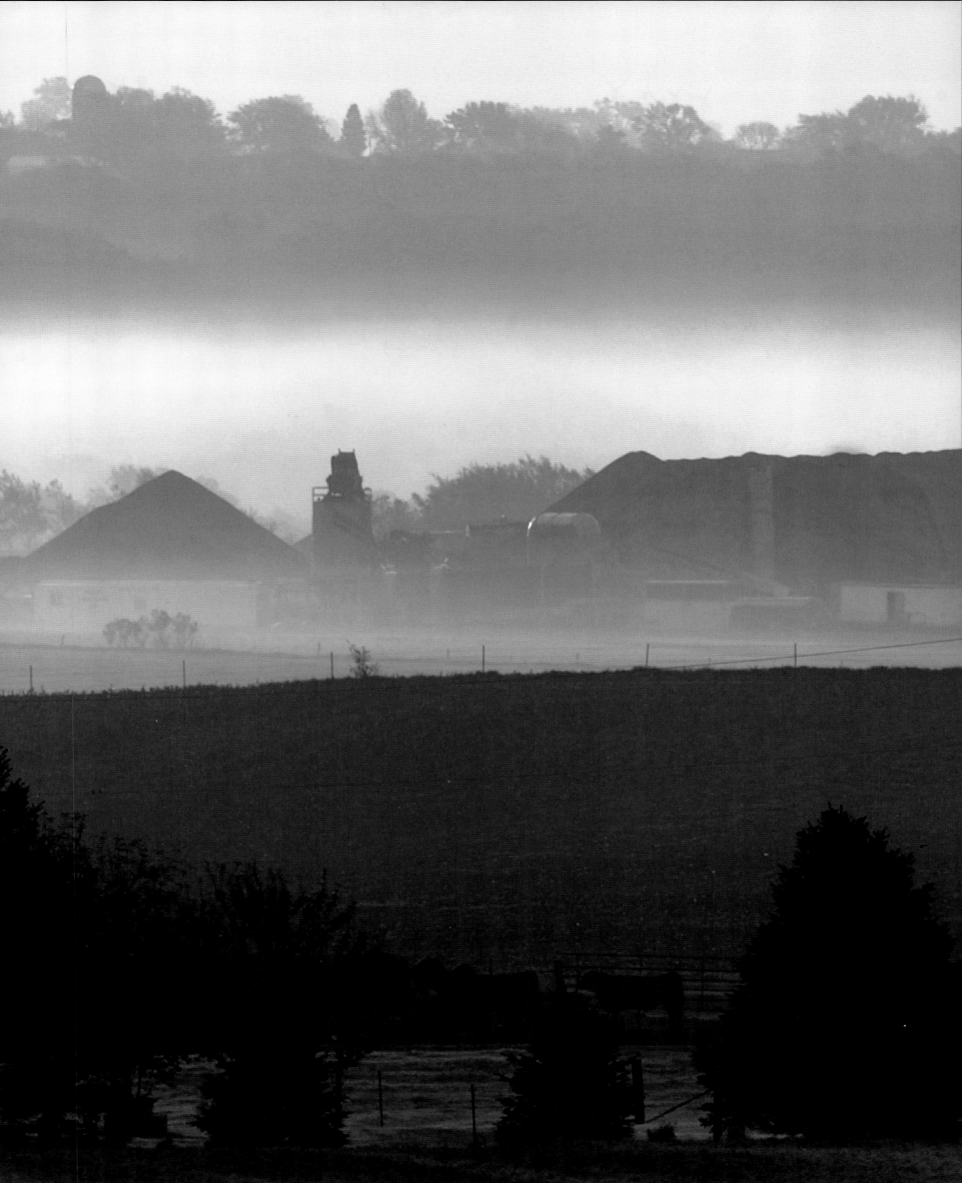

### ST. DONATUS

Sometimes referred to as "the land where the tall corn grows," Iowa holds about a third of the nation's top-grade farmland.

*Photo by Joey Wallis*

### PRAIRIE CITY

The residents of Prairie City (pop. 1,365) ran for cover when this spring storm moved in. Photographer David Peterson happened to be driving by when a sheet of sunlight crossed paths with falling water droplets; the light separated into a spectrum and he clicked.

*Photo by David Peterson*

### BLOOMFIELD

Amish buggies travel the roads west of Bloomfield. There are more than 90 varieties of Amish buggy, and they come in black, gray, white, and yellow. Their speed, though, has less range and rarely exceeds 8 miles per hour.

*Photo by Gary Fandel*

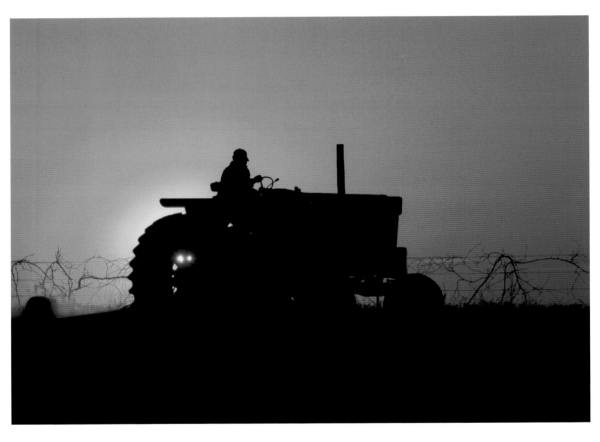

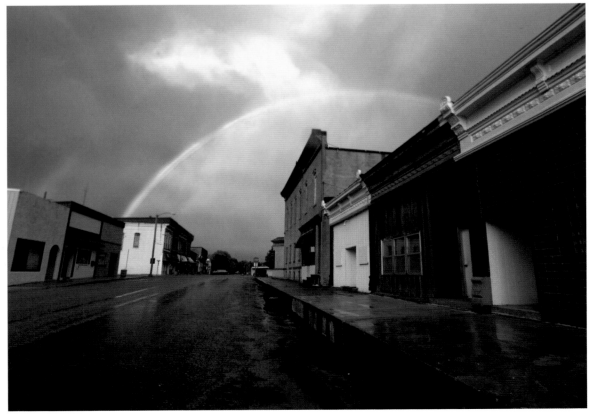

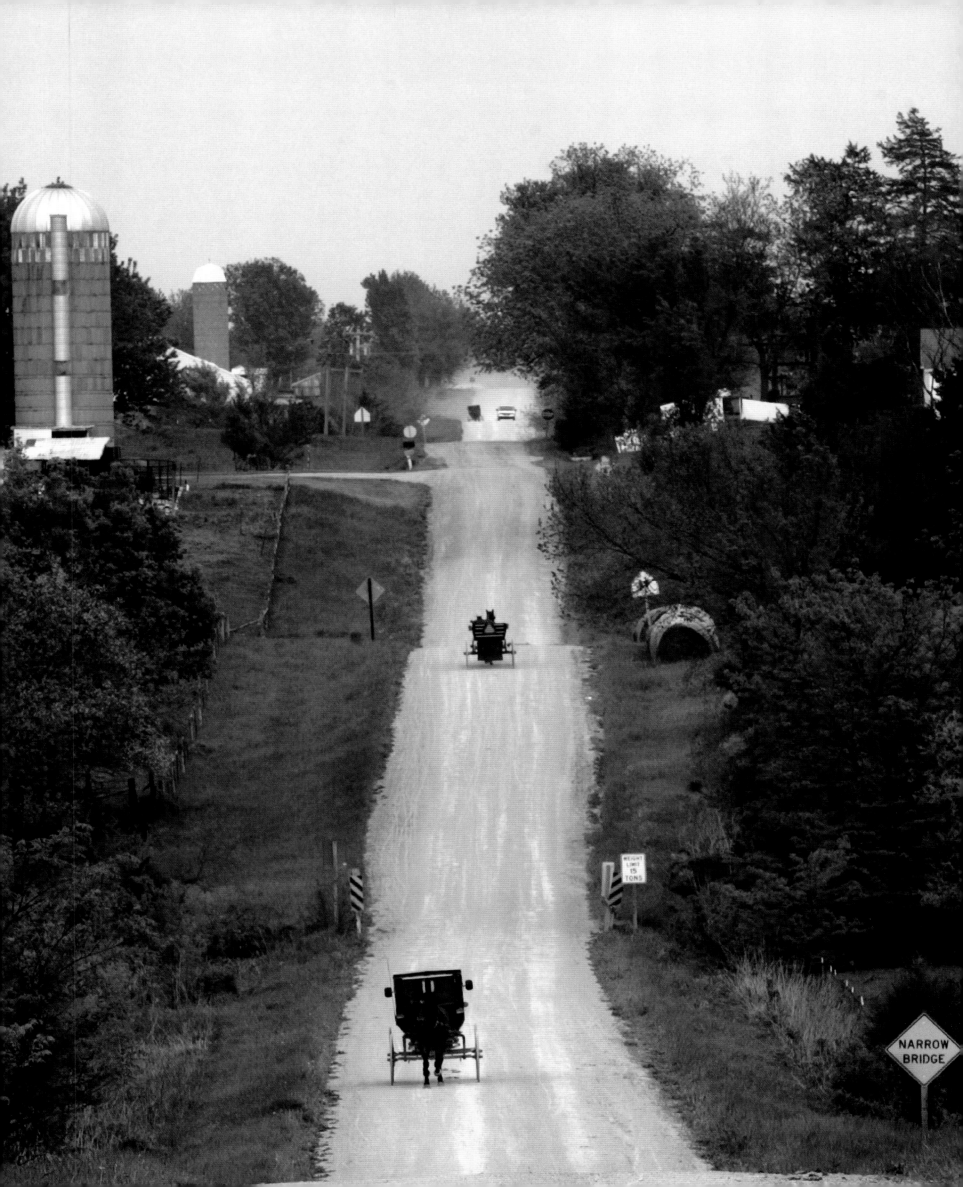

### STRAWBERRY POINT

The ripe stuff: The Strawberry Point City Hall's 1,430-pound fiberglass fruit, erected amid much pomp and circumstance in March of 1967, was promptly plucked by a windstorm two months later. Quickly reinstalled as a matter of civic pride, it has withstood the vicissitudes of the prairie ever since.

*Photo by Mike Brunette*

### WAUKEE

Bill Krause, president of the Iowa-based Kum & Go convenience-store chain, commissioned sculptor John Brommel to construct this 30-foot rendition of Iowa artist Grant Wood's *American Gothic* painting. "It's a legacy for my grandchildren and for others who share my passion for Iowa," says Krause. The sculpture, located on Krause's Waukee property, is made of recycled tractor parts.

*Photo by Alex Dorgan-Ross*

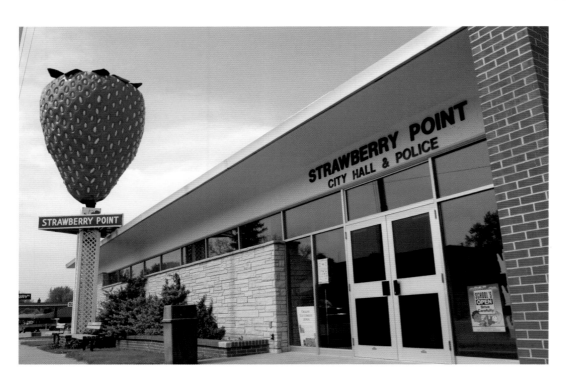

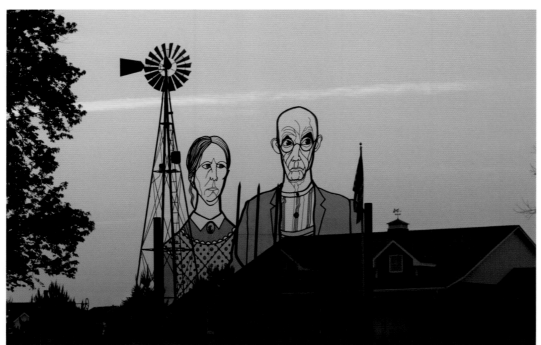

**IOWA CITY**

After a tiring afternoon of hide-and-seek and hunting for ladybugs at the University of Iowa, Melia Barbour and her 22-month-old son Liam rest on *Oracle* a stainless steel sculpture by artist Lila Katzen. Liam and his mom, who arranges her freelance writing schedule around playtime, visit the campus often to frolic by the Iowa River.
**Photo by Harry Baumert, *The Des Moines Register***

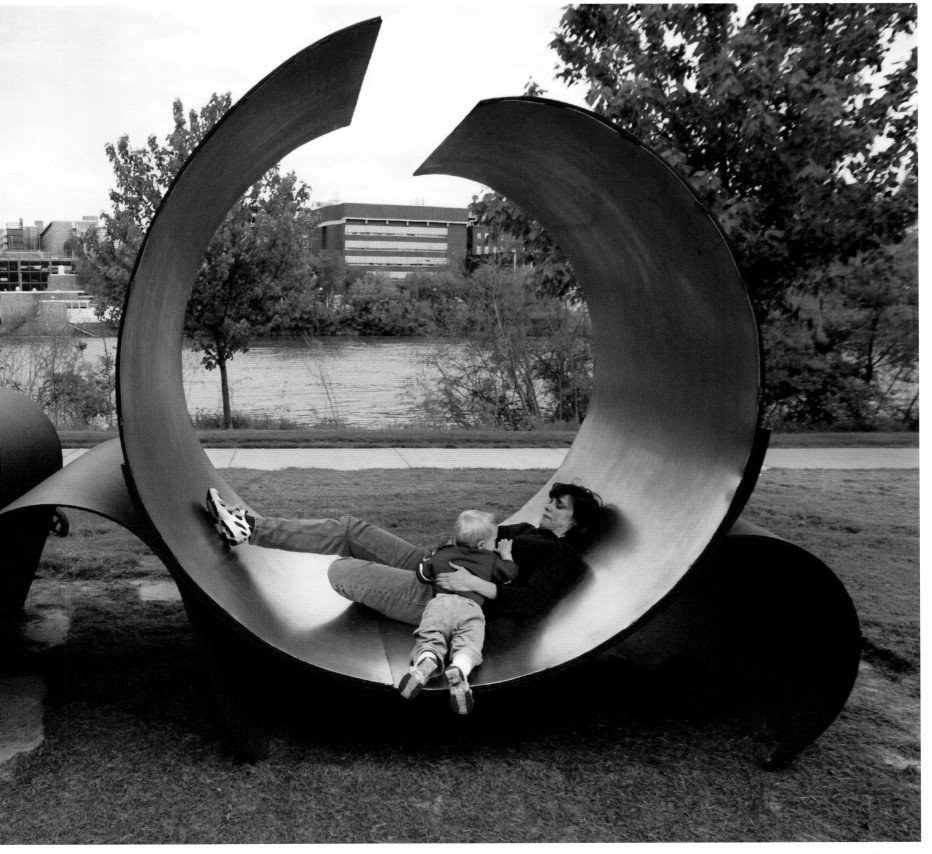

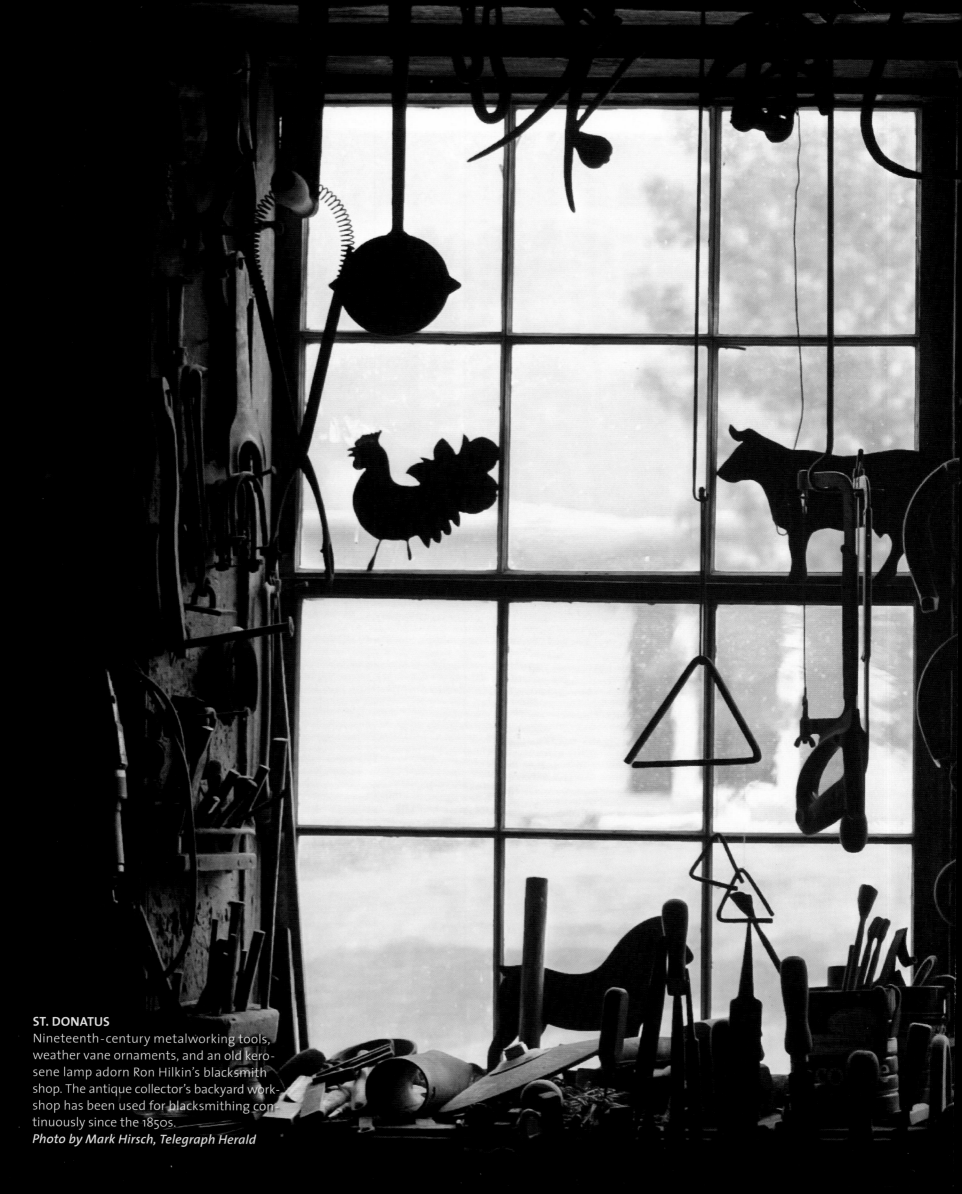

**ST. DONATUS**
Nineteenth-century metalworking tools, weather vane ornaments, and an old kerosene lamp adorn Ron Hilkin's blacksmith shop. The antique collector's backyard workshop has been used for blacksmithing continuously since the 1850s.
*Photo by Mark Hirsch, Telegraph Herald*

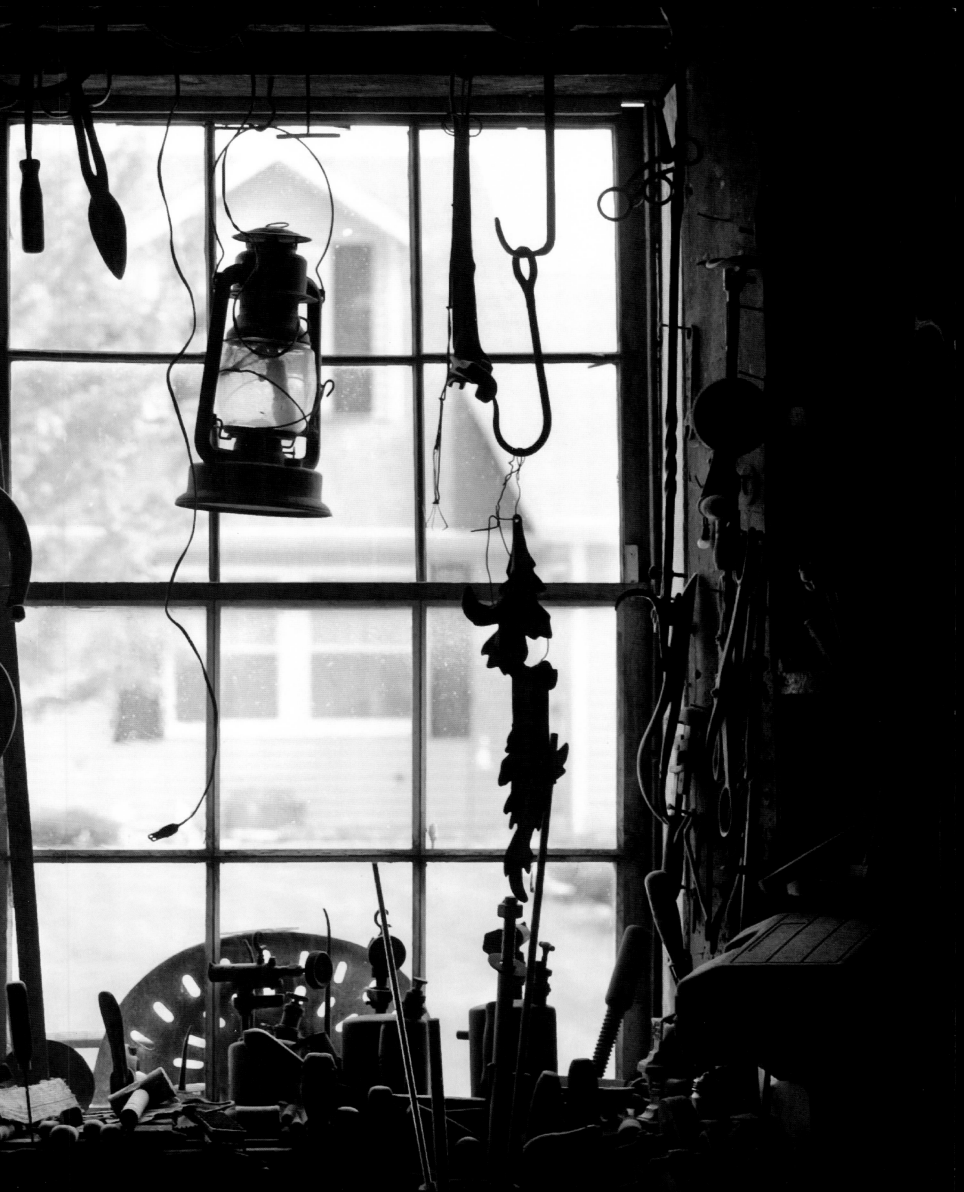

**IOWA CITY**

An abstract mural by local artist Anna Ullerich serves as a backdrop for the Iowa Avenue Literary Walk, a series of bronze relief panels set in the sidewalk along two blocks of Iowa Avenue.
*Photo by Brian Ray, The Gazette*

**DES MOINES**

The Wallace Office Building reflects the Iowa State Capitol and its splendid golden dome. Constructed between 1871 and 1886, the capital actually has five domes. The largest is gilded with 23-karat gold leaf. The four smaller domes—one at each corner—are copper clad with vertical gilded ribs.
*Photo by Kim Seang Poam*

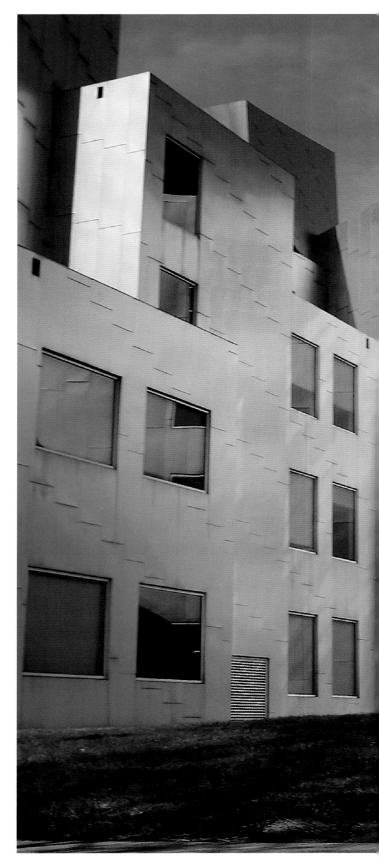

**IOWA CITY**

Members of the Hawkeyes women's rowing team carry their oars past the Advanced Technology Laboratories at the University of Iowa. The complex, sheathed in matte-finish stainless steel and Anamosa limestone, was designed by superstar architect Frank Gehry and completed in 1992. It houses a computer design and environmental research center.

*Photo by Mike Brunette*

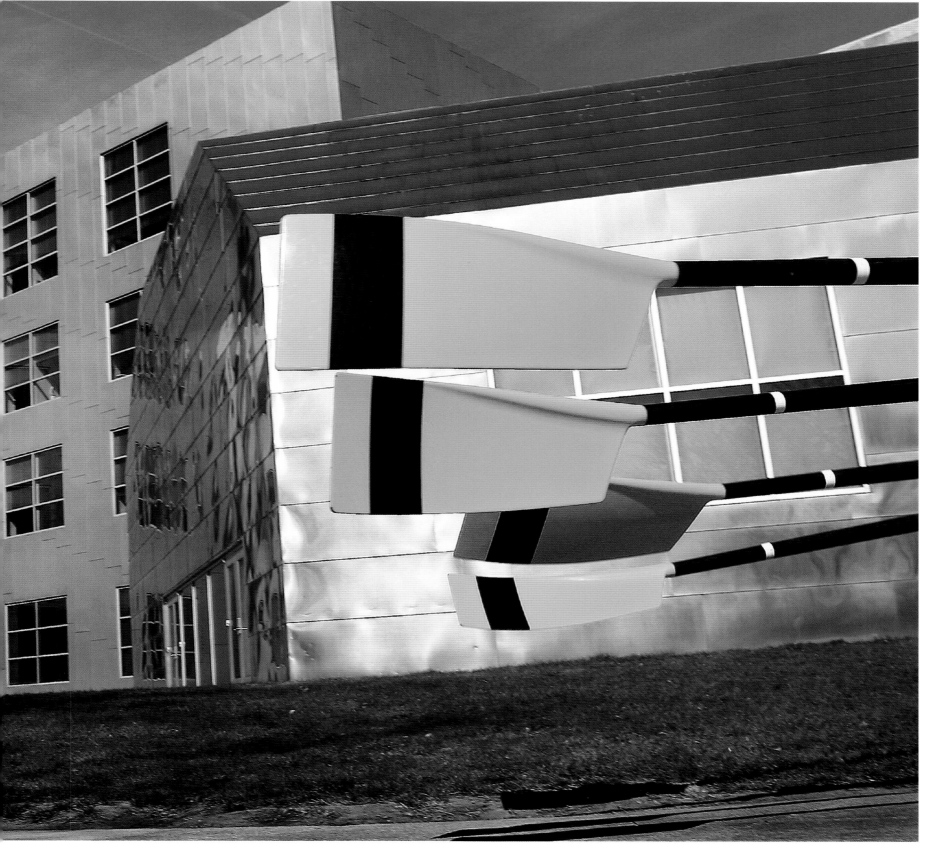

## DE SOTO

Robert Ellefson pilots his T-Bird ultralight 300 feet above De Soto. In addition to being part owner of Golden Circle Air—a manufacturer of assembly-kit ultralight aircraft—Ellefson teaches flying at his other business, Aircraft Supermarket. "I can have someone soloing an ultralight in six to ten lessons," he asserts.

*Photo by Rodney White*

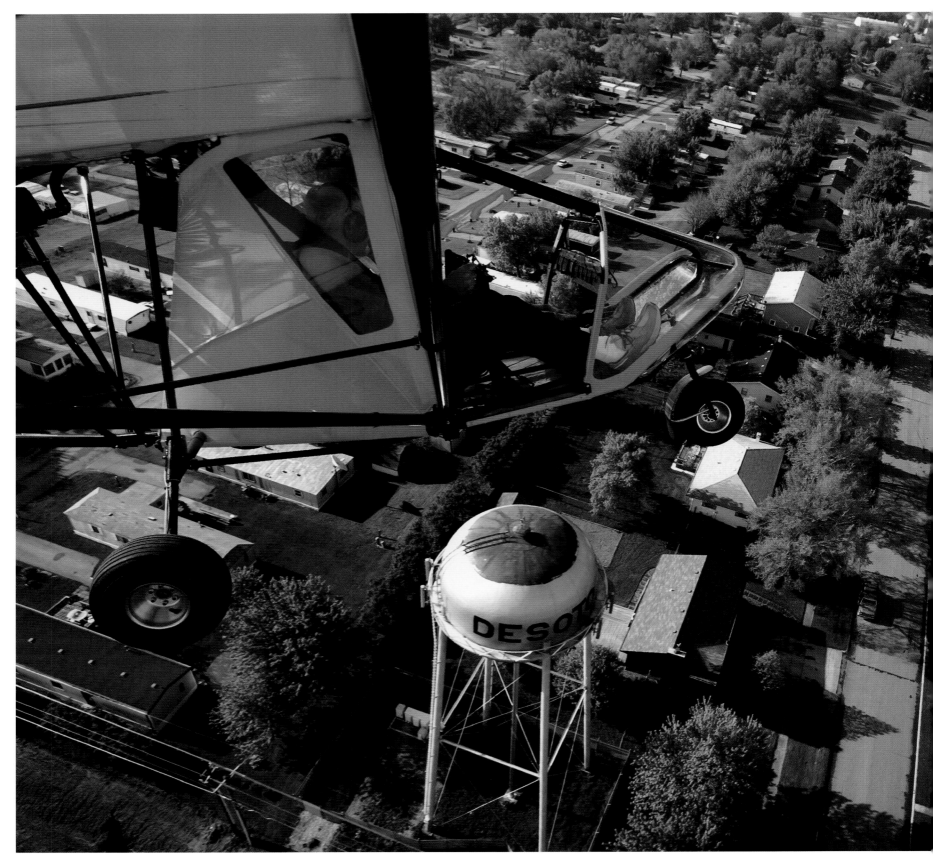

**ADEL**

Between 1848 and 1858, Dallas County had three courthouses. The fourth one, built at the close of the 19th century, was modeled after a French castle and has endured. Made of Bedford stone, the courthouse has a 128-foot tower and is listed on the National Register of Historic Places.
*Photo by Charlie Neibergall, Associated Press*

**STUART**

When her coworkers noticed Rita Faust planting petunias outside of First State Bank, they joked that their vice president had been demoted. In reality, Faust had found a side career as a master gardener. Faust studied for three months at the Iowa State University Extension program to get certification. To maintain it, she must perform 40 hours of volunteer gardening each year.
*Photo by Alex Dorgan-Ross*

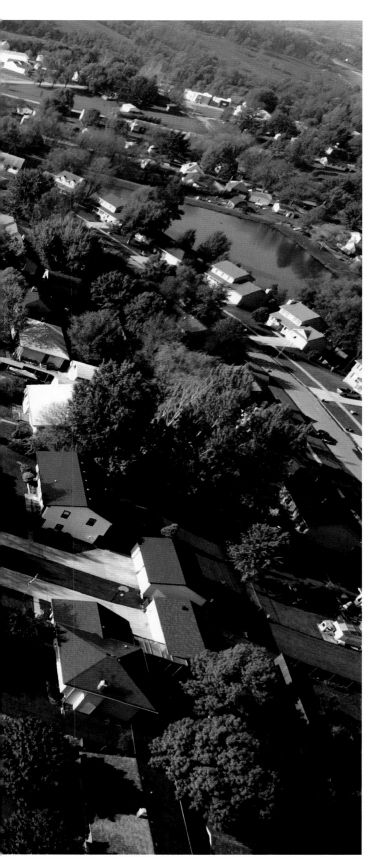

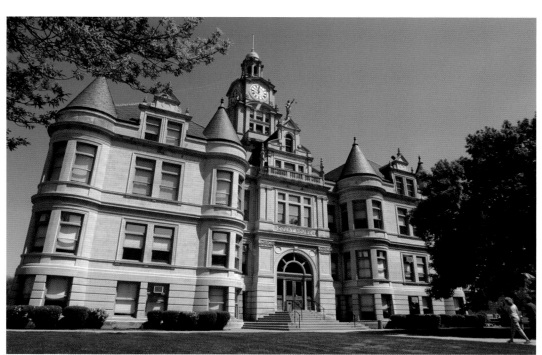

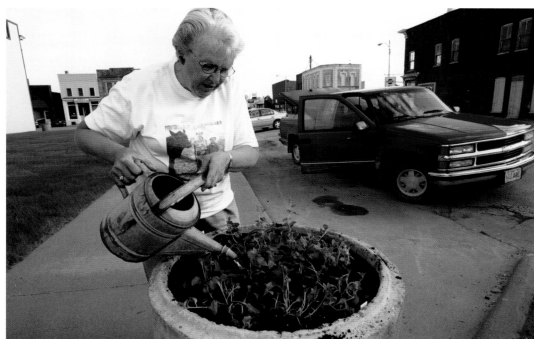

**OELWEIN**

Following a morning sendoff ceremony at Oelwein High School, friends and family wave goodbye to departing Iowa Army National Guardsmen headed for Fort Carson, Colorado. From there, the soldiers will travel to the Sinai Peninsula. More than 500 Iowa soldiers were called up for this observer mission.

*Photo by Harry Baumert, The Des Moines Register*

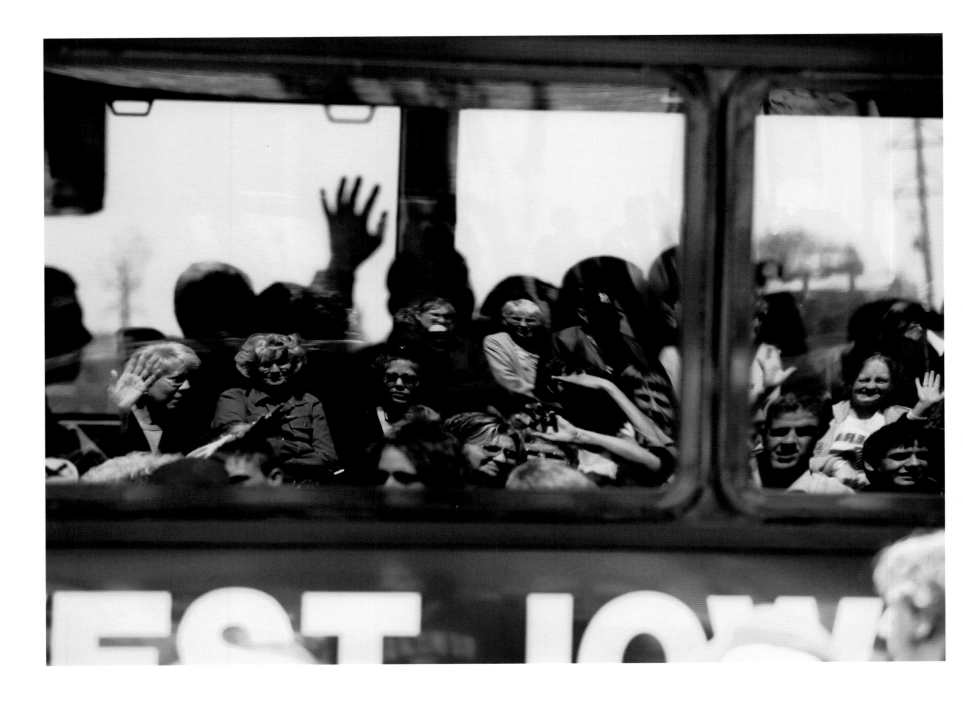

**DUBUQUE**

Austin Schwendinger bids dad Rob goodbye as his Iowa National Guard unit, the 133rd Infantry Battalion, leaves for a mission to the Sinai Peninsula. Two months earlier, Austin's mom Amy Shepherd left for duty in Kuwait with the Guard's 109th Medical Battalion. In his parents' absence, his aunt, Diane Schwendinger, and other relatives take care of Austin .

*Photo by Clint Austin*

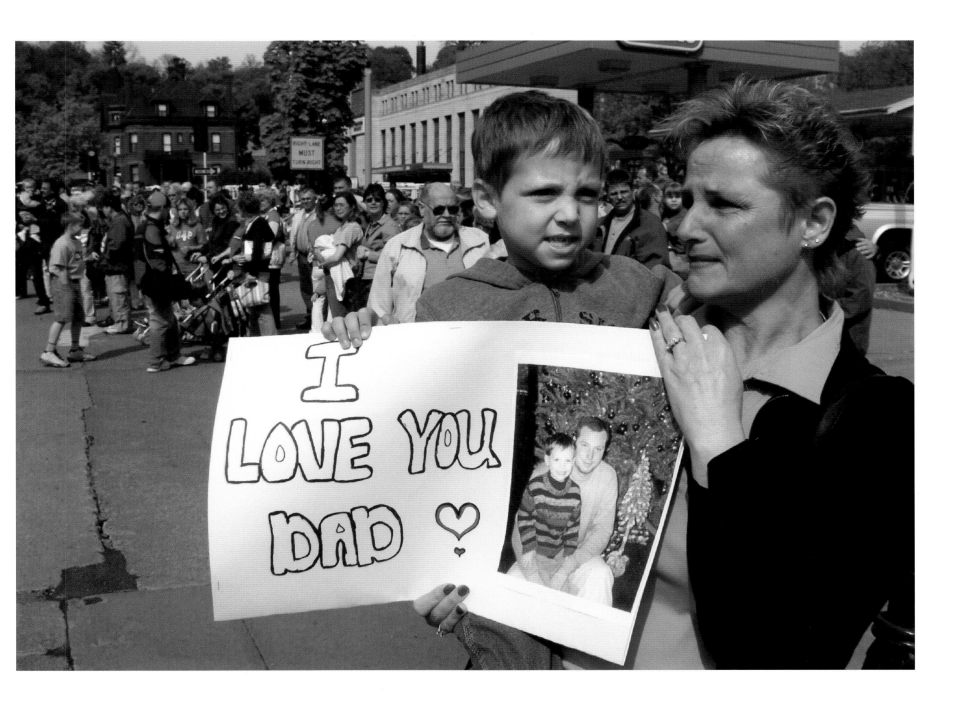

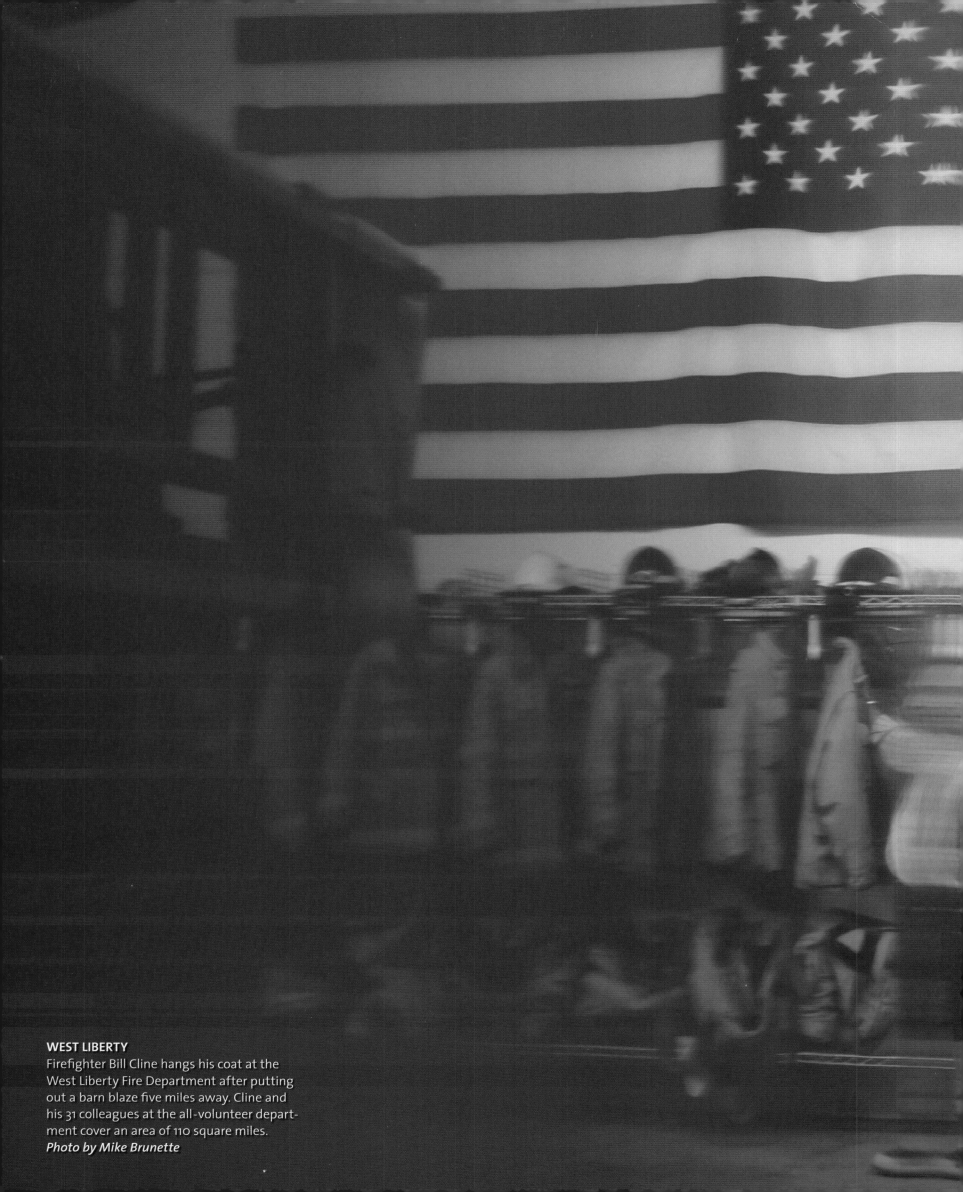

**WEST LIBERTY**
Firefighter Bill Cline hangs his coat at the
West Liberty Fire Department after putting
out a barn blaze five miles away. Cline and
his 31 colleagues at the all-volunteer depart-
ment cover an area of 110 square miles.
*Photo by Mike Brunette*

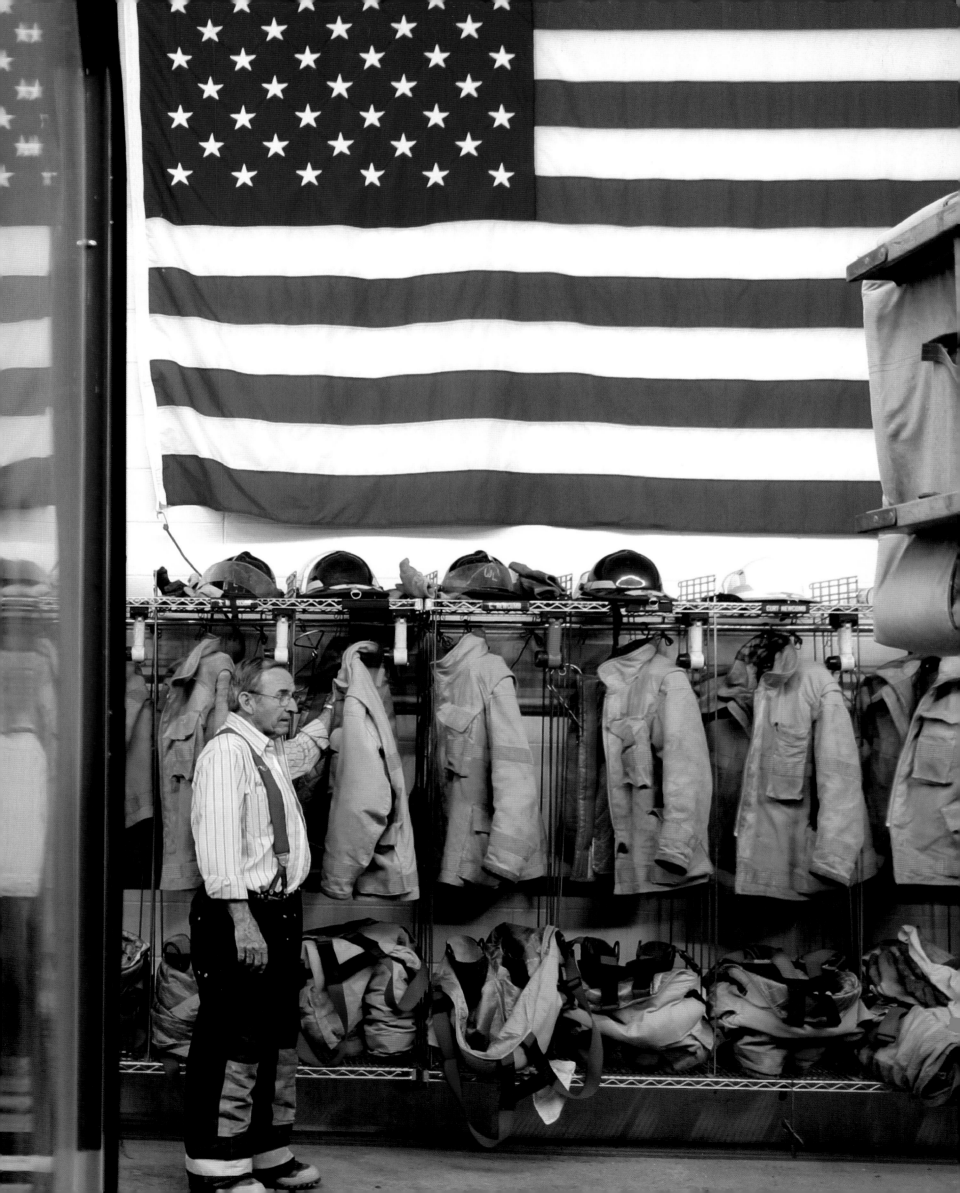

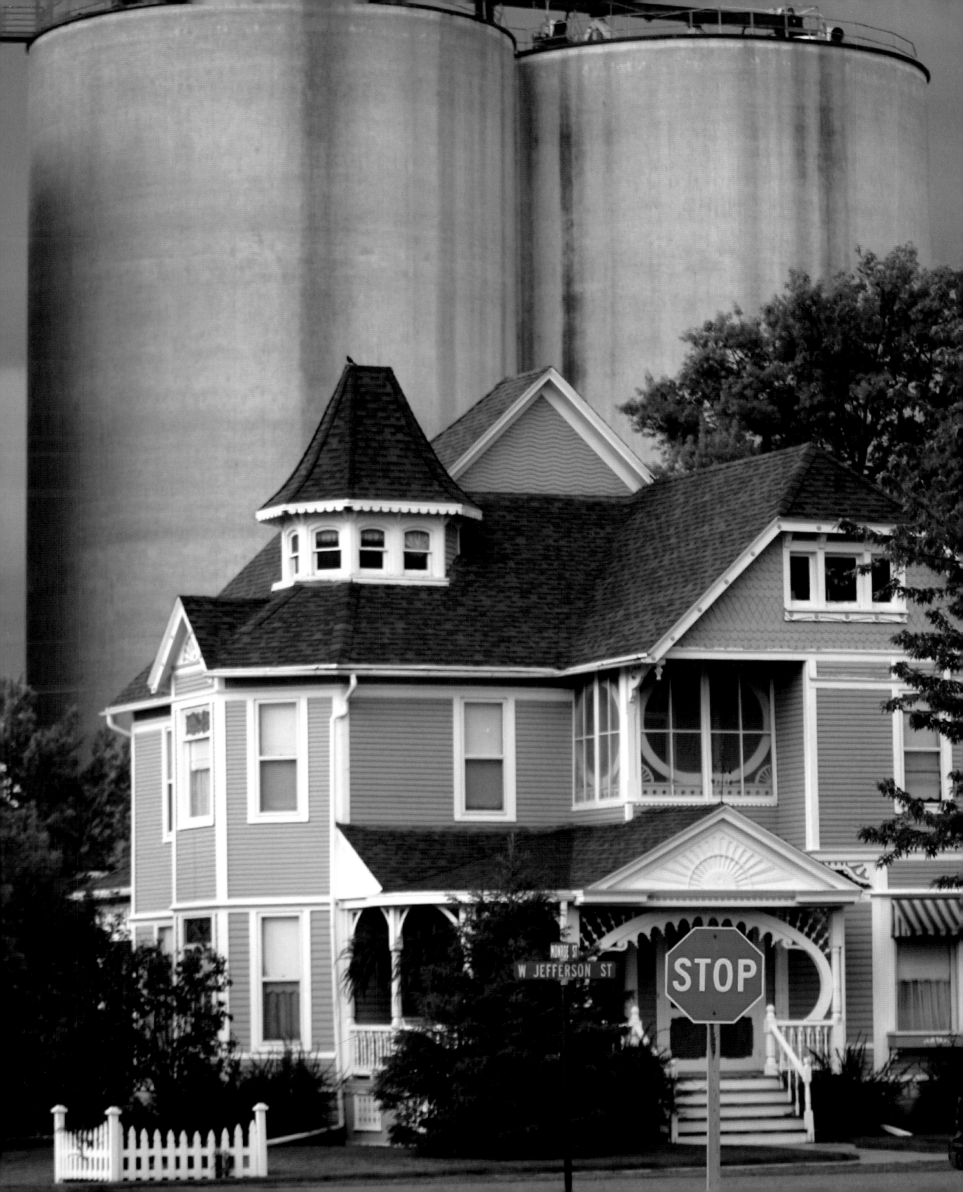

### PRAIRIE CITY

When Jean Cook, a Des Moines-based real estate agent, saw this 1886 Queen Anne Victorian, it was love at first sight. Even the backyard grain elevators add to its charm, says Cook. "We pretend we have a view of the mountains."
*Photo by David Peterson*

### ALTA

Storm Lake Wind Power Facility is among the world's largest wind farms. The site stretches over 19 miles of farmland and has 260 turbines producing 193 megawatts—enough power to service 72,000 homes. The green energy from this facility saves 278,000 tons of coal a year.
*Photo by Rodney White*

### PANORA

Outside Panora in Guthrie County, alto-cumulus clouds fan across the evening sky. The name Panora is a contraction of panorama, and was chosen because a rare hill in the area afforded a nice view.
*Photo by Alex Dorgan-Ross*

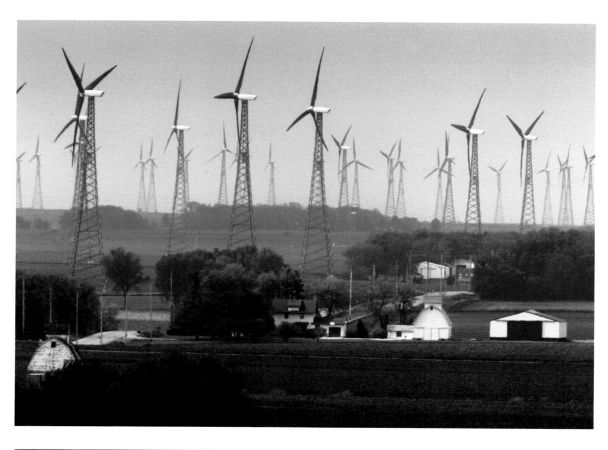

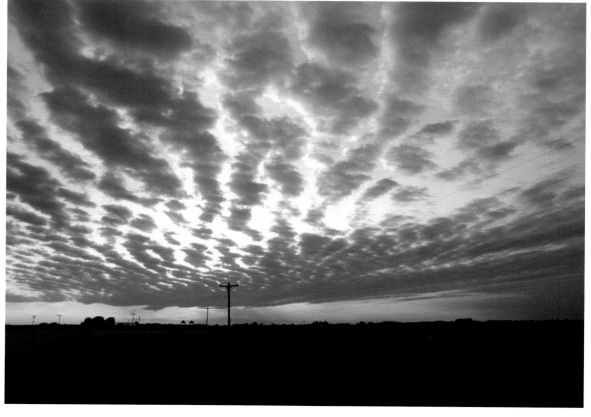

**DES MOINES**

"Yo, Adrian!" At the downtown Simon Estes Amphitheater, local families watch Rocky Balboa come from behind and beat the odds. Des Moines's Park and Recreation Department hosts a free outdoor movie series every Friday night for a month in the spring and fall.
*Photo by Rodney White*

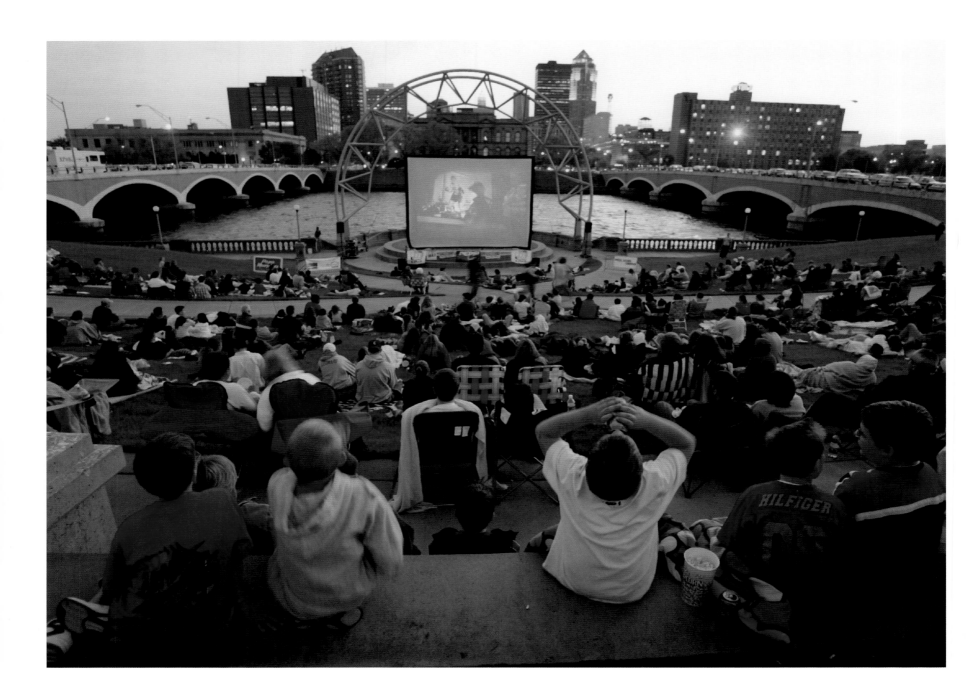

## DES MOINES

Members of the Chariton Amish community bide their time after stocking up on plants and groceries at the Valley Junction Farmers Market. It's a long trip back to Chariton: The four shoppers will spend eight hours in a horse-drawn buggy making the 54-mile journey.
*Photo by David Peterson*

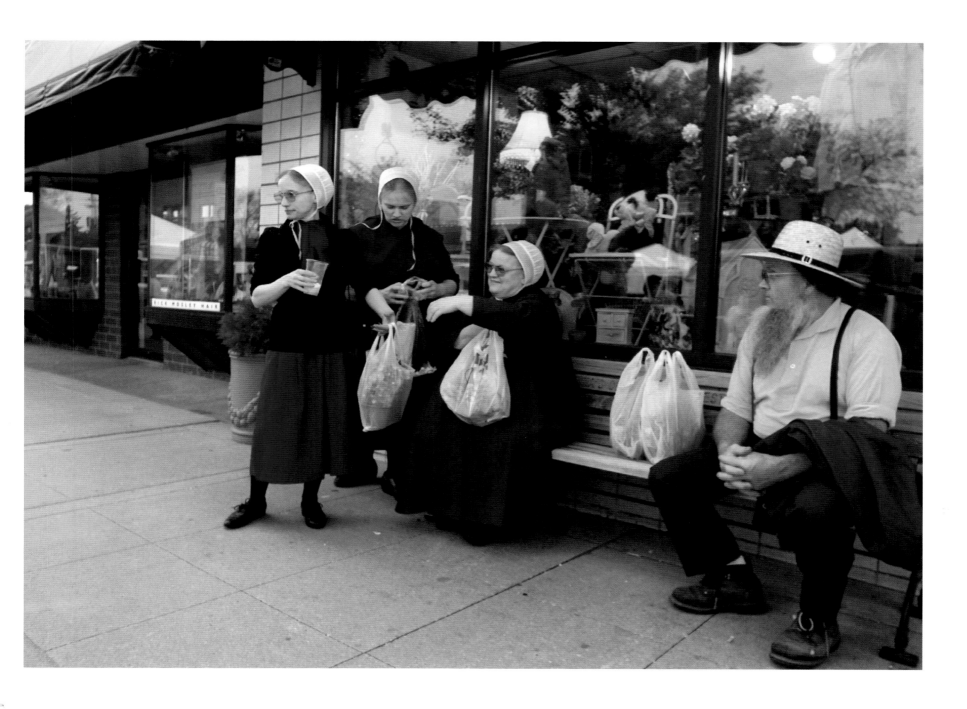

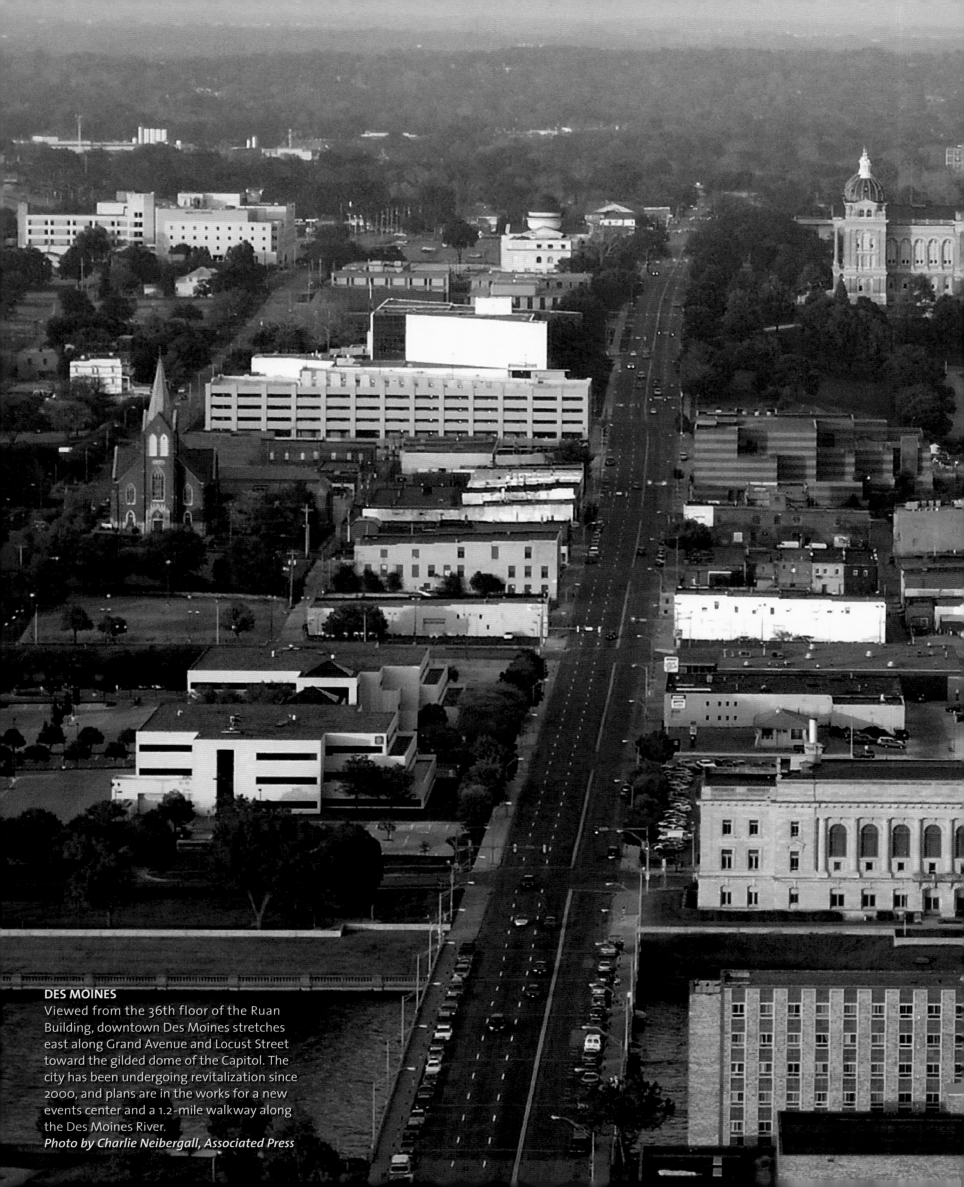

**DES MOINES**
Viewed from the 36th floor of the Ruan Building, downtown Des Moines stretches east along Grand Avenue and Locust Street toward the gilded dome of the Capitol. The city has been undergoing revitalization since 2000, and plans are in the works for a new events center and a 1.2-mile walkway along the Des Moines River.
*Photo by Charlie Neibergall, Associated Press*

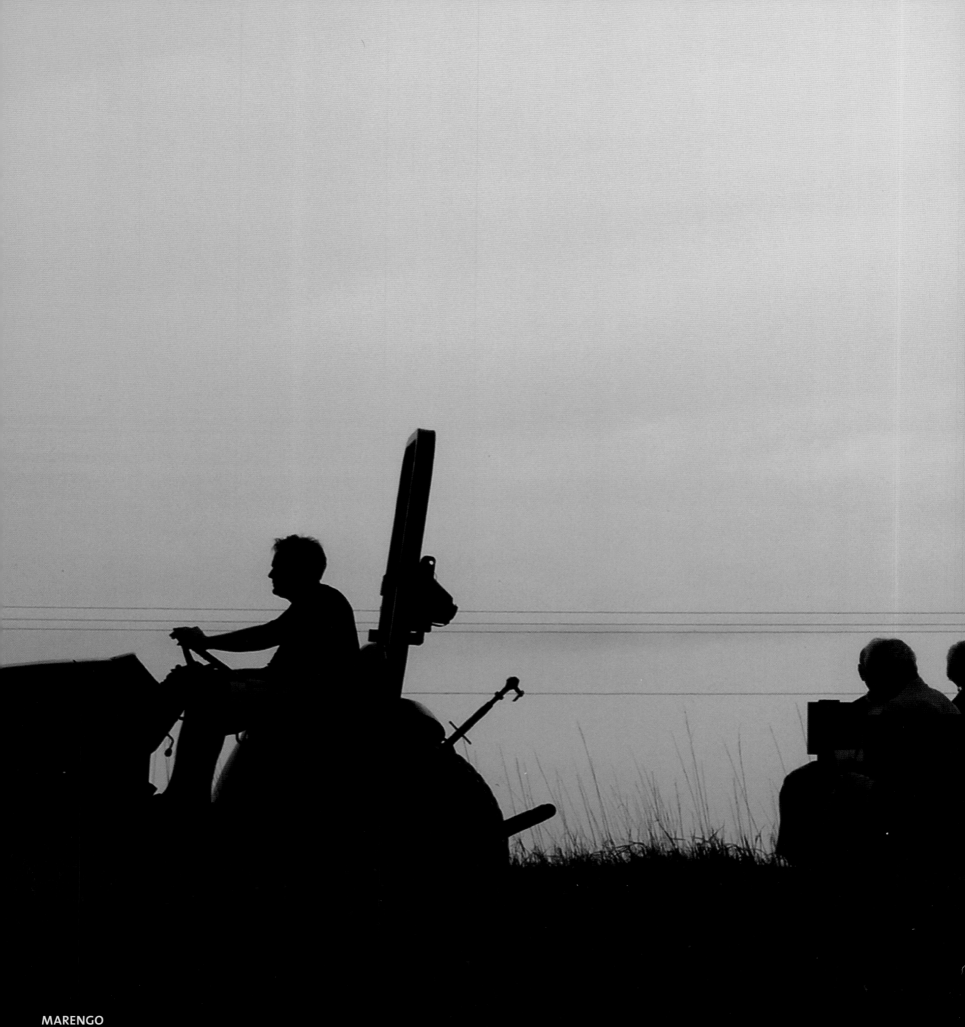

**MARENGO**
Revelers' silhouette: Hay rides, a hog roast, and a barn dance at the family farm are part of Russell and Mary Ellen Sandersfeld's 50th wedding anniversary celebration. The 300 guests started arriving at 5 p.m. and stayed until the wee hours.
*Photo by Kevin R. Wolf*

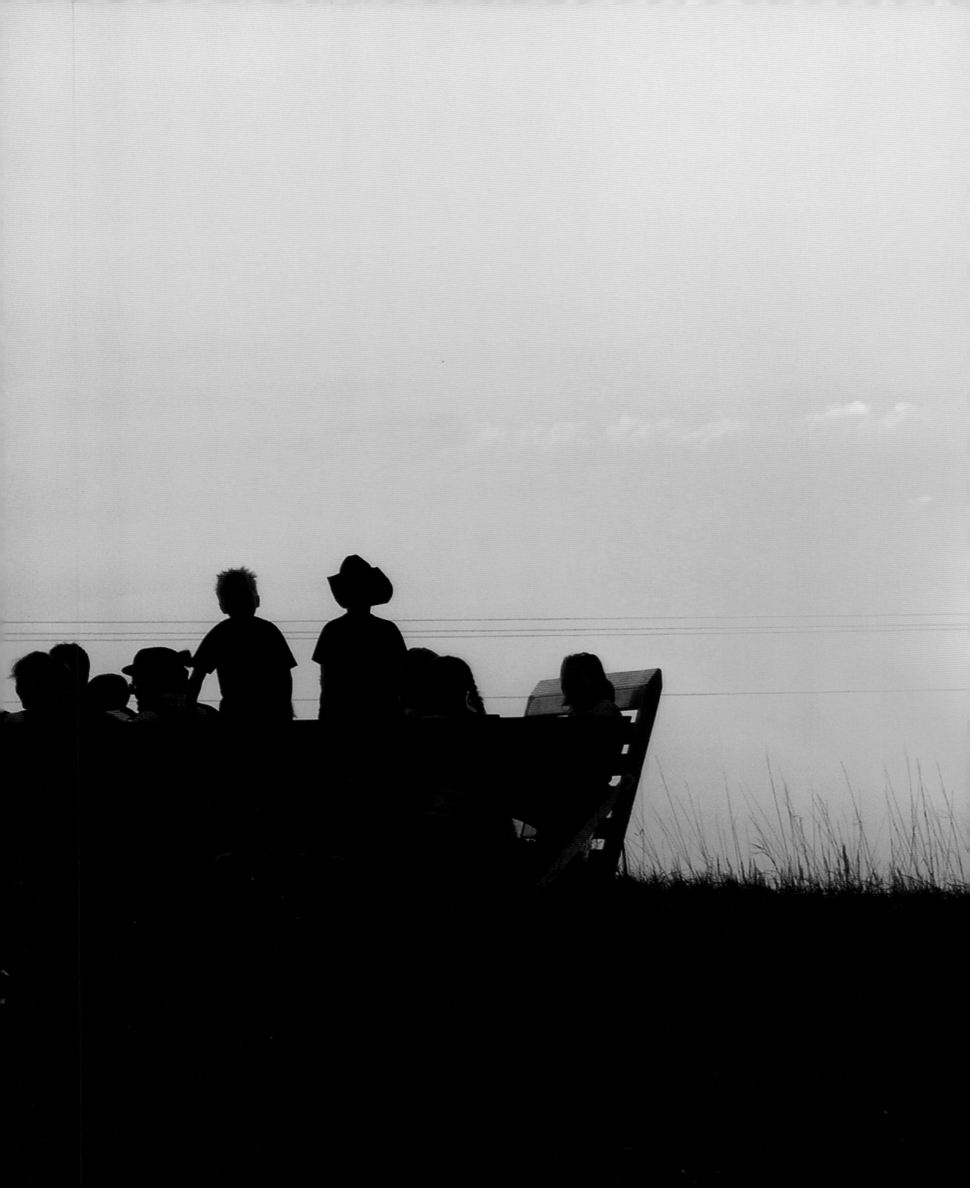

The week of May 12-18, 2003, more than 25,000 professional and amateur photographers spread out across the nation to shoot over a million digital photographs with the goal of capturing the essence of daily life in America.

The professional photographers were equipped with Adobe Photoshop and Adobe Album software, Olympus C-5050 digital cameras, and Lexar Media's high-speed compact flash cards.

The 1,000 professional contract photographers plus another 5,000 stringers and students sent their images via FTP (file transfer protocol) directly to the *America 24/7* website. Meanwhile, thousands of amateur photographers uploaded their images to Snapfish's servers.

At *America 24/7*'s Mission Control headquarters, located at CNET in San Francisco, dozens of picture editors from the nation's most prestigious publications culled the images down to 25,000 of the very best, using Photo Mechanic by Camera Bits. These photos were transferred into Webware's ActiveMedia Digital Asset Management (DAM) system, which served as a central image library and enabled the designers to track, search, distribute, and reformat the images for the creation of the 51 books, foreign language editions, web and magazine syndication, posters, and exhibitions.

Once in the DAM, images were optimized (and in some cases resampled to increase image resolution) using Adobe Photoshop. Adobe InDesign and Adobe InCopy were used to design and produce the 51 books, which were edited and reviewed in multiple locations around the world in the form of Adobe Acrobat PDFs. Epson Stylus printers were used for photo proofing and to produce large-format images for exhibitions. The companies providing support for the *America 24/7* project offer many of the essential components for anyone building a digital darkroom. We encourage you to read more on the following pages about their respective roles in making *America 24/7* possible.

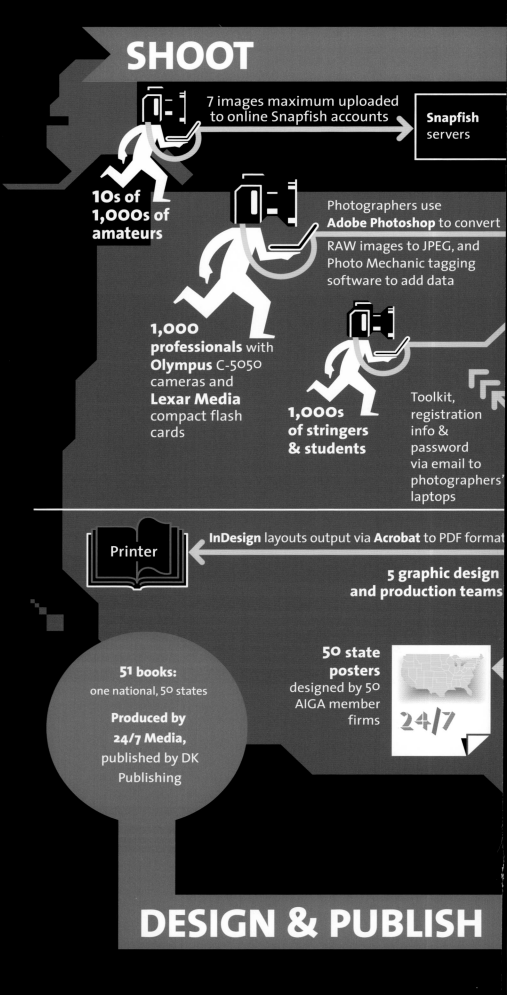

**SHOOT**

7 images maximum uploaded to online Snapfish accounts

**Snapfish** servers

**10s of 1,000s of amateurs**

Photographers use **Adobe Photoshop** to convert RAW images to JPEG, and Photo Mechanic tagging software to add data

**1,000 professionals** with **Olympus** C-5050 cameras and **Lexar Media** compact flash cards

**1,000s of stringers & students**

Toolkit, registration info & password via email to photographers' laptops

Printer

**InDesign** layouts output via **Acrobat** to PDF format

**5 graphic design and production teams**

**51 books:** one national, 50 states

**Produced by 24/7 Media,** published by DK Publishing

**50 state posters** designed by 50 AIGA member firms

24/7

**DESIGN & PUBLISH**

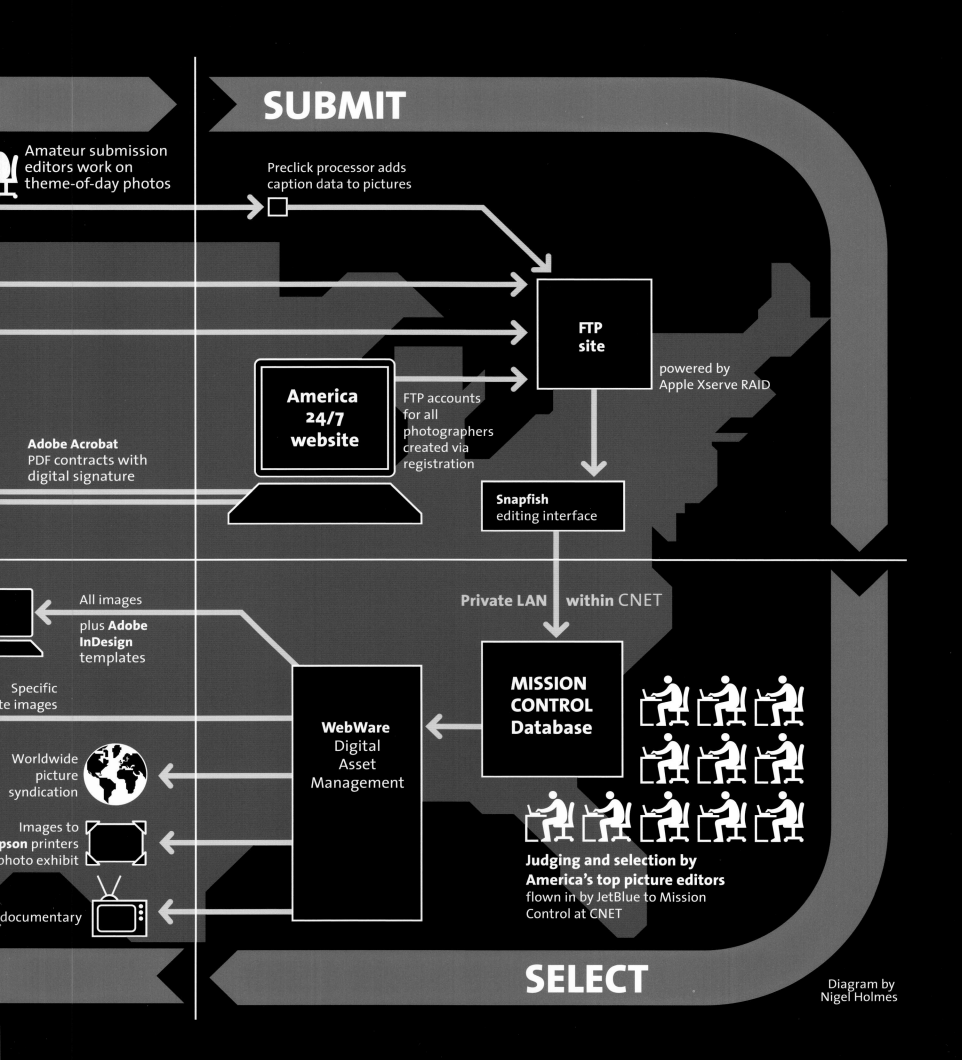

Amateur submission
editors work on
theme-of-day photos

Preclick processor adds
caption data to pictures

**FTP
site**

powered by
Apple Xserve RAID

**America
24/7
website**

FTP accounts
for all
photographers
created via
registration

**Adobe Acrobat**
PDF contracts with
digital signature

**Snapfish**
editing interface

All images

plus **Adobe
InDesign**
templates

Private LAN within CNET

Specific
te images

**MISSION
CONTROL
Database**

**WebWare**
Digital
Asset
Management

Worldwide
picture
syndication

Images to
pson printers
photo exhibit

**Judging and selection by
America's top picture editors**
flown in by JetBlue to Mission
Control at CNET

documentary

Diagram by
Nigel Holmes

# About Our Sponsors

*America 24/7* gave digital photographers of all levels the opportunity to share their visions of what it means to live in the United States. This project was made possible by a digital photography revolution that is dramatically changing and improving picture-taking for professionals and amateurs alike. And an Adobe product, Photoshop®, has been at the center of this sea change.

Adobe's products reflect our customers' passion for the creative process, be it the photographer, graphic designer, layout artist, or printer. Adobe is the Publishing and Imaging Software Partner for *America 24/7* and products such as Adobe InDesign®, Photoshop, Acrobat®, and Illustrator® were used to produce this stunning book in a matter of weeks. We hope that our software has helped do justice to the mythic images, contributed by well-known photographers and the inspired hobbyist.

Adobe is proud to be a lead sponsor of *America 24/7*, a project that celebrates the vibrancy of the American spirit: the same spirit that helped found Adobe and inspires our employees and customers to deliver the very best.

Bruce Chizen
President and CEO
Adobe Systems Incorporated

Olympus, a global technology leader in designing precision healthcare solutions and innovative consumer electronics, is proud to be the official digital camera sponsor of *America 24/7*. The opportunity to introduce Americans from coast to coast to the thrill, excitement, and possibility of digital photography makes the vision behind this book a perfect fit for Olympus, a leader in digital cameras since 1996.

For most people, the essence of digital photography is best grasped through firsthand experience with the technology, which is precisely what *America 24/7* is about. We understand that direct experience is the pathway to inspiration, and welcome opportunities like this sponsorship to bring the power of the digital experience into the lives of people everywhere. To Olympus, *America 24/7* offers a platform to help realize a core mission: to deliver and make accessible the power of the digital experience to millions of American photographers, amateurs, and professionals alike.

The 1,000 professional photographers contracted to shoot on the America 24/7 project were all equipped with Olympus C-5050 digital cameras. Like all Olympus products, the C-5050 is offered by a company well known for designing, manufacturing, and servicing products used by professionals to perform their work, every day. Olympus is a customer-centric company committed to working one-to-one with a diverse group of professionals. From biomedical researchers who use our clinical microscopes, to doctors who perform life-saving procedures with our endoscopes, to professional photographers who use cameras in their daily work, Olympus is a trusted brand.

The digital imaging technology involved with *America 24/7* has enabled the soul of America to be visually conveyed, not just by professional observers, but by the American public who participated in this project—the very people who collectively breath life into this country's existence each day.

We are proud to be enabling so many photographers to capture the pictures on these pages that tell the story of who we are as a nation. From sea to shining sea, digital imagery allows us to connect to one another in ways we never dreamed possible.

At Olympus, our ideas have proliferated as rapidly as technology has evolved. We have channeled these visions into breakthrough products and solutions to meet the demands of our changing world-products like microscopes, endoscopes, and digital voice recorders, supported by the highly regarded training, educational, and consulting services we offer our customers.

Today, 83 years after we introduced our first microscope, we remain as young, as curious, and as committed as ever.

Lexar Media has grown from the digital photography revolution, which is why we are proud to have supplied the digital memory cards used in the America 24/7 project. Lexar Media's high-performance memory cards utilize our unique and patented controller coupled with high-speed flash memory from Samsung, the world's largest flash memory supplier. This powerful combination brings out the ultimate performance of any digital camera.

Photographers who demand the most from their equipment choose our products for their advanced features like write speeds up to 40X, Write Acceleration technology for enabled cameras, and Image Rescue, which recovers previously deleted or lost images. Leading camera manufacturers bundle Lexar Media digital memory cards with their cameras because they value its performance and reliability.

Lexar Media is at the forefront of digital photography as it transforms picture-taking worldwide, and we will continue to be a leader with new and innovative solutions for professionals and amateurs alike.

Snapfish, which developed the technology behind the *America 24/7* amateur photo event, is a leading online photo service, with more than 5 million members and 100 million photos posted online. Snapfish enables both film and digital camera owners to share, print, and store their most important photo memories, at prices that cannot be equaled. Digital camera users upload photos into a password-protected online album for free. Users can also order film-quality prints on professional photographic paper for as low as 25¢. Film camera users get a full set of prints, plus online sharing and storage, for just $2.99 per roll.

Founded in 1995, eBay created a powerful platform for the sale of goods and services by a passionate community of individuals and businesses. On any given day, there are millions of items across thousands of categories for sale on eBay. eBay enables trade on a local, national and international basis with customized sites in markets around the world.

Through an array of services, such as its payment solution provider PayPal, eBay is enabling global e-commerce for an ever-growing online community.

JetBlue Airways is proud to be *America 24/7's* preferred carrier, flying photographers, photo editors, and organizers across the United States.

Winner of Condé Nast Traveler's Readers' Choice Awards for Best Domestic Airline 2002, JetBlue provides friendly service and low fares for travelers in 22 cities in nine states across America.

On behalf of JetBlue's 5,000 crew members, we're excited to be involved in this remarkable project, and for the opportunity to serve American travelers each and every day, coast to coast, 24/7.

**DIGITAL POND**

Digital Pond has been a leading creator of large graphic displays for museums, corporations, trade shows, retail environments and fine art since 1992.

We were proud to bring together our creative, print and display capabilities to produce signage and displays for mission control, critical retouching for numerous key images for the book, and art galleries for the New York Public Library and Bryant Park.

The Pond's team and SplashPic® Online service enabled us to nimbly design, produce and install over 200 large graphic panels in two NYC locations within the truly "24/7" production schedule of less than ten days.

WebWare Corporation is pleased to be a major sponsor of the America 24/7 project. We take pride in being part of a groundbreaking adventure that is stretching the boundaries—and the imagination—in digital photography, digital asset management, publishing, news, and global events.

Our ActiveMedia Enterprise™ digital asset management software is the "nerve center" of *America 24/7*, the central repository for managing, sharing, and collaborating on the project's photographs. From photo editors and book publishers to 24/7's media relations and marketing personnel, ActiveMedia provides the application support that links all facets of the project team to the content worldwide.

WebWare helps Global 2000 firms securely manage, reuse, and distribute media assets locally or globally. Its suite of ActiveMedia software products provide powerful media services platforms for integrating rich media into content management systems marketing and communication portals; web publishing systems; and e-commerce portals.

Google's mission is to organize the world's information and make it universally accessible and useful.

With our focus on plucking just the right answer from an ocean of data, we were naturally drawn to the America 24/7 project. The book you hold is a compendium of images of American life distilled from thousands of photographs and infinite possibilities. Are you looking for emotion? Narrative? Shadows? Light? It's all here, thanks to a multitude of photographers and writers creating links between you, the reader, and a sea of wonderful stories. We celebrate the connections that constitute the human experience and are pleased to help engender them. And we're pleased to have been a small part of this project, which captures the results of that interaction so vividly, so dynamically, and so dramatically.

**Special thanks to additional contributors:** FileMaker, Apple, Camera Bits, LaCie, Now Software, Preclick, Outpost Digital, Xerox, Microsoft, WoodWing Software, net-linx Publishing Solutions, and Radical Media. The Savoy Hotel, San Francisco; The Pan Pacific, San Francisco; Four Seasons Hotel, San Francisco; and The Queen Anne Hotel. Photography editing facilities were generously hosted by CNET Networks, Inc.

# Participating Photographers

**Coordinator:** John Gaps III, Director of Photography, *The Des Moines Register*

Clint Austin
Harry Baumert, *The Des Moines Register*
John Bernau
Mike Brunette
Jeff Bundy, *Omaha World-Herald*
Alex Dorgan-Ross
Sarah Ehrler
Gary Fandel
Scott Frisch
John Gaines, *The Hawk Eye*
John Gaps III, *The Des Moines Register*
J J Gerlitz
Mark Hirsch, *Telegraph Herald*
Dave Kettering, *Telegraph Herald*
Brian Mishmash
Charlie Neibergall, Associated Press

Rob O'Keefe
Buzz Orr
Thomas Payne
David Peterson*
Kim Seang Poam
Don Poggensee
Brian Ray, *The Gazette*
Angela Smith
Jeff Storjohann
Joey Wallis
Rodney White
Danny Wilcox Frazier
Kevin R. Wolf
Heidi Zeiger

*Pulitzer Prize winner

# Thumbnail Picture Credits

Credits for thumbnail photographs are listed by the page number and are in order from left to right.

**18** Mark Hirsch, *Telegraph Herald*
Dave Kettering, *Telegraph Herald*
Mark Hirsch, *Telegraph Herald*
Dave Kettering, *Telegraph Herald*
Mark Hirsch, *Telegraph Herald*
Mark Hirsch, *Telegraph Herald*
Mark Hirsch, *Telegraph Herald*

**19** Dave Kettering, *Telegraph Herald*
Mark Hirsch, *Telegraph Herald*
Gary Fandel
Dave Kettering, *Telegraph Herald*
Dave Kettering, *Telegraph Herald*
Mark Hirsch, *Telegraph Herald*
Dave Kettering, *Telegraph Herald*

**20** Dave Kettering, *Telegraph Herald*
Buzz Orr
Harry Baumert, *The Des Moines Register*
Barb Officer
David Peterson
John Gaines, *The Hawk Eye*
Buzz Orr

**21** Rodney White
Monty Scott, Scott's Enterprises
Alex Dorgan-Ross
John Gaines, *The Hawk Eye*
Rodney White
Monty Scott, Scott's Enterprises
Kim Seang Poam

**24** Cyan R. James, Iowa State University
Danny Wilcox Frazier
Danny Wilcox Frazier
Brian Ray, *The Gazette*
Danny Wilcox Frazier
Danny Wilcox Frazier
Charlie Neibergall, Associated Press

**25** Gary Fandel
John Gaines, *The Hawk Eye*
Emily B. Hertz
Jeff Storjohann
Gary Fandel
Heidi Zeiger
Mark Hirsch, *Telegraph Herald*

**28** Charlie Neibergall, Associated Press
Rodney White
Kevin R. Wolf
Charlie Neibergall, Associated Press
Charlie Neibergall, Associated Press
David Peterson
Charlie Neibergall, Associated Press

**29** John Gaines, *The Hawk Eye*
Jeff Storjohann
David Peterson
Joey Wallis
Kevin R. Wolf
Sarah Ehrler
Charlie Neibergall, Associated Press

**30** Monty Scott, Scott's Enterprises
Kim Seang Poam
David Peterson
Rodney White
Charlie Neibergall, Associated Press
Kim Seang Poam
Jeff Storjohann

**31** Todd Mizener
Todd Mizener
John Gaines, *The Hawk Eye*
Rodney White
Kim Seang Poam
Rodney White
Gary Fandel

**34** Joey Wallis
Joey Wallis
Mike Brunette
Mike Brunette
John Gaines, *The Hawk Eye*
Mike Brunette
Sarah Ehrler

**35** Sarah Ehrler
John Gaines, *The Hawk Eye*
Sarah Ehrler
Sarah Ehrler
Jeff Storjohann
Mike Brunette
John Gaines, *The Hawk Eye*

**38** Clint Austin
Clint Austin
Clint Austin
Clint Austin
Clint Austin
Clint Austin
Clint Austin

**39** Clint Austin
Clint Austin
Clint Austin
Clint Austin
Clint Austin
Clint Austin
Clint Austin

**46** Michael T. Northrup,
University of South Dakota
Charlie Neibergall, Associated Press
Charlie Neibergall, Associated Press
Dave Kettering, *Telegraph Herald*
Charlie Neibergall, Associated Press
Charlie Neibergall, Associated Press
Alex Dorgan-Ross

**47** Dave Kettering, *Telegraph Herald*
Charlie Neibergall, Associated Press
Charlie Neibergall, Associated Press
Mark Hirsch, *Telegraph Herald*
Charlie Neibergall, Associated Press
Gary Fandel
Michael T. Northrup,
University of South Dakota

**48** Mark Hirsch, *Telegraph Herald*
Mark Hirsch, *Telegraph Herald*
Mark Hirsch, *Telegraph Herald*
Mark Hirsch, *Telegraph Herald*
Mark Hirsch, *Telegraph Herald*
Mark Hirsch, *Telegraph Herald*
Mark Hirsch, *Telegraph Herald*

**49** Mark Hirsch, *Telegraph Herald*
Mark Hirsch, *Telegraph Herald*
Mark Hirsch, *Telegraph Herald*
Mark Hirsch, *Telegraph Herald*
Mark Hirsch, *Telegraph Herald*
Mark Hirsch, *Telegraph Herald*
Mark Hirsch, *Telegraph Herald*

**50** Matthew Peake, Waldorf College
Gary Fandel
Monty Scott, Scott's Enterprises
John Gaps III, *The Des Moines Register*
Monty Scott, Scott's Enterprises
Don Poggensee
Kevin R. Wolf

**54** Charlie Neibergall, Associated Press
Rodney White
Charlie Neibergall, Associated Press
Charlie Neibergall, Associated Press
Charlie Neibergall, Associated Press
Charlie Neibergall, Associated Press
Charlie Neibergall, Associated Press

**55** John Gaines, *The Hawk Eye*
Heidi Zeiger
Monty Scott, Scott's Enterprises
Cyan R. James, Iowa State University
Charlie Neibergall, Associated Press
Charlie Neibergall, Associated Press
Heidi Zeiger

**56** Gary Fandel
Alex Dorgan-Ross
Mark Hirsch, *Telegraph Herald*
Dave Kettering, *Telegraph Herald*
Kim Seang Poam
Mark Hirsch, *Telegraph Herald*
Gary Fandel

**57** Gary Fandel
Gary Fandel
John Gaines, *The Hawk Eye*
Dave Kettering, *Telegraph Herald*
John Gaines, *The Hawk Eye*
Gary Fandel
Gary Fandel

**62** Don Poggensee
Mark Hirsch, *Telegraph Herald*
Gary Fandel
John Gaines, *The Hawk Eye*
Buzz Orr
Gary Fandel
Jeff Storjohann

**63** John Gaps III, *The Des Moines Register*
Gary Fandel
Cyan R. James, Iowa State University
Heidi Zeiger
Heidi Zeiger
Kim Seang Poam
Mike Brunette

**64** Mike Brunette
Mike Brunette
Kim Seang Poam
Michael T. Northrup,
University of South Dakota
Cyan R. James, Iowa State University
Mike Brunette
Michael T. Northrup,
University of South Dakota

**65** Mark Hirsch, *Telegraph Herald*
Mark Hirsch, *Telegraph Herald*
Kim Seang Poam
Mark Hirsch, *Telegraph Herald*
Mark Hirsch, *Telegraph Herald*
Emily B. Hertz
Mark Hirsch, *Telegraph Herald*

**68** Alex Dorgan-Ross
Gary Fandel
Rodney White
Alex Dorgan-Ross
Heidi Zeiger
Rodney White
Don Poggensee

**69** Rodney White
Dave Kettering, *Telegraph Herald*
Dave Kettering, *Telegraph Herald*
Alex Dorgan-Ross
Mark Hirsch, *Telegraph Herald*
Rodney White
Rodney White

**75** David Peterson
David Peterson
Mike Brunette
Jeff Storjohann
Heidi Zeiger
Jeff Storjohann
Mike Brunette

**76** David Peterson
Brian Ray, *The Gazette*
Danny Wilcox Frazier
Jeff Storjohann
Brian Ray, *The Gazette*
David Peterson
Brian Ray, *The Gazette*

**77** David Peterson
David Peterson
David Peterson
David Peterson
David Peterson
Joey Wallis
Dave Kettering, *Telegraph Herald*

**80** David Peterson
David Peterson
David Peterson
David Peterson
David Peterson
Alex Dorgan-Ross
David Peterson

**81** Sarah Ehrler
Sarah Ehrler
Joey Wallis
David Peterson
Mike Brunette
John Gaines, *The Hawk Eye*
Monty Scott, Scott's Enterprises

**82** Mark Hirsch, *Telegraph Herald*
Rodney White
Mark Hirsch, *Telegraph Herald*
Mark Hirsch, *Telegraph Herald*
Mark Hirsch, *Telegraph Herald*
Mark Hirsch, *Telegraph Herald*
Mark Hirsch, *Telegraph Herald*

**83** Buzz Orr
Jeff Storjohann
Rodney White
Mark Hirsch, *Telegraph Herald*
Buzz Orr
Mark Hirsch, *Telegraph Herald*
Alex Dorgan-Ross

**86** John Gaines, *The Hawk Eye*
John Gaines, *The Hawk Eye*
John Gaines, *The Hawk Eye*
John Gaines, *The Hawk Eye*
David Peterson
Harry Baumert, *The Des Moines Register*
John Gaines, *The Hawk Eye*

**87** Kevin R. Wolf
Charlie Neibergall, Associated Press
David Peterson
Alex Dorgan-Ross
David Peterson
Kim Seang Poam
Gary Fandel

**88** Alex Dorgan-Ross
Heidi Zeiger
Buzz Orr
Buzz Orr
John Gaines, *The Hawk Eye*
Heidi Zeiger
Alex Dorgan-Ross

**89** David Peterson
Alex Dorgan-Ross
John Gaps III, *The Des Moines Register*
Brian Ray, *The Gazette*
David Peterson
Dave Kettering, *Telegraph Herald*
Brian Ray, *The Gazette*

**92** Heidi Zeiger
David Peterson
Heidi Zeiger
David Peterson
Heidi Zeiger
David Peterson
David Peterson

**93** David Peterson
Heidi Zeiger
David Peterson
David Peterson
David Peterson
David Peterson
David Peterson

**99** Kevin R. Wolf
Joey Wallis
Charlie Neibergall, Associated Press
Charlie Neibergall, Associated Press
Mark Hirsch, *Telegraph Herald*
John Gaps III, *The Des Moines Register*
John Gaines, *The Hawk Eye*

**102** Don Poggensee
Buzz Orr
Charlie Neibergall, Associated Press
Don Poggensee
Harry Baumert, *The Des Moines Register*
Gary Fandel
Matthew Peake, Waldorf College

**103** Harry Baumert, *The Des Moines Register*
Monty Scott, Scott's Enterprises
Mark Hirsch, *Telegraph Herald*
Danny Wilcox Frazier
Gary Fandel
Don Poggensee
Harry Baumert, *The Des Moines Register*

**104** Alex Dorgan-Ross
David Peterson
David Peterson
David Peterson
David Peterson
David Peterson
David Peterson

**105** David Peterson
Buzz Orr
David Peterson
David Peterson
David Peterson
Mark Hirsch, *Telegraph Herald*
Mark Hirsch, *Telegraph Herald*

**106** John Gaines, *The Hawk Eye*
Jeff Storjohann
Jeff Storjohann
Jeff Storjohann
Jeff Storjohann
Emily B. Hertz
Jeff Storjohann

**107** Jeff Storjohann
John Gaps III, *The Des Moines Register*
Jeff Storjohann
Jeff Storjohann
John Gaines, *The Hawk Eye*
John Gaps III, *The Des Moines Register*
Jeff Storjohann

**110** Mike Brunette
Cyan R. James, Iowa State University
Don Poggensee
Jeff Bundy, *Omaha World-Herald*
Jeff Bundy, *Omaha World-Herald*
Don Poggensee
Jeff Bundy, *Omaha World-Herald*

**111** John Gaps III, *The Des Moines Register*
Don Poggensee
Clint Austin
Clint Austin
Don Poggensee
Clint Austin
Clint Austin

**116** Brian Ray, *The Gazette*
Joey Wallis
Cyan R. James, Iowa State University
David Peterson
David Peterson
Gary Fandel
Charlie Neibergall, Associated Press

**118** Clint Austin
Mike Brunette
David Peterson
Dave Kettering, *Telegraph Herald*
Alex Dorgan-Ross
Clint Austin
Gary Fandel

**119** Gary Fandel
John Gaps III, *The Des Moines Register*
Jeff Storjohann
Monty Scott, Scott's Enterprises
Harry Baumert, *The Des Moines Register*
John Gaps III, *The Des Moines Register*
John Gaps III, *The Des Moines Register*

**122** Gary Fandel
Brian Ray, *The Gazette*
David Peterson
Cyan R. James, Iowa State University
Kim Seang Poam
Brian Ray, *The Gazette*
Mark Hirsch, *Telegraph Herald*

**123** John Gaines, *The Hawk Eye*
Todd Mizener
Monty Scott, Scott's Enterprises
Mike Brunette
Rodney White
Alex Dorgan-Ross
Rodney White

**124** Brian Ray, *The Gazette*
Charlie Neibergall, Associated Press
Rodney White
Monty Scott, Scott's Enterprises
Alex Dorgan-Ross
Cyan R. James, Iowa State University
John Gaines, *The Hawk Eye*

**125** Rodney White
Charlie Neibergall, Associated Press
David Peterson
Monty Scott, Scott's Enterprises
Alex Dorgan-Ross
Todd Mizener
Charlie Neibergall, Associated Press

**126** Kim Seang Poam
Harry Baumert, *The Des Moines Register*
Harry Baumert, *The Des Moines Register*
Harry Baumert, *The Des Moines Register*
David Peterson
Brian Ray, *The Gazette*
Sarah Ehrler

**127** Clint Austin
Mark Hirsch, *Telegraph Herald*
John Gaps III, *The Des Moines Register*
Clint Austin
Monty Scott, Scott's Enterprises
John Gaps III, *The Des Moines Register*
John Gaps III, *The Des Moines Register*

**131** Mark Hirsch, *Telegraph Herald*
David Peterson
Emily B. Hertz
Rodney White
Don Poggensee
Alex Dorgan-Ross
Rodney White

**132** Dave Kettering, *Telegraph Herald*
Cyan R. James, Iowa State University
Rodney White
Cyan R. James, Iowa State University
Matthew Peake, Waldorf College
Heidi Zeiger
Alex Dorgan-Ross

**133** Dave Kettering, *Telegraph Herald*
Emily B. Hertz
Rodney White
David Peterson
Heidi Zeiger
Rodney White
Danny Wilcox Frazier

# Staff

The *America 24/7* series was imagined years ago by our friend Oscar Dystel, a publishing legend whose vision and enthusiasm have been a source of great inspiration.

We also wish to express our gratitude to our truly visionary publisher, DK.

Rick Smolan, Project Director
David Elliot Cohen, Project Director

## Administrative
Katya Able, Operations Director
Gina Privitere, Communications Director
Chuck Gathard, Technology Director
Kim Shannon, Photographer Relations Director
Erin O'Connor, Photographer Relations Intern
Leslie Hunter, Partnership Director
Annie Polk, Publicity Manager
John McAlester, Website Manager
Alex Notides, Office Manager
C. Thomas Hardin, State Photography Coordinator

## Design
Brad Zucroff, Creative Director
Karen Mullarkey, Photography Director
Judy Zimola, Production Manager
David Simoni, Production Designer
Mary Dias, Production Designer
Heidi Madison, Associate Picture Editor
Don McCartney, Production Designer
Diane Dempsey Murray, Production Designer
Jan Rogers, Associate Picture Editor
Bill Shore, Production Designer and Image Artist
Larry Nighswander, Senior Picture Editor
Bill Marr, Sarah Leen, Senior Picture Editors
Peter Truskier, Workflow Consultant
Jim Birkenseer, Workflow Consultant

## Editorial
Maggie Canon, Managing Editor
Curt Sanburn, Senior Editor
Teresa L. Trego, Production Editor
Lea Aschkenas, Writer
Olivia Boler, Writer
Korey Capozza, Writer
Beverly Hanly, Writer
Bridgett Novak, Writer
Alison Owings, Writer
Fred Raker, Writer
Joe Wolff, Writer
Elise O'Keefe, Copy Chief
Daisy Hernández, Copy Editor
Jennifer Wolfe, Copy Editor

## Infographic Design
Nigel Holmes

## Literary Agent
Carol Mann, The Carol Mann Agency

## Legal Counsel
Barry Reder, Coblentz, Patch, Duffy & Bass, LLP
Phil Feldman, Coblentz, Patch, Duffy & Bass, LLP
Gabe Perle, Ohlandt, Greeley, Ruggiero & Perle, LLP
Jon Hart, Dow, Lohnes & Albertson, PLLC
Mike Hays, Dow, Lohnes & Albertson, PLLC
Stephen Pollen, Warshaw Burstein, Cohen, Schlesinger & Kuh, LLP
Rick Pappas

## Accounting and Finance
Rita Dulebohn, Accountant
Robert Powers, Calegari, Morris & Co. Accountants
Eugene Blumberg, Blumberg & Associates
Arthur Langhaus, KLS Professional Advisors Group, Inc.

## Picture Editors
J. David Ake, Associated Press
Caren Alpert, formerly *Health* magazine
Simon Barnett, *Newsweek*
Caroline Couig, *San Jose Mercury News*
Mike Davis, formerly *National Geographic*
Michel duCille, *Washington Post*
Deborah Dragon, *Rolling Stone*
Victor Fisher, formerly Associated Press
Frank Folwell, *USA Today*
MaryAnne Golon, *Time*
Liz Grady, formerly *National Geographic*
Randall Greenwell, *San Francisco Chronicle*
C. Thomas Hardin, formerly *Louisville Courier-Journal*
Kathleen Hennessy, *San Francisco Chronicle*
Scot Jahn, *U.S. News & World Report*
Steve Jessmore, *Flint Journal*
John Kaplan, University of Florida
Kim Komenich, *San Francisco Chronicle*
Eliane Laffont, *Hachette Filipacchi Media*
Jean-Pierre Laffont, *Hachette Filipacchi Media*
Andrew Locke, MSNBC
Jose Lopez, *The New York Times*
Maria Mann, formerly AFP
Bill Marr, formerly *National Geographic*
Michele McNally, *Fortune*
James Merithew, *San Francisco Chronicle*
Eric Meskauskas, *New York Daily News*
Maddy Miller, *People* magazine
Michelle Molloy, *Newsweek*
Dolores Morrison, *New York Daily News*
Karen Mullarkey, formerly *Newsweek, Rolling Stone, Sports Illustrated*
Larry Nighswander, Ohio University School of Visual Communication
Jim Preston, *Baltimore Sun*
Sarah Rozen, formerly *Entertainment Weekly*
Mike Smith, *The New York Times*
Neal Ulevich, formerly Associated Press

## Website and Digital Systems
Jeff Burchell, Applications Engineer

## Television Documentary
Sandy Smolan, Producer/Director
Rick King, Producer/Director
Bill Medsker, Producer

## Video News Release
Mike Cerre, Producer/Director

## Digital Pond
Peter Hogg
Kris Knight
Roger Graham
Philip Bond
Frank De Pace
Lisa Li

## Senior Advisors
Jennifer Erwitt, Strategic Advisor
Tom Walker, Creative Advisor
Megan Smith, Technology Advisor
Jon Kamen, Media and Partnership Advisor
Mark Greenberg, Partnership Advisor
Patti Richards, Publicity Advisor
Cotton Coulson, Mission Control Advisor

## Executive Advisors
Sonia Land
George Craig
Carole Bidnick

## Advisors
Chris Anderson
Samir Arora
Russell Brown
Craig Cline
Gayle Cline
Harlan Felt
George Fisher
Phillip Moffitt
Clement Mok
Laureen Seeger
Richard Saul Wurman

## DK Publishing
Bill Barry
Joanna Bull
Therese Burke
Sarah Coltman
Christopher Davis
Todd Fries
Dick Heffernan
Jay Henry
Stuart Jackman
Stephanie Jackson
Chuck Lang
Sharon Lucas
Cathy Melnicki
Nicola Munro
Eunice Paterson
Andrew Welham

## Colourscan
Jimmy Tsao
Eddie Chia
Richard Law
Josephine Yam
Paul Koh
Chee Cheng Yeong
Dan Kang

## Chief Morale Officer
Goose, the dog

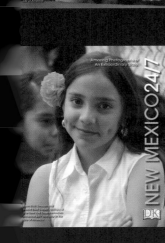

ALABAMA 24/7
ALASKA 24/7
ARIZONA 24/7
ARKANSAS 24/7
CALIFORNIA 24/7

HAWAII 24/7
IDAHO 24/7
ILLINOIS 24/7
INDIANA 24/7
IOWA 24/7

MASSACHUSETTS 24/7
MICHIGAN 24/7
MINNESOTA 24/7
MISSISSIPPI 24/7
MISSOURI 24/7

NEW MEXICO 24/7
NEW YORK 24/7
NORTH CAROLINA 24/7
NORTH DAKOTA 24/7
OHIO 24/7

SOUTH DAKOTA 24/7
TENNESSEE 24/7
TEXAS 24/7
UTAH 24/7
VERMONT 24/7